H A N D B O O K

of the Norton Simon Museum

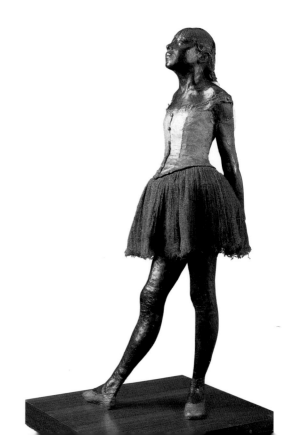

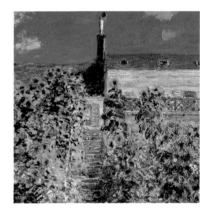

Norton Simon Museum ❖ Pasadena, California

HANDBOOK
of the Norton Simon Museum

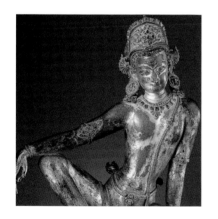

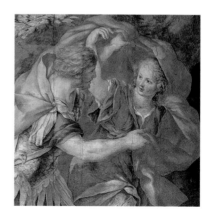

Handbook of the
Norton Simon Museum

Contributors
Sara Campbell
Christine Knoke
Gloria Williams
with assistance from
Michelle Deziel
Mary Catherine Ferguson
Jordan Kim

© 2003 Norton Simon Museum
411 West Colorado Boulevard
Pasadena, California 91105
www.nortonsimon.org

Library of Congress Control Number 202117529
isbn 0-9726681-0-1 (cloth), 0-9726681-1-x (paper)

Editor Jean Patterson
Photographers Antoni Dolinski, Steve Oliver,
Jack Nadelle, Tom Bonner, Frank Thomas
Designer Lilli Colton

Front cover Paul Cézanne, Tulips in a Vase (detail)
Back cover View of the Norton Simon Museum garden
with Aristide Maillol, Mountain
Page 1 Edgar Degas, Little Dancer Aged Fourteen
Title Page Clockwise from upper left, details of:
Sam Francis, Basel Mural i; Giovanni de Paolo,
The Branchini Madonna; Giovanni Francesco
Romanelli, The Royal Hunt and Storm; Nepal,
God Indra; Claude Monet, The Artist's Garden
at Vétheuil; Claude Lorrain, Esther on Her Way
to Ahasuerus

Printed and bound in Japan by Toppan
First Edition

CONTENTS

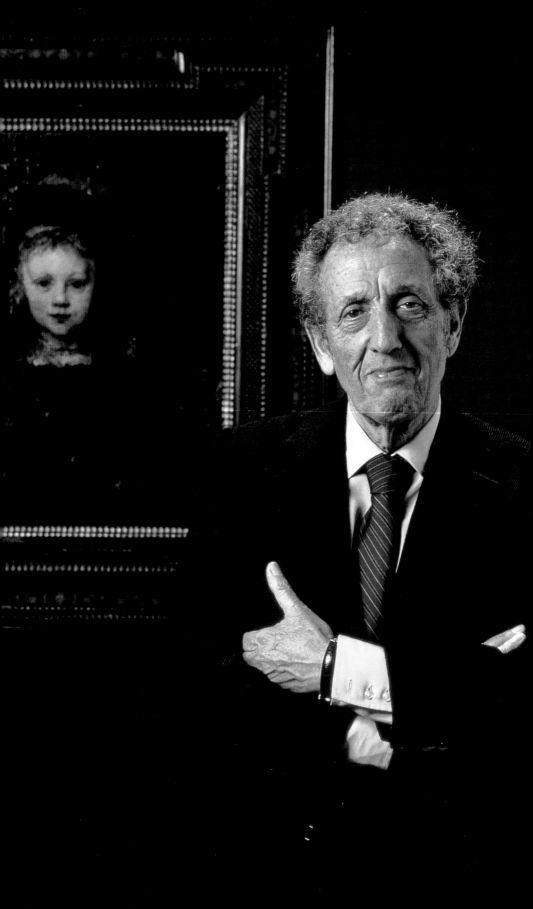

NORTON SIMON
and the
ART OF COLLECTING

NORTON SIMON IS KNOWN as a businessman with great vision and drive, and also as a daring, shrewd art collector. The telling of his entrepreneurial feats, and his focused pursuit of great works of art, has become legendary. Simon was born in Portland, Oregon in 1907 as one of three children. As a hardworking, ambitious teenager, he assisted in his father's retail store on weekends. His brief tenure as a student at the University of California, Berkeley confirmed his goal to enter the world of business. With a gift for understanding production and marketing, he became a dynamic entrepreneur, and by age 24, had invested in a bankrupt orange juice bottling plant in Fullerton, California. The plant prospered and evolved into Hunt Foods Inc., one of the best-known American food companies of the 20th century. Simon built the highly prosperous Hunt Foods into Norton Simon Inc., a multi-industry enterprise that included Canada Dry Corporation, McCall's Publishing, Max Factor Cosmetics, and Avis Car Rental, to name but a few. His rugged countenance was featured on covers of *Time* magazine and inside numerous financial publications.

However, in the mid-1960s, Norton Simon's role as a prominent businessman and industrialist began to blur with another identity that took many of his contemporaries by surprise—that of an art collector. Indeed, the June 1965 issue of *Time* magazine ran a feature on Simon entitled: "The Corporate Cézanne." In the article, a commentator noted that Simon "himself is no longer quite sure whether he is an art connoisseur who engages in business or a businessman who collects art."

Nearly four decades later, the outcome is now perfectly clear. Simon, inspired by his passion for the visual arts, embarked on a journey to collect the finest works of art available. It is no exaggeration to acknowledge that, from the mid-1950s to the mid-1980s, Norton Simon occupied a rare position as one of the major collector-connoisseurs on the international scene. This museum, named after him, houses one of the foremost collections brought together by an individual during the second half of the 20th century.

Above: The Norton Simon Museum, Pasadena, California

Page 6: Norton Simon, 1980, with Rembrandt van Rijn's PORTRAIT OF A BOY, PRESUMED TO BE THE ARTIST'S SON, TITUS

When I first started collecting art, my thoughts about each picture, about each sculpture, were essentially inwardly directed. What does this picture mean to

me? The more I looked, the more I felt my perceptions sharpening, the more I felt the nurturing aspect of art, the more I became convinced that art is the major form of human communication—crossing the years—crossing cultures—crossing age boundaries— crossing all political considerations. Much of it gives us enjoyment, yes, but more important, it helps us to understand ourselves more fully [Norton Simon, 1974].

Mercurial and untraditional in both the business world and the art world, Norton Simon did not articulate a formal plan for collecting. He sought out art based on its quality, rarity, beauty, and authenticity. His collecting expertise was continuously honed by questions about artists and works of art that could be characterized as unorthodox, occasionally confounding dealers and experts alike. In thirty years, he cultivated a collection that included paintings, sculpture, tapestries, and works on paper from the West ranging from the 14th to the 20th centuries. The extensive South Asian sculpture collection, one of the finest in the Western Hemisphere, illuminates the rich traditions of the Indian subcontinent, the Himalayas, and Southeast Asia.

Norton Simon's interest in art began naturally enough. In a conversation with Suzanne Muchnic, his biographer, he commented, "*I don't think I was very interested in art until we moved into a new house and started putting contemporary art in it.…A decorator brought in some paintings. I didn't like them so I went to some dealers to see what was available.*" The year was 1954. Walking through the art galleries located in the famed Ambassador Hotel on Wilshire Boulevard, he stepped into the Dalzell Hatfield Gallery. There he discovered a late portrait by Auguste Renoir depicting a young girl and entitled ANDREA IN BLUE. It was his first acquisition, and the beginning of a sustained involvement with art and the art market. Certainly one of the more remarkable characteristics of Simon's journey from savvy businessman to savvy collector of art was the swiftness and surety of this evolution.

Nobody believes me, but the fact is that I never have a fixed idea about where I am going. I follow the road with the unknown end. I go where the going looks best [Norton Simon, 1953].

Though this quotation from Simon comes from *Fortune* magazine, referring to his zenith as a businessman, it aptly conveys his approach to acquiring works of art. Simon frequented dealers' galleries from Los Angeles to London. Relying on his business acumen, he entered into the auction world with confidence and frequently received press attention. Simon's

seriousness as a collector became more clearly defined in 1964 when he purchased the entire European art inventory of the Duveen Brothers firm in New York. A major tastemaker in the fine arts during the late 19th century, the gallery's founder, Lord Joseph Duveen, successfully cultivated important American magnates-cum-collectors such as Henry Clay Frick, Henry Huntington, Andrew Mellon, and J. Pierpont Morgan. Many of the treasures found in American museums today passed through the Duveen Brothers. On the eve of the retirement of the firm's last associate, the contents of the gallery—some 400 objects—and the building itself were sold through private agreement to Norton Simon.

This noteworthy *en bloc* addition to the Simon collection included Italian marbles, Old Master paintings, and some Chinese porcelains. Important and singular treasures were identified, including several rare 15th-century Flemish tapestries [pp. 33–35], an early Netherlandish painting by Hans Memling of CHRIST GIVING HIS BLESSING [p. 36], and a spectacular early example of Jusepe de Ribera's Baroque tenebrist style, THE SENSE OF TOUCH. Simon decided not to keep the building in New York. Instead of selling it to the New York art gallery that had requested the space, Simon traded the real estate for two paintings from the dealer's inventory. One of these was the intimate WHITE AND PINK MALLOWS IN A VASE by Fantin-Latour, one of the great still life painters of the late 19th century.

By this time, Simon had established two foundations, through which he rapidly acquired and displayed his expanding collection. His intention was to build a museum where he could house the art and make it available for public viewing.

Jusepe de Ribera
Spanish, 1591–1652,
THE SENSE OF TOUCH, c. 1615–16
Oil on canvas
45 ⁵/₈ × 34 ³/₄ in. (115.9 × 88.3 cm)
F.1965.1.052

Henri Fantin-Latour
French, 1836–1904
WHITE AND PINK MALLOWS IN A VASE, 1895
Oil on canvas
21 ¹/₈ × 19 ⁵/₈ in. (53.7 × 49.8 cm)
F.1967.3.1

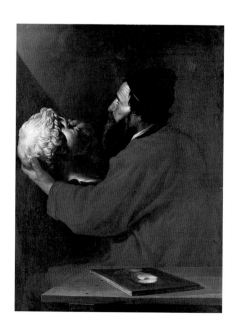

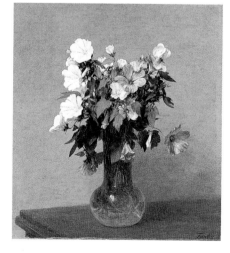

His sense of urgency was not yet acute, however, as large portions of the Foundations' collections were on long-term loan to major institutions around the country, including the Los Angeles County Museum of Art. For the short term, such loans satisfied Simon's desire to make his collections available. Whenever possible, portions of the collection were integrated into the teaching programs of university fine arts departments, such as the one at the Princeton University Art Museum.

Achille Devéria
French, 1800–1857
ODALISQUE, c. 1831
Oil on panel
9 ⁵/₈ x 12 ⁷/₈ in. (24.4 x 32.7 cm)
M.1967.06

Georges Lacombe
French, 1868–1916
THE CHESTNUT GATHERERS, 1893–94
Oil on canvas
60 ¹/₈ x 93 in. (152.7 x 236.2 cm)
M.1979.35

IF ONE EXAMINES THE EVOLUTION of the Simon collection, there are few patterns that can be identified definitively. His tastes and interests were broad and catholic. For instance, the paintings collection is chronologically and geographically expansive. Paintings on copper, panel, and canvas span six centuries, offering superb examples by major artists from all national schools. Subjects include landscape, still life, portraiture, and genre. Simon also showed daring in finding exemplary works by lesser known artists. His choices of Lacombe's CHESTNUT GATHERERS, and Devéria's ODALISQUE attest to his adventuresome taste.

Simon did favor certain artists, including Rembrandt, Rubens, Courbet, Degas, van Gogh, Rodin, and Picasso. It is not possible to say which characteristics or qualities unified these artists in Simon's eyes. Perhaps it was the fact that their ambitions and preoccupations as artists were manifest in their public lives. In 1962, Simon acquired his first work by Rubens, MELEAGER AND ATALANTA AND THE HUNT OF THE CALYDONIAN BOAR [p. 45]. A vigorously painted easel panel depicting a scene from classical mythology, it has since been joined by seven more Rubens depicting Biblical episodes and portraits. Between 1969 and 1970, Simon acquired four Courbets: one portrait, one still life, and two landscapes. His last Courbet acquisition, in 1989, a painting of a young peasant girl lost in a daydream, brought the Museum's total to seven high-quality examples by this important French Realist.

Surely the inexhaustible and probing eye of Degas appealed to Simon—how else can we explain his ongoing search for the best works of this artist? From 1955 to 1983, Simon acquired eighty-seven Degas sculptures and forty paintings, drawings, and pastels. The bronzes, or *modèles*, occupy a unique position in Degas's three-dimensional oeuvre. They were the original bronzes cast from Degas' waxes, and served as the foundry models to reproduce all of the subsequent sets. Simon was particularly fond of late-19th-century artists. Visitors to the museum are often surprised by its extensive selection of Impressionist and Post-Impressionist paintings by Manet, Monet, Renoir, Toulouse-Lautrec, Pissarro, and Cézanne. Van Gogh is represented in eight examples.

The shape of Norton Simon's collection took a new and exciting path in the 1970s, when he began to acquire Indian and Southeast Asian art. Until this point, with the exception of a few ancient Greek and Egyptian objects, the collection had reflected the achievements of European culture, featuring mainly works by Old Masters, Impressionists, and Modernists. During a honeymoon trip to India with his wife, Jennifer Jones, Simon began to explore the monuments and museums of New Delhi. One of the most popular objects in the Museum today, a 19th-century ivory chess set from India's Mughal period, was his first purchase in the region[p. 259]. Simon's enthusiasm for Asian art, particularly the primacy and sensuality that it accorded the human figure, matched his zeal for acquiring Western art. This admiration for two disparate artistic traditions occupied his collecting activity for the rest of his life.

The South Asian collection is a major repository for the sculptural traditions of the Indian subcontinent and Southeast Asia. Formed in less than a decade, this fine, comprehensive collection is unrivaled in the Western world.

Indian and Southeast Asian galleries

Buddhist sculptures from Gandhara and Mathura of the Kushan Period (1st–3rd centuries) are among the earliest works on display. Hindu art, characterized by dynamic themes and symbolic configurations, is represented through images of voluptuous celestial maidens, passionate loving couples and nurturing mother goddesses [p. 231]. Gods appear in their anthropomorphic forms and via incarnations that combine the shapes of man and animal [p. 248]. The Chola (c. 880–1279) and Vijayanagar (14th–16th centuries) bronzes, considered among the best outside of India, display a variety of images, including forms of Shiva, Vishnu, Krishna, and other saints. Himalayan cultural traditions, inspired by Hinduism and Buddhism and dominated by the geographical areas of Kashmir, Nepal, and Tibet, are represented in metal sculpture and painting [p. 267]. Artworks from Thailand and Cambodia comprise the majority of examples from Southeast Asia.

Once the size of Simon's collection grew to almost 4,000 works, it became increasingly difficult for him to continue the Foundations' loan programs. Norton Simon decided to search for a permanent home for his expanding collection. In 1974, an opportunity arose in Pasadena, California, where the prestigious Pasadena Art Museum was facing severe financial hardship. The Museum had been one

of the most progressive venues in the Western United States for the viewing of contemporary art. Its collections included 20th-century painting, sculpture, prints and photography, plus some 500 Japanese woodblock prints by masters such as Katsushika Hokusai and Ando Hiroshige. It was also home to the esteemed Galka Scheyer Collection of Blue Four artists: Paul Klee, Lyonel Feininger, Alexei Jawlensky and Vasily Kandinsky. Among its critically acclaimed exhibitions, the Pasadena Art Museum had hosted important retrospectives for Marcel Duchamp (1963) and Andy Warhol (1970), as well as the groundbreaking *New Paintings of Common Objects* show (1962). Nevertheless, the combined financial obligations of its programs and the price of constructing a new building proved insurmountable. The Museum's trustees forged an agreement with Simon in which he absorbed the institution's debts. In exchange, he assumed responsibility for the Museum's collections and building.

For the first time, Norton Simon could unite his entire collection under one roof and open it to the public. One would have thought that the installation of the collections and the responsibilities of museum management would have diminished Norton Simon's momentum in acquiring new works of art. It had no effect whatsoever. In 1977, for example, Simon acquired a total of 108 works by Western artists, including some Degas bronzes and several prints by Rembrandt and Picasso. Another twenty objects from India and South Asia also entered the collections that year.

Having acknowledged Norton Simon's eclectic reach as a collector, and having noted that there are few discernible

Impressionist gallery with Edgar Degas' LITTLE DANCER AGED FOURTEEN

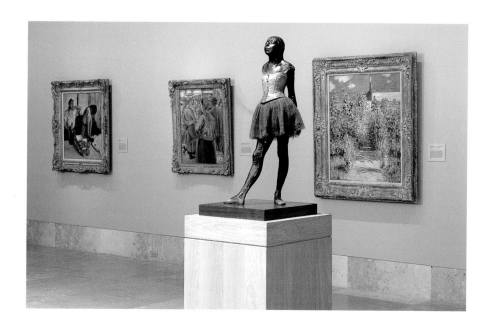

patterns in his acquisitions, it should be mentioned that certain concentrations within the collection are peculiar to his taste and distinguish the Museum as it is recognized today. While the paintings collection is relatively broad, the works on paper collection is focused on the production of three artists in particular: Rembrandt van Rijn, Francisco de Goya and Pablo Picasso. These painter-printmakers are distinguished not only for their creativity and originality, but also for their pioneering experiments in their chosen medium, be it etching, lithography, or linocut. Each one chose the human form as the vehicle for his expressive intent.

Collecting works on paper certainly satisfied Norton Simon's tendency to acquire objects en masse. In 1977, he purchased one of the finest Rembrandt print collections still in private hands. From this beginning of 118 etchings, he expanded the Rembrandt holdings to 300, representing most of the subjects and states from his oeuvre, including some rare examples. Simon appreciated and sought etchings by Goya with equal zeal. The Museum maintains and exhibits multiple editions of LOS CAPRICHOS (1799), LA TAUROMAQUIA (1816), LOS DESASTROS (1863), and LOS PROVERBIOS (1864). Its singular Picasso collection of works on paper is one of the most important in the United States. Every phase of Picasso's career is represented in the collection, including rare working and trial proofs, illustrated books and suites, and famous "Bon à Tirer" prints. They represent a curator's dream for exhibitions both thematic and technical.

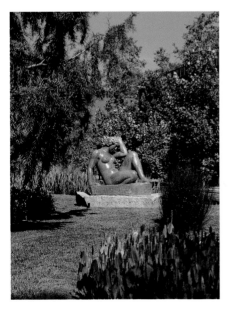

The sculpture garden with a view of Aristide Maillol's MOUNTAIN, 1937

Western sculpture in the Norton Simon Museum is primarily modern in character, with an emphasis on sculptors from the late 19th and early 20th centuries. Seven bronzes by Auguste Rodin can be viewed in the gardens surrounding the Museum. Additional works in bronze, lead, and marble by Henry Moore, Aristide Maillol, Isamu Noguchi, and Picasso are situated inside the galleries and in the garden.

In 1995, the Museum embarked on a major renovation project at the behest of Jennifer Jones Simon, with the support of the Board of Trustees. Celebrated architect Frank Gehry redesigned 51,000 square feet of gallery space. His plan focused on improving the lighting, increasing ceiling heights, and converting the large gallery corridors that had originally been designed for large-scale contemporary works of art. Gehry transformed these corridors into intimate spaces that are better suited to the display of the Museum's collections. An entire floor is dedicated to the installation of Asian

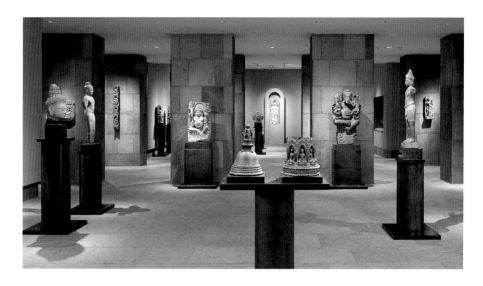

Indian and Southeast Asian galleries

art. Since most of the Museum's Asian art was created for devotional purposes, these galleries were designed to provide the type of ambiance found at religious sites. Three galleries were created to host special, rotating exhibitions.

An entirely new garden environment offers a verdant, colorful foil to the 20th-century sculpture collection. Nancy Goslee Power planned this remarkable environment, finding inspiration in Claude Monet's Giverny and the natural pond at its center. The final phase of the Museum's renovation was completed with the inauguration of the Norton Simon Theater, designed by Arthur Gensler Jr. & Associates Inc. The theater serves as a venue for lectures, concerts, films, and dance performances that complement the museum's collections.

> *I am not essentially a religious person, but my feeling about a museum is that it can serve as a substitute for a house of worship. It is a place to respect man's creativity and to sense a continuity with the past. It is a place to give us a feeling of the dignity of man and to help us strive towards our own creativity and fulfillment* [Norton Simon, 1974].

Simon believed in the power of art to communicate and to help us better know ourselves. His guiding principle was his regard for the wonder and magic that the visual arts could inspire. Today, the Museum continues to fulfill Norton Simon's dream of exhibiting great works of art in surroundings that encourage a personal and meaningful encounter for its visitors.—*Gloria Williams* ❖

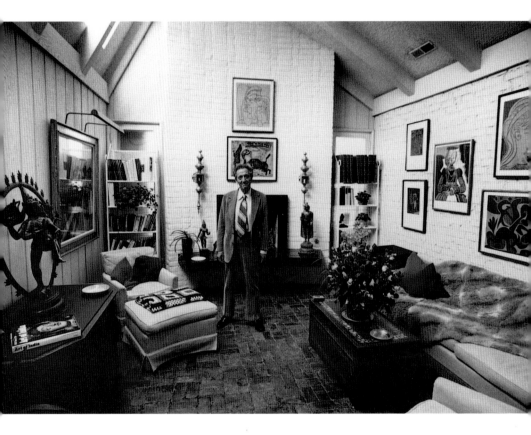

Norton Simon at home in Malibu,
1972. NSM Archives

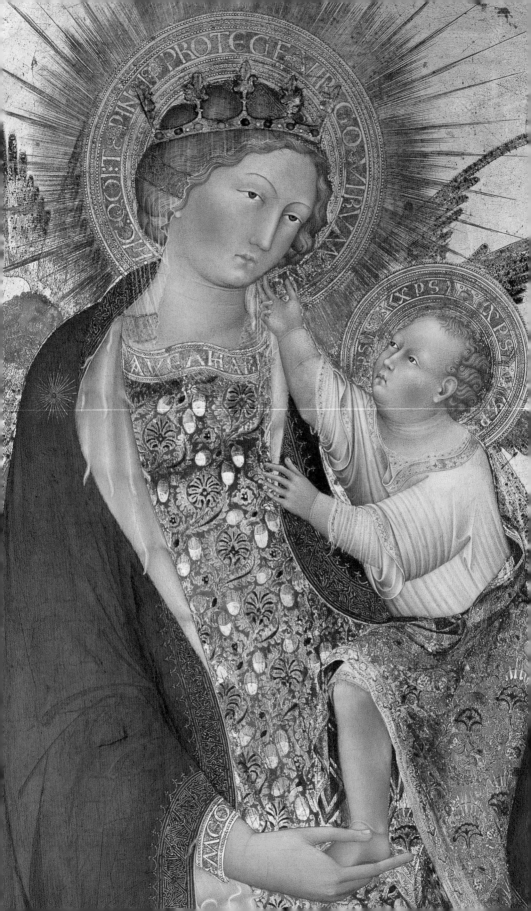

PAINTINGS

Pietro Lorenzetti

Italian, c. 1280–1348?
THE PROPHET ELISHA and
ST. JOHN THE BAPTIST, c. 1329
Tempera and gold leaf on panel
49¾ x 18⅜ in.
(126.4 x 46.7 cm) each
F.1973.08.1

These panels are fragments of a much larger altarpiece, now dismembered, which was commissioned for the Carmelite Church of Santa Maria del Monte Carmelo in 1329. Elisha and St. John, together with Saints Agnes and Catherine, originally flanked a large panel depicting the Virgin and Child enthroned with saints. The Carmelite Altarpiece marks a new phase in Lorenzetti's style, with its illusion of three-dimensional forms in space. St. John the Baptist and Elisha stand solidly and monumentally within the clearly implied space of an architectural niche. Lorenzetti's well-conceived palette is evident in the striking use of red for the Baptist's cloak and the infinite shades of white in Elisha's cope. Full length, calm, and dignified, they form a compelling and immediate image. ❖

Paolo Veneziano

Italian, active c. 1325–1358
MADONNA AND CHILD, c. 1340
Tempera and gold leaf on panel
43⅝ x 24⅜ in. (110.8 x 61.9 cm)
F.1973.24

Venice's strategic location on the Adriatic Sea fostered the development of a culture and an art that distinguished the city from the rest of Italy. Its link to the sea and the resulting trade with the Byzantine Empire led to a rich exchange of cultural traditions. It was in this fertile environment that Venetian painting found its most authoritative voice in Paolo Veneziano. In the MADONNA AND CHILD, Paolo married the Venetian aesthetic, based on color and its unifying, descriptive aspect, to the reserved, hieratic Byzantine style. The Christ Child, looking closely at His mother, holds a palm branch, symbolizing His future entry into Jerusalem and His subsequent death. He touches the goldfinch perched atop the Madonna's hand, which symbolizes the winged soul. The picture is designed as a web of color and lines, a luxurious tapestry with few independent forms. ❖

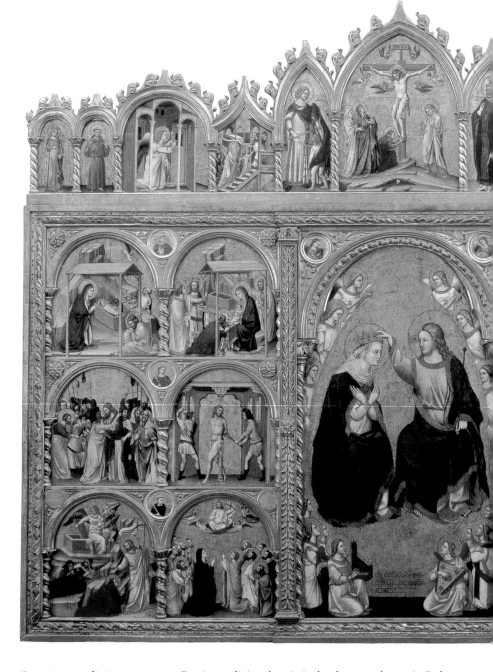

Guariento di Arpo

Italian, c. 1310–1370
THE CORONATION OF THE
VIRGIN ALTARPIECE, 1344
Tempera and gold leaf
on 32 panels
overall: 86 x 104⅜ in.
(218.4 x 265.1 cm)
M.1987.3.1–32

Guariento di Arpo's artistic development began in Padua,
where the influence of Giotto prevailed. Guariento endowed
his figures with solidity and naturalism. His individual
expression is evident in the refined linear technique and
limpid color, which anticipate the International Gothic
Style. Even so, Guariento retained the early Italo-Byzantine
pictorial tradition of using gold-leafed backgrounds to
emphasize the spiritual and celestial nature of Christian
mysteries. Following Italian tradition, the devotional image
of the Virgin Mary's Coronation as Queen of Heaven occu-
pies the center of the altarpiece, with smaller narrative scenes

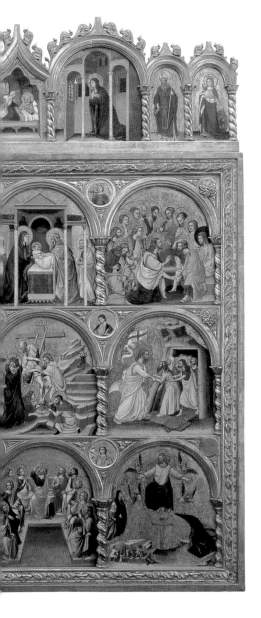

from the life of Christ and representations of saints and angels surrounding it. The altarpiece functioned to illustrate, for the viewer, the major events of the New Testament, and likely occupied the place of honor in the Church, above the main altar. This masterwork by Guariento is said to be the only fourteenth-century polyptych of this size and quality in America. It was commissioned for a convent in Padua, and later belonged to the Tuscan Grand Ducal Collections in Florence. The thirty-two extant panels were reframed in the nineteenth century. ❖

Details:
Above: EPIPHANY
17¼ x 15½ in. (43.8 x 39.4 cm)
M.1987.3.03
Below: NOLI ME TANGERE
16¾ x 15⅝ in. (42.5 x 39.7 cm)
M.1987.3.06

Giovanni di Paolo

Italian, c. 1403–1482
THE BRANCHINI MADONNA, 1427
Tempera and gold leaf on panel
72 x 39 in. (183 x 99 cm)
F.1978.01

Giovanni di Paolo has created a sumptuous composition combining richness of surface and incisive drawing. This panel unites two pictorial types of the Virgin: the Madonna of Humility, seated on the ground, and the Virgin as Queen of Heaven, crowned and wearing an ermine cloak. Scattered throughout are symbolic references to the Virgin and Christ: thistles on Christ's drapery allude to His Passion; pomegranates foretell the promise of the Resurrection; roses and marigolds refer to Mary, while the cornflowers are associated with Christ and heaven. The painting presents an image of spirituality that, though formal, is also personal, soft, and lyrical. Inscriptions on the clothing and haloes underscore the devotional intention. "MGO" and "AVEAMARIA" herald the glory of the Madonna, while "XPS" proclaims the role of the Savior. Around the Virgin's halo, the artist has inscribed his own prayer, "HC QUI TE PINSIT PROTEGE VIRGO VIRUM" (Protect, O Virgin, the man who has painted thee). The painting functions as an object of devotion and acts as a perpetual and very personal prayer to the Virgin. ❖

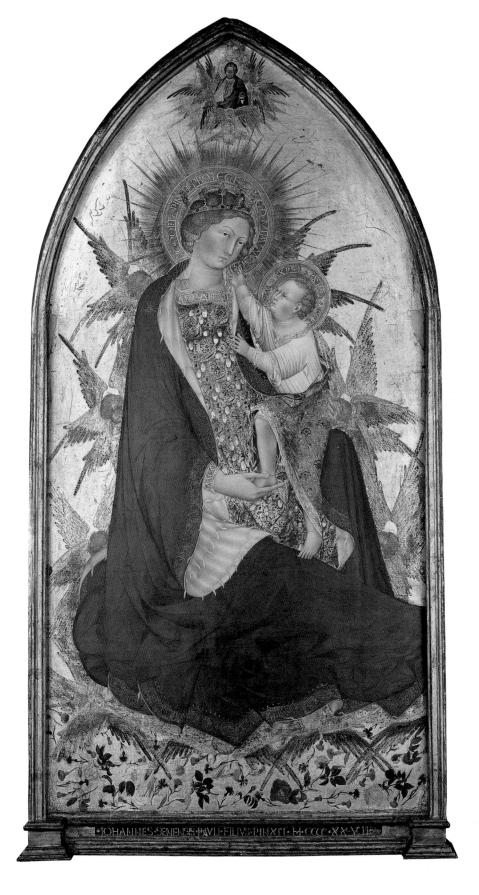

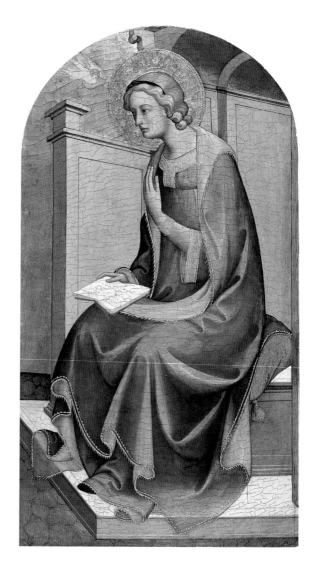

Piero di Giovanni, called
Lorenzo Monaco

Italian, c. 1370–1425
The Virgin Annunciate,
c. 1410–15
Tempera and gold leaf on panel
31 ⅝ x 17 ½ in. (80.3 x 44.5 cm)
M.1973.5

Lorenzo Monaco began his artistic career as an illuminator of manuscripts. His paintings display the delicacy of expression and decorative design that characterized the traditions of his native Siena and the then-popular International Gothic style. The soft, sinuous folds of the Virgin's mantle fall across the floor in playful, ornamental patterns. The delicate use of blue, pink, green, and gold intensifies the decorative quality of the picture. The gentle yet aristocratic Virgin originally faced a corresponding panel representing Gabriel, the Angel of the Annunciation. Interrupted from her reading, Mary looks up to receive the message that she has been chosen to be the mother of Christ. The dove of the Holy Ghost descends upon her from the upper left. ❖

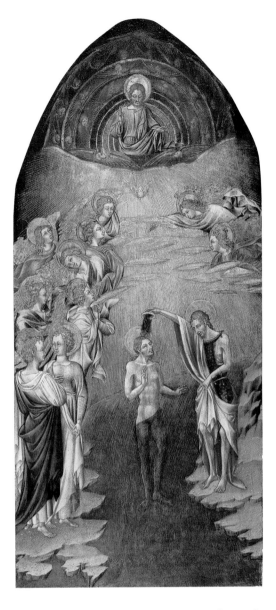

Giovanni di Paolo

Italian, c. 1403–1482
THE BAPTISM OF CHRIST,
early 1450s
Tempera and gold leaf on panel
30 x 13⅜ in. (76 x 34 cm)
F.1973.07

Giovanni di Paolo's composition is presented in an abstracted and hierarchical arrangement. Christ stands in the Jordan River, whose banks extend in back of, but little beyond him. Both the plane of water and land and the row of attendant angels incline steeply toward the golden rays of light, above which God the Father gives his blessing. Giovanni's love of precise detail and pattern is everywhere evident. His tight, linear drawing creates a tension that, in combination with the sacred narrative, presents a scene of magic and mystery. This painting belonged to a narrative cycle depicting the life of St. John the Baptist. The vertical proportion of this and the other surviving panels suggests that they may have formed part of a *custodia*, or cupboard that contained a sacred relic. ❖

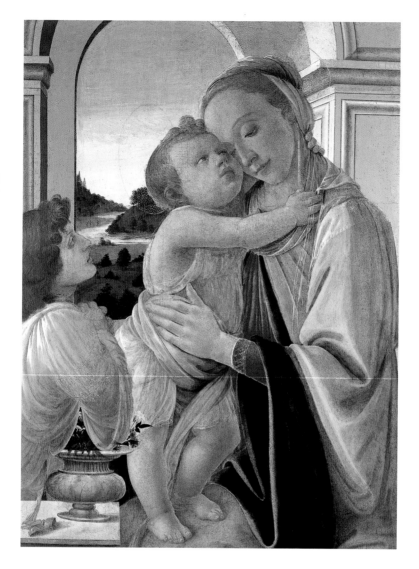

Alessandro Filipepi,
also known as

Botticelli

Italian, c. 1444–1510
MADONNA AND CHILD WITH
ADORING ANGEL, c. 1468
Tempera on panel
35 x 26¾ in. (89 x 68 cm)
M.1987.2

Botticelli was one of the most individual and influential painters in Florence at the end of the fifteenth century. His melodic, linear designs have been greatly admired and are readily apparent in this panel. The composition is unusually sculptural for the artist: forms are substantial and their disposition leads the eye into a space firmly defined by the stone parapet and middle ground arcade. The rounded hills of the landscape in the background complete the plasticity of the design. In this work, lyricism is bound to the description of natural data and to the suggestion of human grace. This subtle combination of function and decoration in Botticelli's use of line provides the poetry of his paintings. ❖

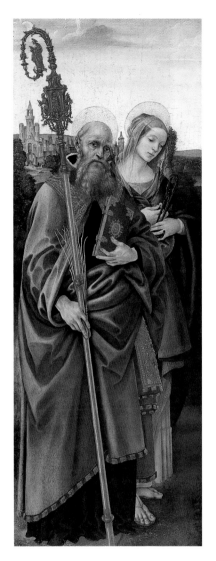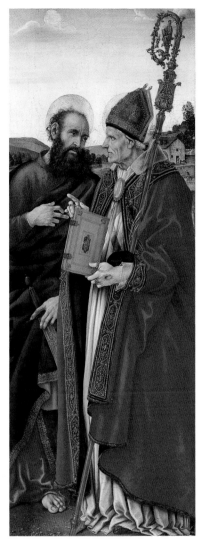

Filippino Lippi

Italian, 1457–1504
SAINTS BENEDICT AND APOLLONIA;
SAINTS PAUL AND FREDIANO, C. 1483
Tempera glazed with oil on panel, a pair
62 x 23⅜ in. (157.5 x 60 cm) each
F.1973.21.1–2

These two panels were created for the Church of San Ponziano in Lucca, where they formed part of a triptych on either side of a statue of St. Anthony. At left, St. Benedict, founder of Western monasticism, accompanies St. Apollonia, a third-century martyr, who holds a tooth and dental extractors, the instruments of her torture. At right is the apostle Paul, who holds a sword, symbol of his death, and St. Frediano, patron saint of Lucca. The decorative linear manner that associated Lippi with his teacher, Botticelli, is integrated with the representation of mass. The figures are broadly conceived and impress us with their monumental presence. Material richness, reflective surfaces, and textural variety impart a larger-than-life quality to the scene. The physiognomical analysis and emotional depth of the figures is almost unprecedented in Italian painting at this date and extraordinary in light of Filippino's age of twenty-five. ❖

Raffaello Sanzio, called

Raphael

Italian, 1483–1520
MADONNA AND CHILD WITH BOOK, c. 1502–3
Oil on panel
21¾ x 15¾ in. (55.2 x 40.0 cm)
M.1972.2

Raphael has simply and naturally described his balanced, serene figures. A lucid geometry organizes the composition, from the pyramidal grouping of the Madonna and Child to the geometric idealization of their faces and bodies. The deep, blue arch of the Madonna's silhouette encloses the figure of the Child and frames the book, which is further emphasized by the touching hands that hold it. The inscription in the book introduces the ninth hour or Nones of the Canonical Offices, recited daily by all monastic communities. The Nones commemorates Christ's Crucifixion and Death. With eyes turned to heaven, the Christ Child contemplates His own sacrifice as man's Redeemer. Raphael has depicted more than just a beautiful image of the Madonna and Child—he has created a meditation piece. The profoundly spiritual quality achieved by Raphael explains why his Madonnas were in such high demand. ❖

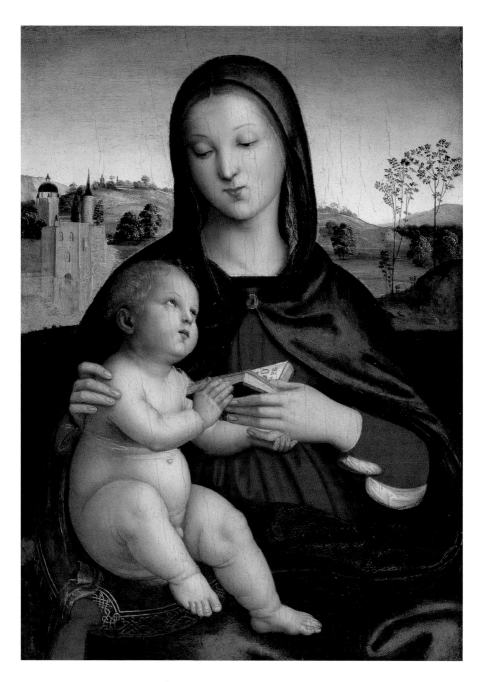

Francesco di Giorgio

Italian, 1439–1501
FIDELITY, c. 1485
Fresco transferred to canvas,
mounted on wood panel
49½ x 29¾ in. (125.7 x 75.6 cm)
F.1965.1.022

A painter, sculptor, architect, and military engineer, Francesco di Giorgio typified the ideal of the Renaissance man. As the outstanding artistic personality in Siena during the middle of the fifteenth century, he chose a style that combined the refined elegance of the Sienese tradition with the most forward-looking innovations of the Florentine school. This fresco, transferred to canvas, exemplifies a popular interior decoration of the Renaissance: the cycle of famous persons and the allegorical personification of the virtues. Here, Faith is identified by the collared dog (*fidelitas*) on which she stands, a symbol of fidelity. The pair exchanges a devoted glance as Faith points heavenward with her right hand and to the dog with her left. The image implies that the trust and loyalty shared between master and servant also exists between God and the devout. ❖

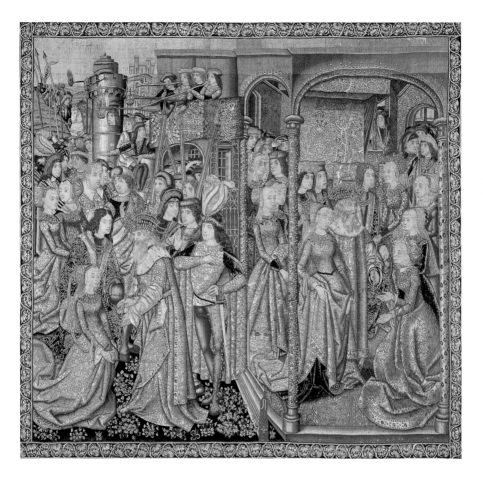

Flemish

The Arrival of Paris and Helen at
the Court of Priam, King of Troy, c. 1500
Wool and silk tapestry
152 x 164 in. (386.1 x 416.6 cm)
F.1965.1.129.1

In the fifteenth and sixteenth centuries, the
story of the Trojan War was known through
the popular works of medieval writers rather
than through the words of Homer. For instance,
the story of Helen of Troy depicted in this
magnificent tapestry, comes from Raoul
Lefèvre's "Anthology of the Stories of Troy."
Instead of illustrating the battle scenes or
heroic feats we usually associate with the
Iliad, the tapestry weavers chose to focus on
the pageantry of the royal court of Priam.

The figures are not dressed in the ancient
attire of the Homeric era, but wear richly
decorated contemporary garments. A jewel-
encrusted column divides the composition
into two equal halves. To the left an elegant
procession, illuminated by torchlight, makes
its way to the city gates. Priam welcomes
Helen and his son Paris as trumpeters sound
the fanfare. Helen kneels amid blooming
flowers. On the right half of the tapestry, the
party has moved to the sumptuous palace
interior. Paris greets his mother, Hecuba,
while Priam presents Helen to the ladies of
the court. Barely visible below the figures of
Helen and Priam are their names, woven into
the design. This tapestry is one of three in
the collection illustrating the story of Helen
of Troy. ❖

Flemish

THE JUSTICE OF THE EMPEROR
TRAJAN, C. 1510
Wool and silk with
gilt silver yarn
129 X 145 in. (327.7 X 368.3 cm)
F.1965.1.132

The entire story in this magnificent tapestry unfolds through the depiction of several different scenes set in the same composition, a distinctive feature in medieval designs. At the top left, the Emperor Trajan's young son accidentally drowns a companion by pushing him off a bridge. At the top center, the Emperor implements the full weight of the law by insisting that his own son be thrown into the river by the father of the victim. Below, an angel restores the two boys to Trajan and the thankful court. Such themes of justice and its divine reward were usually hung in courtrooms and palaces. ❖

Flemish

THE HOLY FAMILY WITH
MUSIC-MAKING ANGELS,
C. 1520
Wool tapestry with silk and
gold threads
102 X 116 in. (259.1 X 294.6 cm)
F.1965.1.130

This is a fine example of the smaller devotional tapestries that were characteristic products of the Flemish workshops. The Virgin and Child sit on a throne decorated with jewels and tapestries. The two ornate columns, arranged to give the effect of a triptych, aid in the hierarchical separation of the heavenly group. The woman seated before the group of angels to the Madonna's right is St. Cecilia, the patron saint of music. The women in the foreground may be the donors of the tapestry. They are engrossed in their handiwork, a common pastime for ladies of the period. The presence of St. Cecilia, suggests that one of the women was named Cecilia, or that the tapestry may have been a donation to a church or chapel dedicated to that saint. An alternative explanation is that the two women are the Virgin's half-sisters, Mary Cleophas and Mary Salome. Yet another is that they represent the active and contemplative life. Joseph is a minor figure, shown entering at the left. ❖

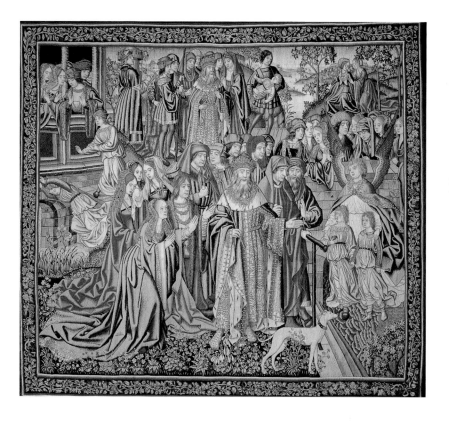

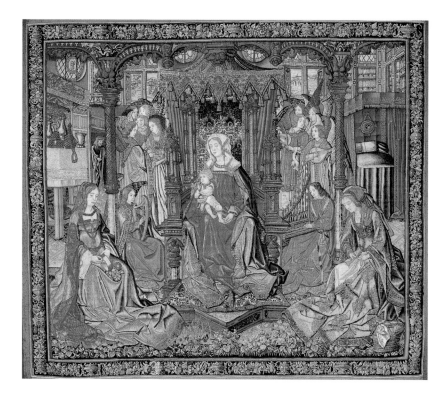

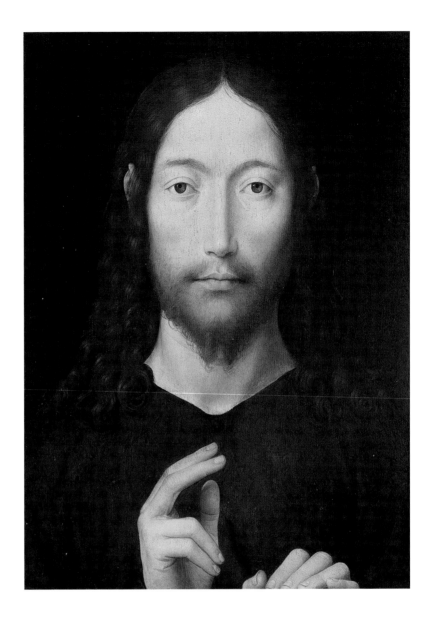

Hans Memling

Netherlandish, c. 1430/40–1494
CHRIST GIVING HIS BLESSING,
1478
Oil on oak panel
15⅛ x 11⅛ in. (38.4 x 28.3 cm)
M.1974.17

Hans Memling was the dominant artist of the late fifteenth century in Bruges. His CHRIST GIVING HIS BLESSING recalls an iconographical type found in early Christian and Byzantine sacred icons. However, Memling's depiction of Christ is not severe or characterized by tragic pathos. In form and feeling, it shares much with contemporary Italian portraiture: the search for clarity and order, the monumental effect achieved by filling the frame with Christ's head and shoulders, and the close-up view of the delicately modeled face. The gentle spirit and grace of the Redeemer, presented in fully human terms, makes this a compelling devotional image. ❖

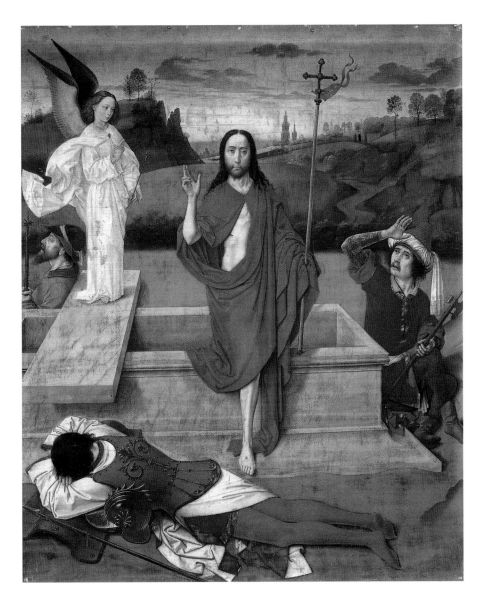

Dieric Bouts

Netherlandish, c. 1420–1475
THE RESURRECTION, c. 1455
Distemper on linen
35⅜ x 29¼ in. (88.9 x 74.3 cm)
F.1980.1

One of the leading artists of his generation, Bouts favored a contemplative approach to painting that conveyed an austere and powerful spirituality. Occupying the very center of the composition, Christ rises from the tomb with an august and sublime dignity. The drama and tumult of the moment are stilled by His intent gaze and by the rigid order and placement of the figures and other elements. The scene unfolds in front of a wide, placid expanse of land, constructed with a luminous atmospheric perspective. THE RESURRECTION formed part of a now-dismantled altarpiece; the medium, distemper on unprimed linen, allowed the altarpiece to be lightweight and portable. ❖

Aelbert Bouts

Netherlandish, c. 1452/5–1549
SAINT JEROME IN PENITENCE, c. 1500–1510
Oil on panel
16⅛ x 17¾ in. (41.0 x 45.1 cm)
F.1969.20

Aelbert Bouts was the second son of Dieric Bouts. He special-
ized in the production of modest, small-scale devotional
pictures, such as this image of St. Jerome. The precisely
painted landscape is a testament to the Flemish love for
detail and realism. St. Jerome is portrayed as a penitent,
kneeling before the crucifix and holding the stone that he
uses to beat his breast. The cardinal's robes, strewn across
a small tree, allude to his position as a Doctor of the Church.
Nearby sits the lion that became his devoted companion
after the saint removed a thorn from his paw. ❖

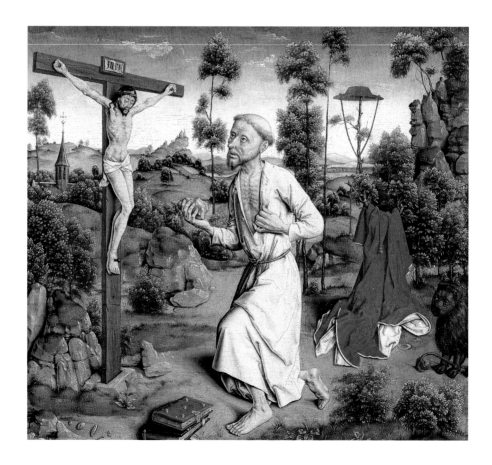

Gerard David

Flemish, c. 1450–1523
CORONATION OF THE VIRGIN,
c. 1515
Oil on panel
27⅞ x 21¼ in. (70.8 x 54.0 cm)
F.1965.1.17

Gerard David was Hans Memling's pupil and artistic successor in Bruges. The subject, the Coronation of the Virgin Mary as the Queen of Heaven, illustrates the Virgin's rich and varied role within the Church. The sumptuous, gold background and the incised lines emanating from the Virgin refer to both the brilliance of the sun and to Mary's role as a source of celestial radiance. Two angels hold a crown above Mary, preparing to place it on her head. The crescent moon (chastity), the white rose (purity), and her costume all allude to the Immaculate Conception, the doctrine that Mary was conceived without Original Sin. David's gift as a portraitist is admirably realized in the four male prophets, which were undoubtedly based on portraits of living men. ❖

Giovanni Bellini

Italian, c. 1430–1516
PORTRAIT OF JOERG FUGGER, 1474
Oil on panel
10¼ x 7⅞ in. (26.0 x 20.0 cm)
M.1969.13

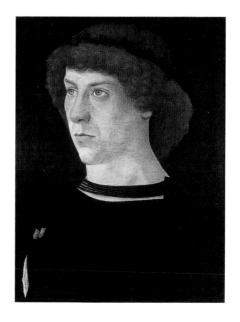

Considered to be Bellini's earliest dated work, this portrait depicts twenty-one-year-old Joerg Fugger, member of a powerful banking family from Augsburg. Bellini has painted the earnest young man in a somber pose, made more so by the juxtaposition of his pale skin with the dark background. He wears a garland in his hair, designating him as a student of ancient learning. This work is of great historical importance, both as Bellini's first-known portrait, and as one of the first paintings by an Italian artist to be painted in oil instead of tempera. The objective, realistic description of this youth is one of the earliest departures from the stiff, stylized, late Gothic tradition of portraiture that still prevailed in late-fifteenth-century Venice. ❖

Giovanni Battista Moroni

Italian, c. 1525–1578
PORTRAIT OF AN ELDERLY MAN, c. 1575
Oil on canvas
20 x 16½ in. (50.8 x 41.9 cm)
F.1969.29

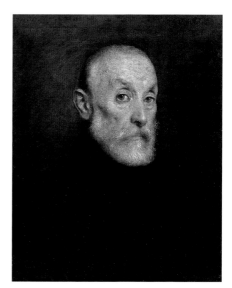

Moroni's brush recorded, with characteristic Lombard candor, the features of countless men and women in his native Bergamo. His male subjects are deadly serious, their thin lips tight, their eyebrows arched, conscious that they are being studied by the artist. In the present picture, the priming is visible through the thinly applied glazes, and the canvas weave presents its textured surface to the light. The extreme economy of detail is typical of Moroni's last period. The portrait is a masterpiece of psychological penetration and objectivity and reflects the ethical values of the Counter-Reformation period, which favored truth over idealization. ❖

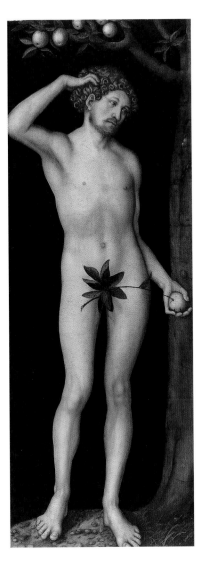
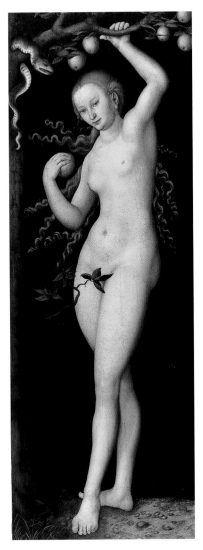

Lucas Cranach the Elder

German, 1472–1553
ADAM AND EVE, c. 1530
Oil on panel
75 x 27½ in. (190.5 x 69.9 cm) each
M.1971.1; M.1991.1

The son of a painter, Cranach was born in the town of Kronach in Franconia. In 1504, he became Court Painter to Frederick the Wise of Saxony. A master of religious painting, portraiture, and the woodcut, Cranach also developed this type of refined, full-length nude painted with a glossy, enamel-like finish.

His highly linear and ornamental style, with its corresponding emotional detachment, is consistent with the Mannerist aesthetic of the sixteenth century. The sensual body of Eve, for instance, is stylized and defined by unlikely anatomical proportions. The spiraling curves of her hair have a life of their own. Cranach envisioned her as a temptress and she is clearly meant to allure. The sensuous nudes were likely meant for both pleasure and instruction. Having captured our attention, they remind us of our own potential for temptation and the resolve needed to resist it. ❖

Jacopo da Ponte, called
Jacopo Bassano

Italian, 1510–1592
THE FLIGHT INTO EGYPT,
c. 1544–45
Oil on canvas
48½ x 77¼ in. (123.2 x 196.2 cm)
M.1969.35

One of the great Venetian painters of the sixteenth century, Jacopo Bassano came from a family of painters who lived and worked in Bassano, north of Venice. He painted rustic biblical-pastoral scenes set against mountainous landscapes, which allowed him to introduce peasants and animals. His paintings were admired for their richness of color and complex designs. This procession is animated by the strong sense of diagonal movement, the swirling draperies and the emphatically gesturing angel. Only the Madonna and Child, the physical and spiritual apex of the composition, are tranquil. Lost in their tender communication, they appear oblivious to the flurry of activity around them. The sublimely eccentric angel leads them into undefined, even precipitous territory. His right hand points to a sprouting tree, a symbol of Christ's Resurrection. ❖

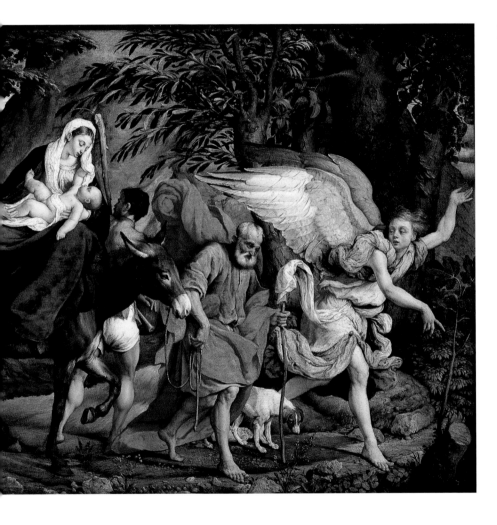

Peter Paul Rubens

Flemish, 1577–1640
THE HOLY WOMEN AT THE
SEPULCHRE, c. 1611–14
Oil on panel
34½ x 42¼ in. (87.6 x 107.3 cm)
F.1972.51

On the third day after the Crucifixion, women visiting Christ's tomb are greeted by two angels surrounded by a blazing light of celestial radiance [Luke 24:4]. The angels deliver the astonishing news of the Resurrection. Each woman reacts differently to the miraculous announcement, contemplating the profound significance of what they have heard. Working under the influence of Roman art, Rubens gives a deeply sculptural effect to this dramatic composition. Using highly rounded forms, with clear contours and rich colors, he creates a surging movement of rhythmic undulations from left to right. Though the exact identity of each figure has fallen into question, recent debate has convincingly suggested that the woman shielding her eyes with her veil is Mary Magdalene. The central figure is the Virgin Mary, whose form is derived directly from the Roman *Pudicitia*, now in the Vatican. ❖

Peter Paul Rubens

Flemish, 1577–1640
MELEAGER AND ATALANTA
AND THE HUNT OF THE
CALYDONIAN BOAR, c. 1618–19
Oil on panel
18¾ x 29⅛ in. (47.6 x 74.0 cm)
M.1975.21

The subject is derived from Homer's *Iliad*, but it is probable that Ruben's composition is drawn from Ovid's colorful narrative in the *Metamorphoses*. The goddess Diana has taken insult over the Calydonian king's failure to pay her tribute during the harvest festival. To avenge herself, she sends a ferocious boar to ravage the land. The king's son Meleager, accompanied by the bravest warriors, seeks to destroy the creature. Atalanta, the beautiful virgin huntress, joins the hunt and is the first to wound the boar with her arrow, much to the chagrin of her male competitors. Here Atalanta actively shoots the arrow at the deadly target while Meleager prevents the boar's escape with his spear. Rubens imparts a sense of immediacy through the use of rapid and spontaneous brushstrokes. Such a vigorous technique typifies the lively flavor of the Baroque style and distinguishes this oil sketch, or *modello*, from the larger, finished painting in the Kunsthistoriches Museum in Vienna. ❖

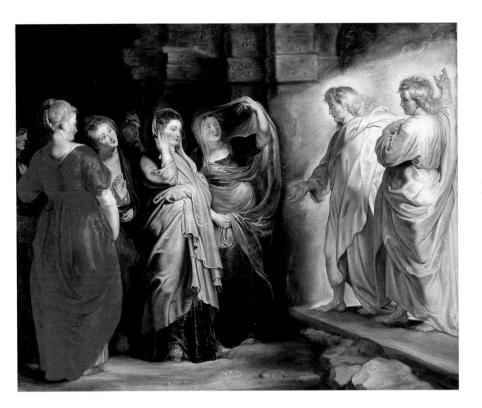

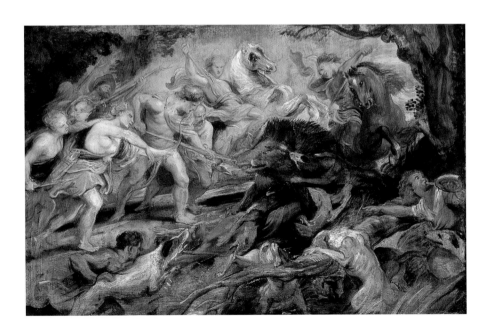

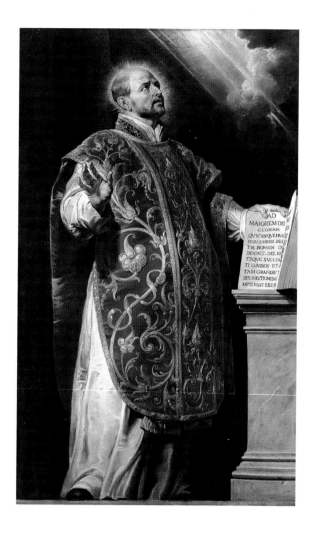

Peter Paul Rubens

Flemish, 1577–1640
SAINT IGNATIUS OF LOYOLA,
c. 1620–22
Oil on canvas
88 x 54½ in. (223.5 x 138.4 cm)
M.1975.3

This depiction of Saint Ignatius of Loyola was painted for Il Gesu, the Mother Church of the Jesuit Order in Rome. It likely dates between 1620–22, as the saint wears a nimbus, a sign of his sanctity, which was confirmed during his canonization feast in 1622. The founder of the Jesuits wears a brocaded chasuble and gazes ecstatically to the right, where beams of heavenly light break through the clouds. His right hand is raised in a gesture of admonition; his left hand holds a copy of the *Constitutions* of the Society of Jesus, with a page open to the Jesuits' famous motto: "To the greater glory of God." Ignatius, painted to be seen from below, is presented as a Christian hero, full of Baroque sentiment designed to strengthen worshipers in their belief and spur them to emulation. The representation of saints plays an important role in Rubens' works devoted to religious subjects. He created an artistic language fully adapted to the Counter-Reformation movement, which stressed the heroic, emotional, or ascetic aspects of saints' lives. ❖

Peter Paul Rubens

Flemish, 1577–1640
DAVID SLAYING GOLIATH,
c. 1630
Oil on canvas
48⅜ x 39 in. (122.9 x 99.1 cm)
F.1972.05

Rubens chose to depict the moment when David, having felled the giant and taken possession of his sword, is about to sever the head of his adversary. The two monumental figures occupy nearly the entire painting, with only a fragment of the battle in the background. A strong circular motion (which will be completed with the impending swing of the sword) animates the composition and increases the tension of the drama. The attacking form of David and the prone one of Goliath are balanced against one another in a wonderfully calculated equilibrium. The background landscape extends into the vast distance, which is emphasized by the low line of the horizon. As a result, the dramatic foreground action is almost completely silhouetted against the sky, and is relieved and balanced only by the variation of color. ❖

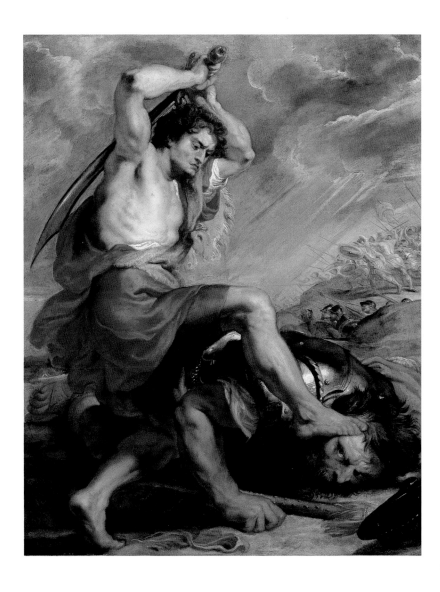

Guido Reni

Italian, 1575–1642
SAINT CECILIA, 1606
Oil on canvas
37¾ x 29½ in. (95.9 x 74.9 cm)
F.1973.23

Saint Cecilia, the patron saint of musicians, was an early Christian martyr. According to legend, she could play any musical instrument and was so exalted that she could hear the singing of angels. Here, with her eyes turned toward heaven, she plays a violin; in the background is an organ. The elegant SAINT CECILIA exhibits the refined sensibility and pious sentimentality that made Guido Reni the most sought-after Bolognese painter of the seventeenth century. This early work was commissioned from Reni by Cardinal Sfondrato, who enthusiastically promoted the cult of Saint Cecilia after the discovery of her remains in 1599. The picture was soon acquired by Cardinal Scipione Borghese, another prominent Roman patron of Reni, and was later owned by Lucien Bonaparte and by Marie-Louise Josephine, Queen of Etruria. ❖

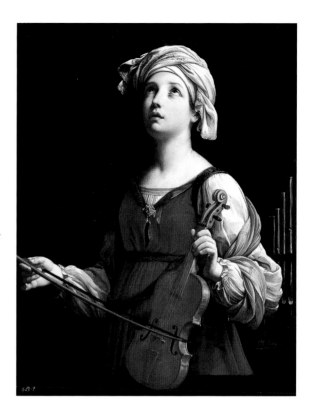

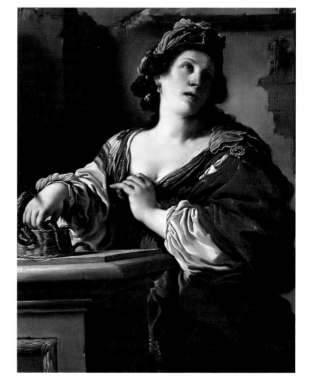

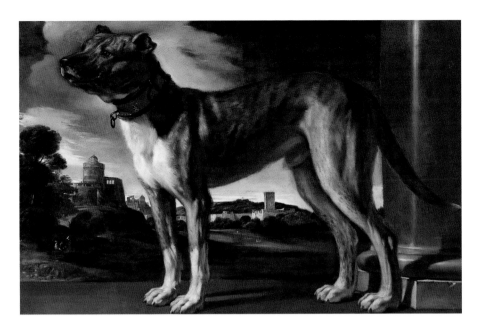

Giovanni Francesco Barbieri, called

Guercino

Italian, 1591–1666
THE ALDROVANDI DOG, c. 1625
Oil on canvas
44 x 68¼ in. (111.8 x 173.4 cm)
F.1984.2

This is surely the portrait of a specific dog, perhaps the prized or favorite possession of Count Filippo Aldrovandi, whose coat of arms is painted on the dog's collar. The view behind the dog may represent the Aldrovandi Castle outside Bologna. With its alert, massive head silhouetted against the clouds, the beast seems ready to respond to the sounds from without. The low horizon line emphasizes his monumental scale. The painting was likely hung high in a large room or salon where the animal would appear to tower over the viewer. Although Guercino is not noted for being an animal painter, he rendered the dog with scrupulous attention to detail and with a vivacity that combines wildness with acute sensitivity. ❖

Giovanni Francesco Barbieri, called

Guercino

Italian, 1591–1666
THE SUICIDE OF CLEOPATRA, c. 1621
Oil on canvas
46 x 36¾ in. (116.8 x 93.3 cm)
F.1973.30

Guercino gained the attention of influential patrons with his vigorous naturalism, flickering light effects, and grace of expression. He was in Rome during the brief pontificate of Gregory XV (1621–23) and there produced a number of important works, including THE SUICIDE OF CLEOPATRA. The tragic stories of the queens and heroines of antiquity were popular with Baroque painters inasmuch as they contained equal measures of drama, pathos, and eroticism. From this remarkable history, Guercino focused on the single, decisive moment when Cleopatra, having taken the asp from the basket of figs, is about to raise it to her breast, where it will deliver the fatal bite. In full play are the dynamic chiaroscuro, supple modeling, and unusual color harmonies that give Guercino's early works their passionate appeal. ❖

Giovanni Francesco Romanelli

Italian, 1610–1662
The Dido and Aeneas Tapestry
Cartoons, c. 1630–35
Gouache and black chalk on
paper, laid down on linen

Romanelli designed this series of tapestry cartoons based on Virgil's famous epic poem, the *Aeneid* [29–19 b.c.], the sublime tale of the love affair between Dido, Queen of Carthage, and Aeneas, a Trojan prince and ancestor of the Romans. The *Aeneid* tells of the shipwrecked Trojans landing in Carthage and how Venus conspired to make Dido fall in love with Aeneas. Unfortunately, the tale was bound to end in tragedy, since Aeneas' departure was ordained by Jupiter. A native of Viterbo, Romanelli went to Rome as a youth and soon became a protégé of the Barberini family. He was drawn into the circle of artists and intellectuals surrounding Cardinal Francesco Barberini, nephew of Pope Urban VIII. Romanelli created his own, highly popular style by modifying the grand Baroque manner of contemporary Rome into a more elegant and composed classical style. Cardinal Barberini established a tapestry manufactory in Rome, and in the 1630s, Romanelli was in charge of tapestry design. Romanelli prepared these cartoons in the traditional manner by painting in gouache on montages of roughly rectangular sheets of paper. The tapestry weavers cut the cartoons into sections to use as models. The sections were later reassembled and mounted on stretched linen. ❖

Above:
The Royal Hunt and Storm,
c. 1630–35
Gouache and black chalk on
paper, laid down on linen
109 x 138 in. (276.9 x 350.5 cm)
f.1969.33.2

Juno and Venus arrange the marriage of Dido and Aeneas by sending them to shelter themselves together in a cave during a sudden storm that scatters their hunting party. Here, Aeneas protects Dido with his red cloak as they rush toward the cave, their eyes fastened on one another. The owl, a bird of darkness, serves as a bad omen of what is to come. ❖

Below:
The Death of Dido, c. 1630–35
Gouache and black chalk on
paper, laid down on linen
109 x 166 in. (276.9 x 421.6 cm)
m.1969.27

Dido, in her frenzied grief, builds a pyre upon which to burn Aeneas' belongings as well as the bed they shared. When she sees the Trojan ships sailing away, she flings herself on the bed and stabs herself with Aeneas' sword. Here, Anna climbs to her dying sister while the goddess Iris, sent by Juno, cuts a lock of the Queen's hair to release her soul and allow her to die. In the background, Aeneas' fleet vanishes in the distance. ❖

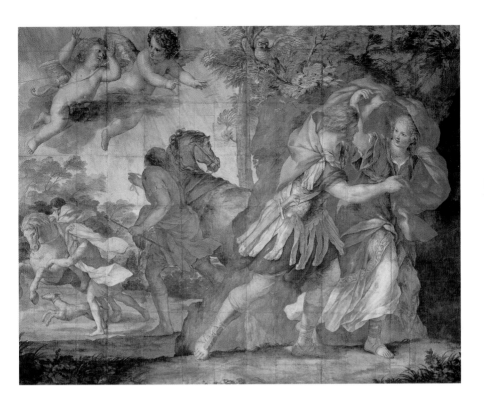

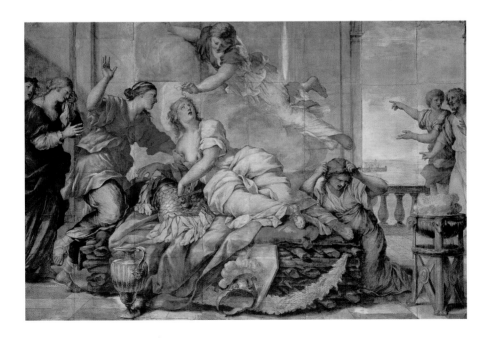

Francisco de Zurbarán

Spanish, 1598–1664
THE BIRTH OF THE VIRGIN,
c. 1627
Oil on canvas
55½ x 42¾ in. (141.0 x 108.6 cm)
F.1970.13

Just as striking as Zurbarán's color scheme are his rich, descriptive treatment of the drapery and the solid masses of his figures. He has arranged the composition in an airy, oval sweep to reveal the subtle play of light and shade. The woman standing at the right in contemporary costume is believed to be a portrait of the donor because she gazes directly toward the viewer. The eggs in her basket allude to the purity of the Virgin and to the Resurrection. Both this and the STILL LIFE (opposite) come from the noted Contini-Bonacossi collection in Florence. ❖

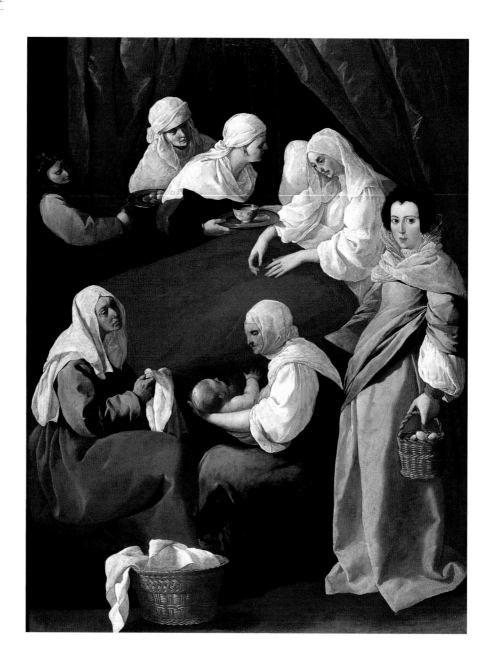

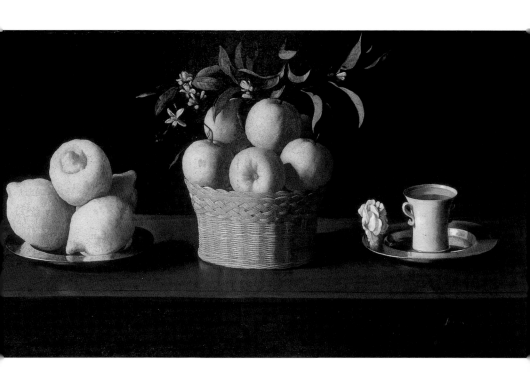

Francisco de Zurbarán

Spanish, 1598–1664
STILL LIFE WITH LEMONS,
ORANGES AND A ROSE, 1633
Oil on canvas
24½ x 43⅛ in. (62.2 x 109.5 cm)
F.1972.06

Zurbarán is best known for his numerous paintings of saints in which he portrayed their devotions, visions, and ecstasies. This painting is his only signed and dated still life. Its underlying and symbolic theme may be an homage to the Virgin. The citrons are a paschal fruit and, along with the orange blossoms, suggest chastity. Love and purity are symbolized in the rose and the water-filled cup. An air of gravity and spiritual austerity proceeds from the strict horizontal rhythm and the limitation of detail. Indeed, the objects appear to be a mystical allusion, just like the votive offerings on an altar. ❖

Bartolomé Esteban Murillo

Spanish, 1617–1682
THE BIRTH OF ST. JOHN THE
BAPTIST, c. 1655
Oil on canvas
57¾ x 74⅛ in. (146.7 x 188.3 cm)
F.1973.38

Murillo, a native of Seville, was a generation younger than Zurbarán and Velázquez. Immensely popular throughout Spain and Europe, he was often called the "Spanish Raphael" for his sweet, idealized Madonnas and the softness and delicacy of his modeling. This painting presents the joyous moment when the infant St. John is about to be bathed. Midwives and helpers surround the child, who will soon be wrapped in the nearby swaddling clothes. The intimacy of this scene, populated by women, suggests that the painting may have served as an image of support for women praying for a successful birth. The characters are portrayed naturalistically yet retain the ideal, innate grace and elegance that are consistent with Murillo's figures from the late 1640s on. His modeling is solid, yet handled with a painterly touch. Although this work displays a strong chiaroscuro, the general effect is one of luminosity: the darks are not so opaque, the lights are strong, and the colors are saturated. ❖

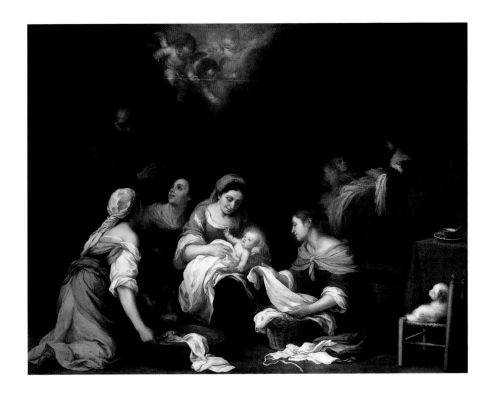

Guido Cagnacci

Italian, 1601–1663
MARTHA REBUKING MARY FOR
HER VANITY, after 1660
Oil on canvas
90¼ x 104¾ in.
(229.2 x 266.1 cm)
M.1982.5

Mary Magdalene's repentance was frequently depicted in the seventeenth century. Cagnacci, however, created a unique version of this episode. He combined reality, idealism, and fantasy into one, vivid allegory of Virtue triumphing over Vice. At center, a penitent Magdalene is rebuked by Martha. The confusion of clothes and jewels cast aside suggests her desertion of vanity. Behind them an angel (Virtue) chases out a devil (Vice). The handmaids at the door further elaborate this struggle between good and evil: the crying woman represents contrition. The other, gesturing in annoyance, represents vanity. Cagnacci's brilliant tableau combines lofty allegory with sensuous representation to create an inventive, but effective, visual metaphor. ❖

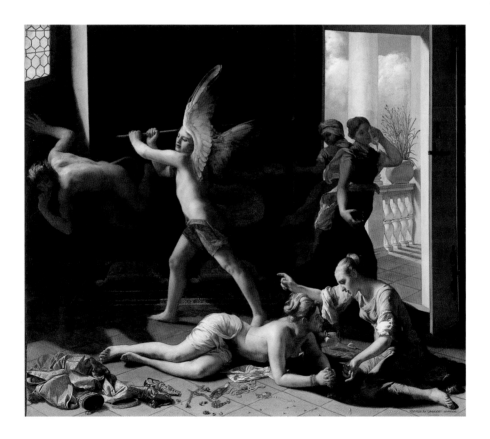

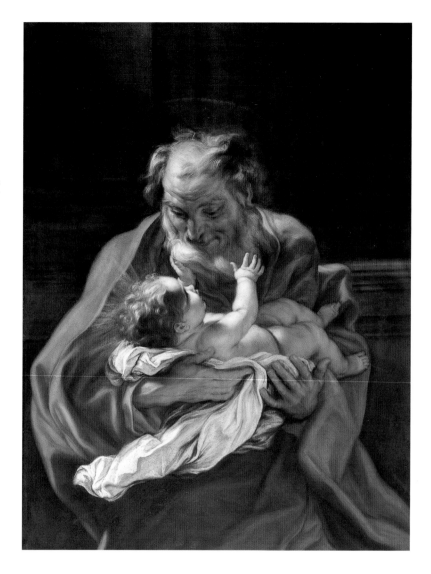

Giovanni Battista Gaulli, called

Baciccio

Italian, 1639–1709
SAINT JOSEPH AND THE INFANT
CHRIST, c. 1670–85
Oil on canvas
50 x 38¼ in. (127 x 97.2 cm)
F.1973.36

Paintings depicting the baby Jesus most often portray him with the Virgin Mary. In the seventeenth century, however, the cult of St. Joseph grew in popularity. This portrayal by Baciccio is a tender and beautiful example. Saint Joseph holds the Holy Infant in a loving and reverent embrace. The Child, bathed in a heavenly glow, softly caresses Joseph's beard. They share a perfect, gentle moment of affection and grace. SAINT JOSEPH AND THE INFANT CHRIST provides a characteristic example of Baciccio's style of easel painting, which is vigorously Baroque in design and conception. The dynamic folds of drapery that envelop the figures are profoundly influenced by the sculptor Gian Lorenzo Bernini. Baciccio's native Genoese traditions are evident in the dark background, the use of highly saturated, warm colors, and the broad, painterly handling. ❖

Matthias Stom

Dutch, c. 1600–after 1651
CHRIST CROWNED WITH THORNS, c. 1633–1639
Oil on canvas
43⅝ x 63⅜ in.
(110.8 x 161.0 cm)
M.1977.25

Dutch by birth, Matthias Stom traveled to Rome, where he belonged to an important group of Caravaggisti (followers of Caravaggio) active there in the early seventeenth century. Similar to Caravaggio, they ranked naturalism and drama high in their pictorial subjects. CHRIST CROWNED WITH THORNS depicts a nighttime scene of torment, illuminated by a single candle. Such a device, favored by the Caravaggisti, created the strong effects of light and dark seen here. The immediacy of Christ's suffering and the cruelty of the soldiers results from the arrangement of all hands and faces directed toward the center. ❖

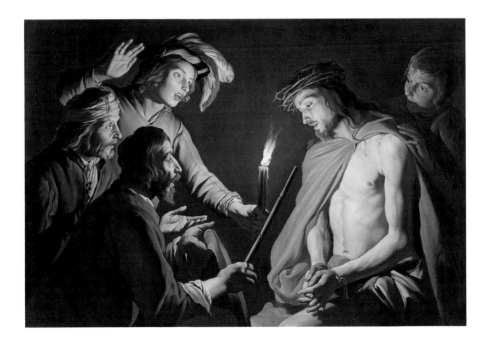

Aelbert Cuyp

Dutch, 1620–1691
EVENING IN THE MEADOWS,
mid-1650s
Oil on canvas
41¾ x 54½ in. (106.0 x 138.4 cm)
F.1970.7

Aelbert Cuyp created seascapes, portraits, and still lifes, but was best known for his paintings of landscapes and animals. EVENING IN THE MEADOWS gives a clear idea of Cuyp's ability to simplify the most complex forms and reinterpret them in terms of light. For a time, Cuyp went further than any other seventeenth-century Dutch painter in his attempt to convey a full chromatic scale of sunset and sunrise. Further, his sense of scale and point of view transforms a bucolic scene into one of grandeur. The painting's perspective places the viewer below ground level so that the large cow appears even more monumental. ❖

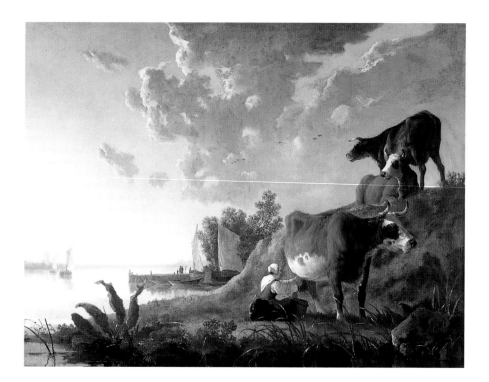

Salomon van Ruysdael

Dutch, 1602/3–1670
LANDSCAPE WITH SANDY ROAD,
1628
Oil on panel
11¼ x 15½ in. (28.6 x 39.4 cm)
F.1970.15

Early-seventeenth-century Dutch landscape paintings were primarily panoramic views painted with a multiplicity of designs and colors. In the 1620s, a group of artists in Haarlem, including Salomon van Ruysdael, began to turn to their native countryside for subject matter. They developed a more unified structure by employing a common tonality of browns, greens, and grays throughout each painting. In addition, they significantly lowered our vantage point so that we feel as though we are standing in the landscape. ❖

Jan Lievens

Dutch, 1607–1674
PANORAMIC LANDSCAPE, 1640
Oil on panel
15¼ x 19⅝ in. (38.7 x 49.8 cm)
F.1974.2

Lievens was a student of Pieter Lastman, as was Rembrandt. In the late 1620s Lievens and Rembrandt worked closely together, treating the same subjects and using the same models. This fantastic, imaginary landscape, painted in warm tones of brown and green, appears to have been inspired by examples from Rembrandt as well as by Flemish master Hercules Seghers, whose landscapes strongly influenced both Dutch artists. From a distance we see a vast panorama that encompasses a walled city, distant mountains, and sandy dunes. The pattern of light and dark areas animates and unifies the diversity of the landscape. This is not the topography of Lievens' native Holland, but a purely fictive invention that brilliantly demonstrates the artist's keen ability to create what is unseen. ❖

Jacob van Ruisdael

Dutch, 1628/9–1682
WOODY LANDSCAPE WITH A
POOL AND FIGURES, c. 1660
Oil on panel
27½ x 36¼ in. (69.9 x 92.1 cm)
M.1969.33

Jacob van Ruisdael is considered to be the greatest and most versatile Dutch landscape painter of the seventeenth century. He probably studied painting with his uncle Salomon van Ruysdael, becoming an accomplished landscape painter by age eighteen. In a Ruisdael landscape, the emphasis is on the natural elements, such as the dramatic topography, sweeping sky, and accurately rendered, highly detailed trees. By contrast, the human and animal figures are less significant and were usually added by figure painters. ❖

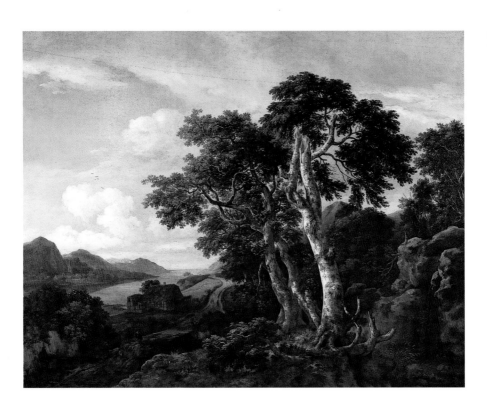

Jacob van Ruisdael

Dutch, 1628/9–1682
THREE GREAT TREES IN A
MOUNTAINOUS LANDSCAPE WITH
A RIVER, c. 1665–70
Oil on canvas
54⅜ x 68⅛ in. (138.1 x 173.1 cm)
F.1971.2

Born in Haarlem, van Ruisdael was the son of a frame-maker and art dealer. In the 1660s, and at the height of his powers, he was creating landscapes of unprecedented force and majesty. In this painting, nature is vividly rendered, rich in color, brilliantly illuminated, and vast. The handling of the sky and light is refined and diffuse; combined with a warm palette, it creates a calm mood. For all its richly observed detail, the landscape is an image of nature in general: beautiful, bountiful, varied, and expansive. In capturing the mutable elements of nature, van Ruisdael has preserved them, perhaps so that we might contemplate the Creator in the creation. ❖

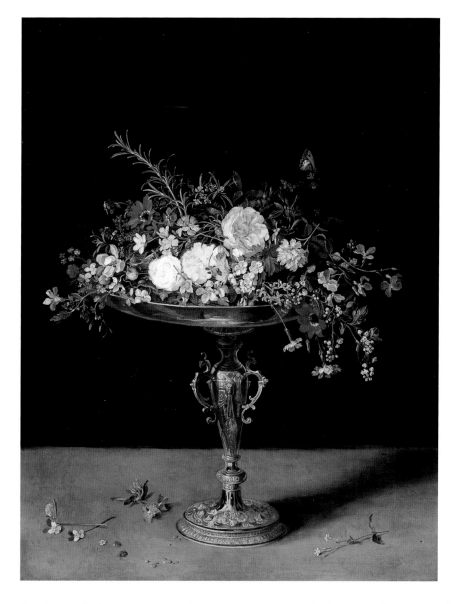

Jan Brueghel
the Elder

Flemish, 1568–1625
AN ARRANGEMENT OF FLOWERS,
c. 1620
Oil on panel
21 ¹⁵/₁₆ x 16⅞ in. (55.7 x 42.9 cm)
F.1972.13

The Impressionist painter Claude Monet called Jan Brueghel one of the greatest poets ever begotten. Brueghel painted huge bouquets with hundreds of flowers as well as more modest-sized bouquets, of which this picture is an excellent example. The gold tazza holding the flowers is small and refined, allowing the flowers to dominate the composition. Brueghel brought the extraordinary scientific eye of his age to bear on these detailed, yet delicate, floral descriptions. These motifs bore a certain symbolism: rosemary symbolized eternity because the sprigs kept their fragrance so long; butterflies symbolized redemption. In this way, messages of hope and the hereafter could be reinforced via still life elements. ❖

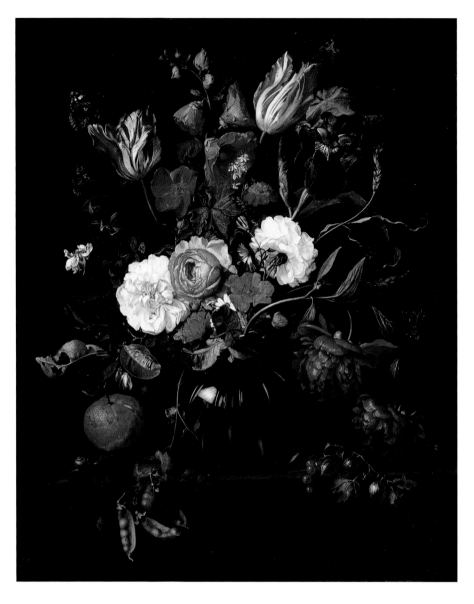

Jan Davidz. de Heem

Dutch, 1606–1683/84
VASE OF FLOWERS, 1654
Oil on canvas
26½ x 21¾ in. (67.3 x 55.2 cm)
F.1973.06

The Utrecht-born de Heem specialized in virtuoso flower and banquet pieces that were enthusiastically collected by aristocrats and wealthy merchants alike. Perhaps the most striking aspect of this Baroque, pyramidal composition is the abundant bouquet, the leaves and flowers cascading down like a waterfall. Everything is lush, including de Heem's palette. In addition to the aesthetic delights offered in the painting, viewers could exercise their intellect by deciphering the hidden meanings of various elements. This type of still life was known as a vanitas, in which moral messages—frequently on the fleeting nature of life or the futility of riches—were encoded via symbols. The decaying leaves at left, for instance, allude to the transiency of life. The butterfly often signifies life, death, and resurrection. ❖

Louise Moillon

French, 1610–1696
STILL LIFE WITH CHERRIES,
STRAWBERRIES AND GOOSE-
BERRIES, 1630
Oil on panel
12⅝ x 19⅛ in. (32.1 x 48.6 cm)
F.1972.36.2

Moillon was one of the pioneers of French still life painting. This exquisitely realized subject, one of the few examples by Moillon in American collections, was painted when the artist was a mere twenty years of age. Moillon rendered her portraits of fruit with a sharp eye aided by her meticulous hand. Whether or not the still lifes by Moillon and her contemporaries lacked the sophistication and panache of their Dutch counterparts, it is apparent that they embraced an entirely different aesthetic—quieter, more contemplative, and satisfying in its own right. ❖

Frans Snyders

Flemish, 1579–1657
STILL LIFE WITH FRUIT AND
VEGETABLES, n.d.
Oil on canvas
68¼ x 101 in. (173.4 x 256.5 cm)
F.1973.16

The still life as an independent subject was born in the seventeenth century and Frans Snyders was one of its greatest practitioners. His bold brushwork and monumentally scaled compositions were new and bold developments in a genre that ranked rather low in importance as a subject of painting. Snyders created a sense of dynamism by combining vivid color, dramatic lighting, and a rhythmic repetition of lines and forms. To this he added a plethora of objects, often piled upon each other. Fruits and vegetables cultivated on land are heaped in piles on the ground. The selection on the table has been picked from trees and bushes. His inclusion of live animals further enhances the sense of animation. ❖

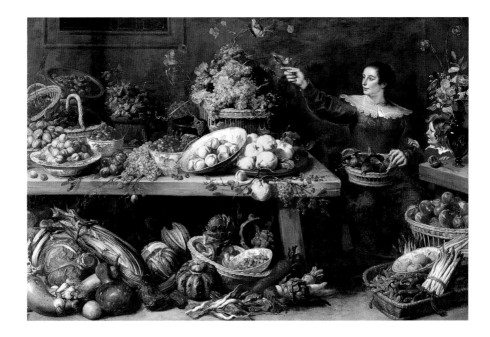

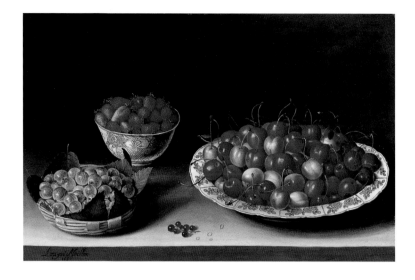

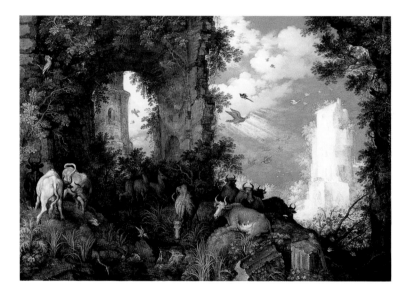

Roelandt Savery

Dutch, 1576–1639
LANDSCAPE WITH RUINS AND
ANIMALS, 1624
Oil on panel
20¾ x 29¾ in. (52.7 x 75.6 cm)
F.1972.36.1

A versatile artist and superb draftsman, Savery painted flower pieces, still lifes, and genre scenes. His landscapes, however, populated with all manner of flora and fauna and painted with a miniaturist's attention to detail, earned him the admiration of artists and collectors. LANDSCAPE WITH RUINS AND ANIMALS presents a multifarious view divided in half by the looming arch on the left, and divided again into several detailed sections. The variety of objects and views prevents any single motif from dominating. The entire composition is enlivened with highly detailed descriptions of animals, foliage, rocks, and ruins. Savery enhances these elements, making them richer and more complicated; the result is at once encyclopedic and fantastic. ❖

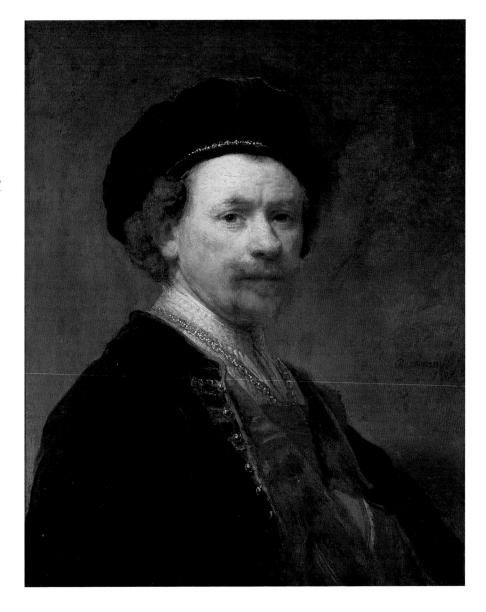

Rembrandt van Rijn

Dutch, 1606–1669
SELF-PORTRAIT, C. 1636–38
Oil on panel
24⅞ x 19¾ in. (63.2 x 50.2 cm)
F.1969.18

Rembrandt was his own favorite model, and there is no moment in the artist's biography that he did not vividly record. Rembrandt portrays himself here in the characteristic beret that had been associated with the artistic milieu since the sixteenth century. The chain around his neck was a symbol of prestige awarded to artists, often by a noble patron. The combination of elegant attire and an artist's attributes elevates Rembrandt to the status of a fine artist. This distinction was important at a time when artists were only beginning to realize their social standing among the creative elite. ❖

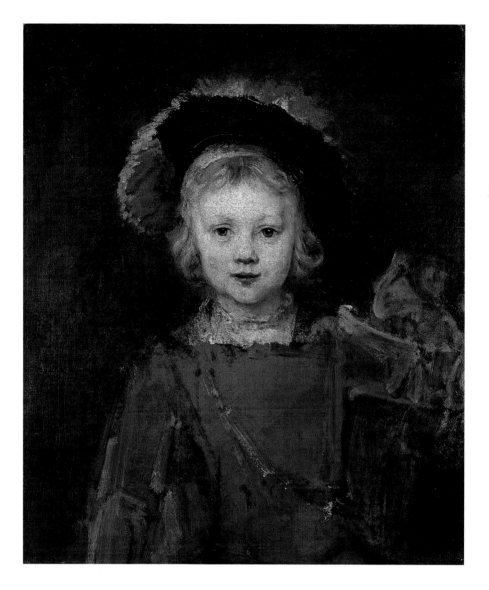

Rembrandt van Rijn

Dutch, 1606–1669
PORTRAIT OF A BOY, PRESUMED
TO BE THE ARTIST'S SON, TITUS,
C. 1645–50
Oil on canvas
25½ x 22 in. (64.8 x 55.9 cm)
F.1965.2

This open, approachable portrait is one of the Museum's most popular artworks. In its unfinished state, this exceptional picture offers invaluable insight into Rembrandt's working method. Over the rich, dark ground, the body and costume have been indicated merely with a few broad, sure brushstrokes. The collar, hair, and head have been developed further, with layers of scumbles and glazes, while the face, particularly the eyes, has been fully modeled and highly finished. The child's face, bathed in an even, frontal light, radiates from the velvety darkness of the background. This unusually straightforward presentation reflects and enhances the engaging charm and openness of the ingenuous child, who eagerly presents himself to the viewer. ❖

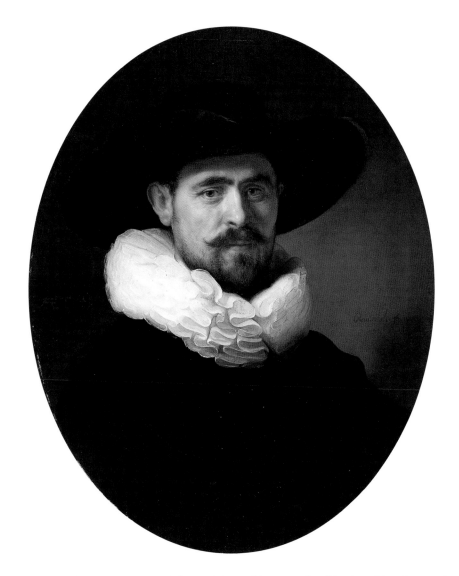

Rembrandt van Rijn

Dutch, 1606–1669
PORTRAIT OF A BEARDED MAN
IN A WIDE-BRIMMED HAT, 1633
Oil on panel
27½ x 21½ in. (69.9 x 54.6 cm)
M.1977.31

This work is a striking example of Rembrandt's early portrait style. The twenty-seven-year-old artist had recently moved to Amsterdam from his native Leiden. His fame had preceded him, and he immediately became the leading portraitist in the commercial capital of the Netherlands. The identity of the sitter is not known. An inscription on the left, the only biographical information we have, informs us that he was forty-one years old when this portrait was executed. A master of depicting light, Rembrandt has created a wonderful sense of movement in the sitter's collar and a sense of flow in the brim of his hat. Strongly lit from the left, the head is carefully painted in the meticulous, somber style of the young Rembrandt. The artist painted a companion portrait of the man's wife the following year, which is now in the collection of the Speed Art Museum in Louisville, Kentucky. ❖

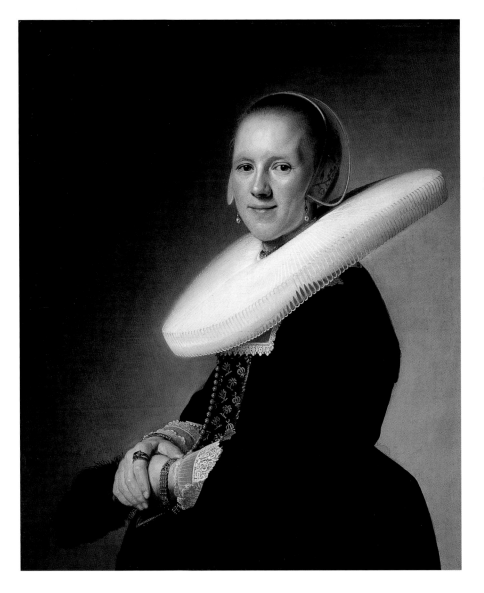

Johannes Cornelisz. Verspronck

Dutch, 1597–1662
PORTRAIT OF A LADY, 1641
Oil on canvas
31⅛ x 26⅛ in. (79.1 x 66.4 cm)
F.1973.34.2

A gifted pupil of Frans Hals, Versponck was at his best as a portraitist of women and children. This portrait presumably represents Trijntgen Adamsdr., wife of Haarlem painter Thomas Wyck. The formality of the dark dress and starched linen collar enhances and frames the lively expression of the sitter, whose glance is warm and engaging. The rich fabric of her dress, in combination with her deep lace cuffs and gold-embroidered bodice, firmly establishes the lady's wealth and social standing among the Dutch middle class. Her image reflects the Dutch pride and confidence in their new nation's prosperity and stability. ❖

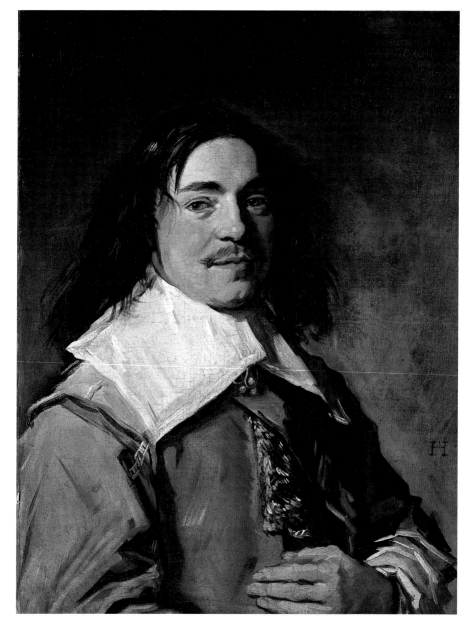

Frans Hals

Dutch, 1580–1666
PORTRAIT OF A YOUNG MAN,
1650–55
Oil on canvas
26½ x 20 in. (67.3 x 50.8 cm)
M.1972.4

A resident of Haarlem, Frans Hals was one of the finest portrait painters of the seventeenth century. He brought to the traditional format and poses of Dutch portraiture a liveliness and dash that made his paintings stand out from those of his competitors. As a specialist in the depiction of cheerful moments, Hals communicated a sense of well-being and high-spiritedness even in his more formal portraits. This liveliness was a powerful part of Hals' appeal. In this painting, the immediacy of the impression depends not only on the responsive facial expression, but also on the vitality of colors and the vigor of the brushstrokes. ❖

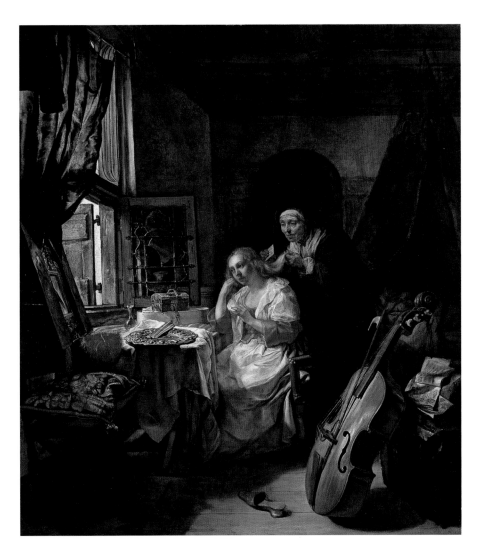

Gabriel Metsu

Dutch, 1629–1667
WOMAN AT HER TOILETTE,
c. 1658
Oil on panel
25½ x 22¾ in. (64.8 x 57.8 cm)
F.1972.15.1

This work may be understood as a type of genre portrait, depicting two highly individualized figures. An artist's family members and friends were often employed in such compositions as models for allegorical or mythological subjects. Objects litter the scene and propel the eye across the richly painted surface. The variety of still life objects attests to Metsu's virtuoso skills and fills the canvas with symbolic overtones. The sheets of music, viola da gamba, empty slipper, and mirror can symbolize either love or vanity. ❖

Jan Steen

Dutch, c. 1626–1679
WINE IS A MOCKER, 1663–64
Oil on canvas
34⅜ x 41¼ in. (87.3 x 104.8 cm)
M.1969.05

Steen is known for his paintings of boisterous genre scenes, often with moralizing overtones. In front of an inn, a richly clad, hopelessly inebriated young woman is being helped into a wheelbarrow. She is the victim of derisive comments and laughter. The quotation above the door reads: "Wine is a mocker, strong drink quarrelsome, unwise is he whom it seduces" [Proverbs 20:1]. By focusing our attention on the woman's exquisitely delineated clothing, Steen is subtly intensifying the message that those of superior position are as susceptible as the lowly to the sins of drink, and their disgrace is perhaps all the more pitiable. ❖

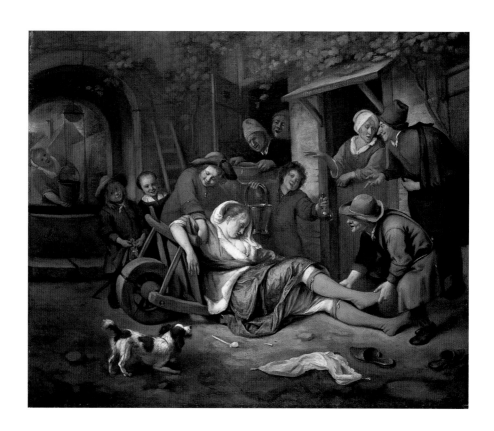

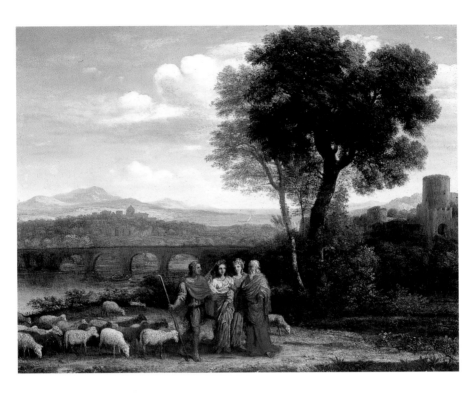

Claude Gellée, called
Claude Lorrain

French, 1600–1682
LANDSCAPE WITH JACOB AND
LABAN AND HIS DAUGHTERS,
1659
Oil on copper
10½ x 13⅞ in. (26.7 x 35.2 cm)
M.1976.01

The subject is from Genesis 29, the story of Jacob and the daughters of Laban, Rachel, and Leah. Jacob wishes to marry the younger, more beautiful Rachel, but this act would have been contrary to the local custom of marrying the oldest child first. In the end, he marries both Leah and Rachel. In return for the two daughters, Jacob faithfully tends to Laban's flocks of sheep and goats for fourteen years. Claude Lorrain arranged this drama against sweeping, panoramic views, arranged in carefully organized horizontal planes. Vertical accents are provided by the trees and architecture. His paintings usually suggest a time of day—in this case, the warm diffused light of late afternoon. ❖

Nicolas Poussin

French, 1594–1665
THE HOLY FAMILY WITH THE
INFANT ST. JOHN THE BAPTIST
AND ST. ELIZABETH, 1650–51
Oil on canvas
39⅝ x 52⅛ in. (100.6 x 132.4 cm)
M.1981.6
Jointly owned with
the J. Paul Getty Museum,
Los Angeles

This is one of Poussin's most lyrical depictions of the Holy Family. The Virgin and Saint Joseph appear to smile as Saint John and Christ playfully embrace. A staff and a bowl at Saint John's feet refer to his wandering in the desert. On the right is a procession of Christ's first martyrs, the Holy Innocents. Their gestures point to the Christ Child, whose sacrifice on the cross will redeem their martyred souls. Two Innocents carry a baptismal font, one carries the Shroud of the Passion, and another kneels to adore the Holy Child. In the distance, a family in a boat and a group of horsemen on land recall the Holy Family's flight into Egypt to save the Christ Child from death, and the Innocents who were killed in His place. This balanced, contemplative composition is a reflection of the artist's preference for the classical and intellectual elements of art. Great attention is paid to the horizontal landscape, which is rhythmically punctuated by the vertical accents of trees and architecture. ❖

Nicolas Poussin

French, 1594–1665
CAMILLUS AND THE
SCHOOLMASTER OF FALERII,
c. 1635–40
Oil on canvas
39⅝ x 54 in. (100.6 x 137.2 cm)
F.1970.14

The incident depicted here is from Livy's account of the life of Republican leader and general Furius Camillus. While the general was besieging the town of Falerii, a local schoolmaster lured his pupils to the Roman camp, hoping to offer them as hostages. Finding the schoolmaster guilty of treason, Camillus offered him up to his students for punishment. The schoolmaster's twisted and distorted figure becomes a symbol of immorality and evil. The ethical Camillus, by contrast, is erect and well proportioned. Whatever the political overtones, Poussin's composition encourages us to contemplate the difference between shapeless ugliness and harmonious form. ❖

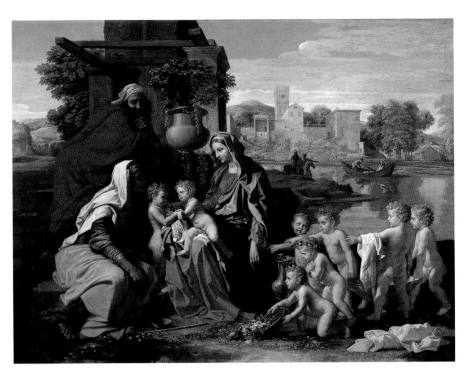

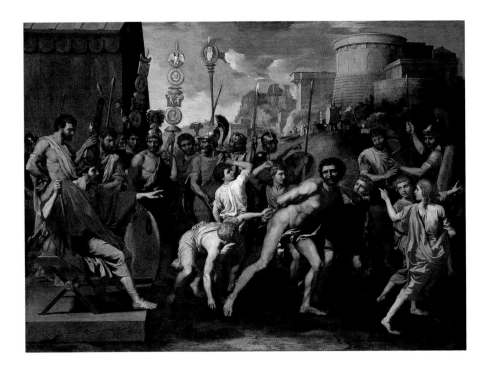

Jean-Honoré Fragonard

French, 1732–1806
THE HAPPY LOVERS, c. 1760–65
Oil on canvas
35½ x 47¾ in. (90.2 x 121.3 cm)
F.1965.1.021

Fragonard was the greatest French painter of the gallant and sentimental themes that were popular during the reign of Louis xv. In this painting, two young lovers have escaped the restraints of the court to a secluded, rustic retreat. The scene is embroidered with patterns of branches and flowers that are as exuberant as the subject itself. The pastel colors, voluptuous painted surface, and portrayal of playful love epitomize the style of the French Rococo. ❖

Nicolas de Largillière

French, 1656–1746
PORTRAIT OF LAMBERT
DE VERMONT, n.d.
Oil on canvas
57½ x 44¾ in. (146.1 x 113.7 cm)
M.1982.6.1

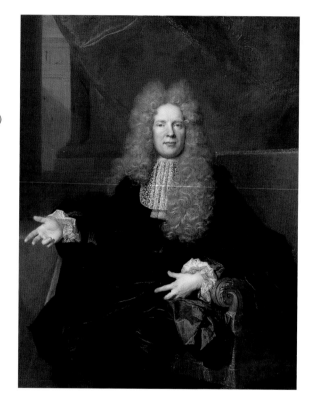

Portraiture represented one of the most important aspects of painting in eighteenth-century France, and Largillière was a leader in this genre. French by birth, he moved to Antwerp as a youth, where he absorbed important lessons of color from the Flemish school. His style was fully developed within the tradition of Rubens and Van Dyck. After he returned to Paris in 1682, Largillière modified his Flemish style and established himself as the foremost portraitist of the Parisian bourgeoisie. Largillière promoted the colorism of the north and was the first to recognize this gift in Chardin. His delicacy of touch and his fondness for the fleeting effects of light and color anticipate the rococo lightness that soon prevailed. ❖

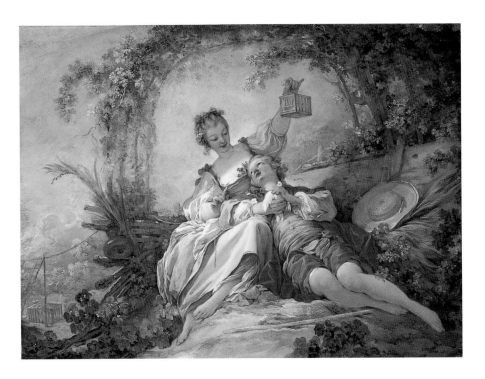

Jean-Antoine Watteau

French, 1684–1721
RECLINING NUDE, c. 1713–17
Oil on panel
6 x 6⅞ in. (15.2 x 17.5 cm)
F.1972.12

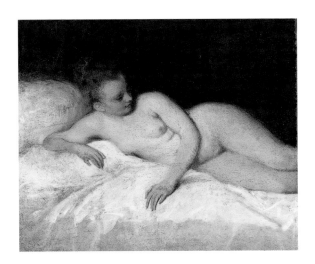

Watteau was received into the Royal Academy as a "painter of fêtes galantes," a designation devised especially for him. His paintings are unique for their suggestion of mood, in particular the transitory sensations of love and melancholy. The subtle, erotic grace of this reclining nude is one in which he took obvious delight. The painting is titillating both for the ambiguity of its subject and for the transitions between passages of subtle and bold brushwork, which add a spontaneity to the intimate moment depicted. ❖

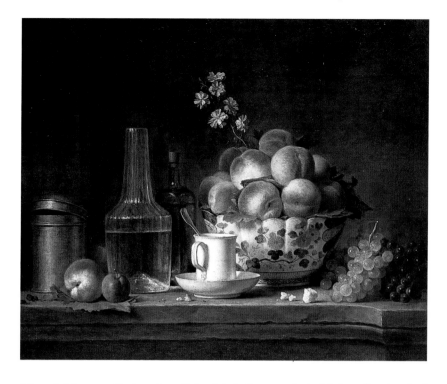

Henri-Horace Roland de la Porte

French, c. 1724–1793
STILL LIFE, c. 1765
Oil on canvas
20⅞ x 25½ in. (53.0 x 64.8 cm)
M.1968.48

Roland de la Porte studied with Jean-Baptiste Oudry, and is frequently cited as a close follower of Chardin. In fact, his brushwork is dryer and more meticulous than Chardin's. Roland de la Porte followed his illustrious rival in choosing everyday objects. The same is true for the light source, which comes from the upper-left-hand side and throws the objects into relief, highlighting them against an indistinct background. His still lifes brought the rococo paradox—the suggestion of messiness and informality accomplished with meticulous technique—to its zenith. ❖

Jean-Baptiste-Siméon Chardin

French, 1699–1779
DOG AND GAME, 1730
Oil on canvas
75¾ x 54¾ in. (192.4 x 139.1 cm)
F.1972.56

Though Chardin may be better known for his kitchen still life paintings, hunting scenes also held his fascination. The power of Chardin's painting stems from the juxtaposition of the alert pointer with the dead game hanging lifelessly from a tree. Visually linked by their proximity in space, the rifle, powder box, and hunting horn rest closely behind and next to the fresh kill. The interrelationship and harmony between the dog, game, and hunting equipment are characteristic of Chardin's still lifes. Equally important in Chardin's painting is the beauty of his brushwork—the dabs of his brush used to render the rabbit's fur, or the longer, rapid slashes of pigment that become the tail feathers of the suspended fowl. This technique lends a vibrancy to the surface of the canvas and to the objects depicted. ❖

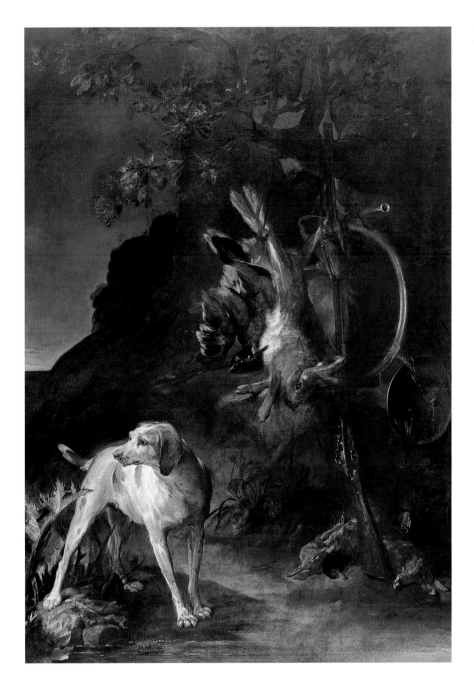

Alessandro Magnasco

Italian, 1667–1749
INTERIOR WITH MONKS, c. 1725
Oil on canvas
36¾ x 52¼ in. (93.3 x 132.7 cm)
F.1973.34.1

Unlike his contemporaries, who preferred bright, glowing colors, Alessandro Magnasco favored the dramatic contrast of lights and darks. Magnasco's small figures are executed with swift brushstrokes and darting flashes of light. In this picture, the artist has painted a large group of monks or friars warming themselves around a fire. Magnasco's fragmented figures, made of quick strokes and a monochromatic palette, create an eerie scene that anticipates the work of Goya. ❖

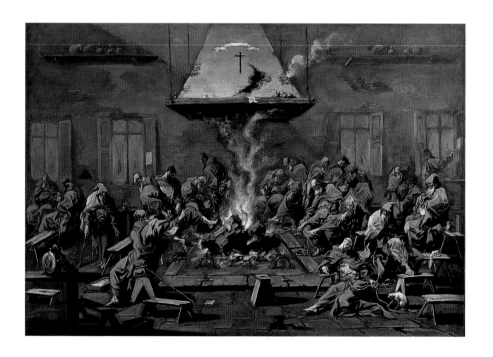

Giovanni Paolo Pannini

Italian, 1691–1765
INTERIOR OF SAINT PETER'S, ROME, 1735
Oil on canvas
60¼ x 86½ in. (153.0 x 219.7 cm)
F.1974.3

Pannini painted close to twenty versions of the interior of
St. Peter's. This painting depicts the interior of the Cathe-
dral as it looked prior to changes that occurred after 1743.
It is based on a work, now in the Louvre, that was commis-
sioned by Cardinal Melchoir de Polignac, French Ambas-
sador to the Vatican. In these paintings, Polignac, dressed
as a Cardinal, is in the basilica surrounded by a small coterie.
The bold description of the vast interior and the sureness
with which the architecture and decor are described on the
canvas remind us of Pannini's thorough familiarity with
scenographic design. ❖

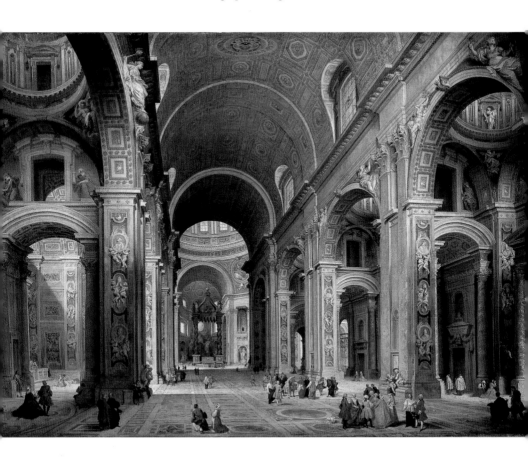

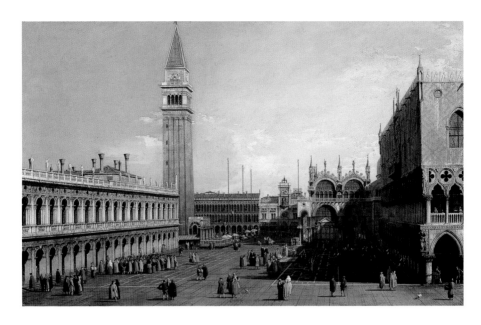

Giovanni Antonio Canal, called
Canaletto

Italian, 1697–1768
THE PIAZZETTA, VENICE, LOOKING NORTH,
Early 1730s
Oil on canvas
29⅞ x 47⅛ in. (75.9 x 119.7 cm)
F.1964.2

A native of Venice, Canaletto began his career as a scene painter in the Baroque theater, designing sets for operas. When he left the theater to take up landscape painting, he probably did more to popularize the image of Venice than any other eighteenth-century artist. Responding to the demand of the numerous visitors to Venice, he created an extraordinary number of view paintings, depicting the city from every possible vantage point. No painter of the time was more popular with the British nobility, and there was a steady flow of Canalettos to England. Canaletto had the unique ability to describe a scene faithfully and accurately and at the same time give it an evocative, personal, poetic quality. His linear precision is complemented by the effect of the bright sunlight, which accents architectural detail and filters into the cool, gray shadows. ❖

Francesco Guardi

Italian, 1712–1793
VIEW OF THE SANTA MARIA
DELLA SALUTE WITH THE
DOGANA DI MARE, n.d.
Oil on canvas
16¾ x 20⅜ in. (42.5 x 51.8 cm)
F.1972.47.1

Guardi's VIEW OF THE SANTA MARIA DELLA SALUTE represents a vision of glittering, ever-changing life. In this fantastic composition, a slice of the Giudecca intersects the painting from the right, separating what would otherwise be a continuous sweep of sea and sky. Two boats and four gondolas strategically anchor the scintillating hues and reflections of the lagoon against the luminous open sky, allowing one to practically feel the Adriatic breeze. With a limited palette and finesse of touch, Guardi has distilled the shimmering light and ethereal quality that made Venice so beloved a destination. ❖

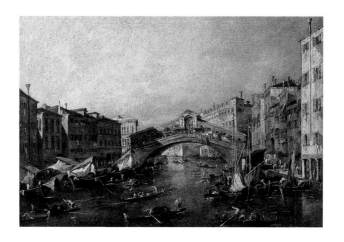

Francesco Guardi

Italian, 1712–1793
VIEW OF THE RIALTO, VENICE, FROM THE
GRAND CANAL, c. 1780–90
Oil on canvas
17 x 24¾ in. (43.2 x 62.9 cm)
M.1966.10.05

Painting for the *forestieri* or foreigners, was a main source of Francesco Guardi's livelihood. This VIEW OF THE RIALTO, VENICE, FROM THE GRAND CANAL must have been quite popular, because Guardi painted it numerous times. The vigorous commercial life of this bridge, the only one spanning the Grand Canal until the middle of the nineteenth century, is not described with a realistic eye to detail. Rather, Guardi has captured the sensation of the bustling canal, showing gondoliers rowing from one bank to the next, boats unloading their wares, people engaged on the bridge. And what better way to suggest the transitory than through the act of painting? Using a small, fine brush, Guardi painted with a rapid, spontaneous, and lively touch. Our eye is led rhythmically along the canal by following the flickering white highlights and the patterns of broken color that animate the buildings and water. ❖

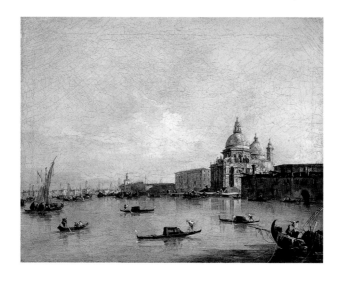

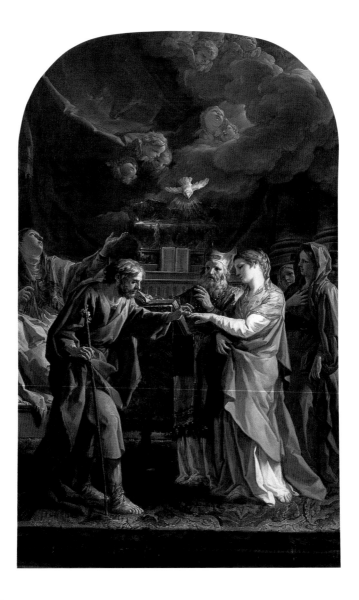

Corrado Giaquinto

Italian, 1703–c. 1766
THE MARRIAGE OF THE VIRGIN, 1764–65
Oil on canvas
112 x 70 in. (284.5 x 177.8 cm)
M.1975.27

A native of Naples, Giaquinto was an early exponent of the Italian Rococo, a style characterized by sumptuous color, exquisite surface finish, and decorative appeal. In 1762, Giaquinto embarked upon his last great project, the decoration for the new sacristy of San Francesco, part of the royal monastery in Naples. The paintings, executed in fresco and oil, illustrated scenes from the life of the Virgin. THE MARRIAGE OF THE VIRGIN is one of four of the original seven paintings that have survived. The underlying theme of the decorative cycle is the doctrine of the Virgin's Immaculate Conception, the belief that Mary was conceived without Original Sin. In Giaquinto's hands the devotional quality and stability of the Italian Grand Manner mingled with the loveliness and refinement of the eighteenth century. This was the true achievement of the Italian Rococo. ❖

Giovanni Battista Tiepolo

Italian, 1696–1770
THE TRIUMPH OF VIRTUE AND
NOBILITY OVER IGNORANCE,
c. 1740–50
Oil on canvas
126 x 154½ in. (320 x 392.4 cm)
F.1972.26

Tiepolo was the purest exponent of the Italian Rococo. He created fresco decorations and paintings for palaces and churches throughout Europe with an unprecedented, inventive freedom of form and expressive, shimmering colors. A master of the airborne figure and of perspective, he excelled in creating the illusion of infinite space articulated with luminous colors and atmospheric effects. This painting was designed for a ceiling in the Palazzo Manin in Venice. Virtue is dressed in white with a sun symbol on her breast. Beside her, Nobility holds a statuette of Minerva and a spear. To the left, Fame blows her trumpet. Below, the figure of Ignorance is being vanquished. The poppy wreath falling through the sky alludes to the "sleep of the mind." The bats symbolize ignorance, which refuses to see the light of wisdom and knowledge. The figures of Virtue and Nobility display a distinctly lofty, detached air indicative of the mythological world they occupy. ❖

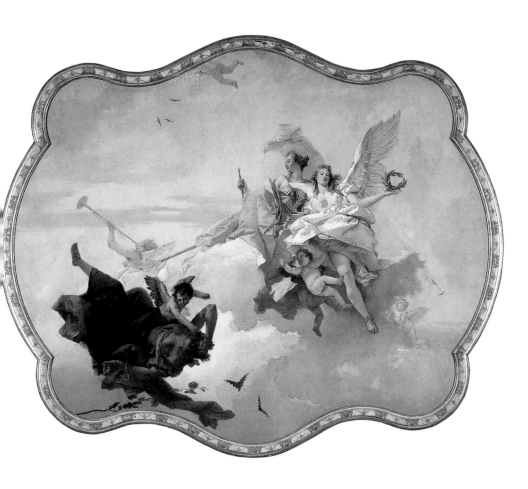

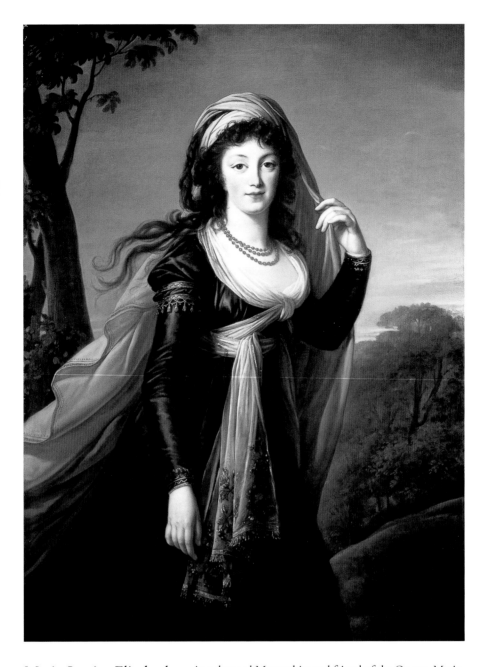

Marie-Louise-Elisabeth Vigée-Lebrun

French, 1755–1842
PORTRAIT OF THERESA, COUNTESS
KINSKY, 1793
Oil on canvas
54⅛ x 39⅜ in. (137.5 x 100 cm)
M.1969.03

As a devoted Monarchist and friend of the Queen, Marie-Antoinette, Vigée-Lebrun chose exile during the French Revolution. While in Vienna in 1793, she produced this image of Theresa, Countess Kinsky. The Countess was the unfortunate victim of an arranged marriage. Her husband, a man whom she had never met, abandoned her at the church immediately after their wedding, and returned to his mistress. Clearly, Vigée-Lebrun was captivated by the beauty and amiable character of Countess Kinsky, as well as by her sad history. ❖

Maurice-Quentin de La Tour

French, 1704–1788
SELF-PORTRAIT, 1764
Pastel on paper
18 x 15 in. (45.7 x 38.1 cm)
F.1969.38.09

Maurice-Quentin de La Tour carried the difficult and capricious pastel medium to a point of sheer technical brilliance not reached before or since. His mastery of pastels led not only to imitation but to fears that he would provoke a distaste for oil paint. La Tour was at his best when concentrating on the face alone. There is a suggestion of mobility in the features of his subjects, and the artist himself referred to "un peu d'exagération" that art allowed beyond nature. His self-portrait is marked by characteristics that aptly describe his style: the tremendous handling and technique, the humorous look to the eyes, and the slight upturn of the lips, all of which lend a vivid actuality and personality to the sitter. ❖

Jean-Auguste-Dominique Ingres

French, 1780–1867
PORTRAIT OF BARON JOSEPH VIALÈTES DE MORTARIEU, 1806
Oil on canvas
24⅛ x 19⅞ in. (61.3 x 50.5 cm)
F.1983.3

The most influential French painter of his time, Ingres is noted for his unique and intensely personal vision of nature and beauty. His portraits are straightforward and scrupulous in their attention to detail. Here, the dark curls framing the finely modeled face, and the focused impact of contrasting light and dark in the Baron's garment, endow this portrait with a distinguished and decidedly romantic quality, further enhanced by the idyllic background sky. Baron Vialètes de Mortarieu became the mayor of Montauban, Ingres' hometown, in 1806; this portrait may have been commissioned to commemorate that event. In addition to the Baron's numerous prestigious civic positions, he was an avid art collector and founded the Musée de Montauban through his bequest to the city of a large portion of his collection. ❖

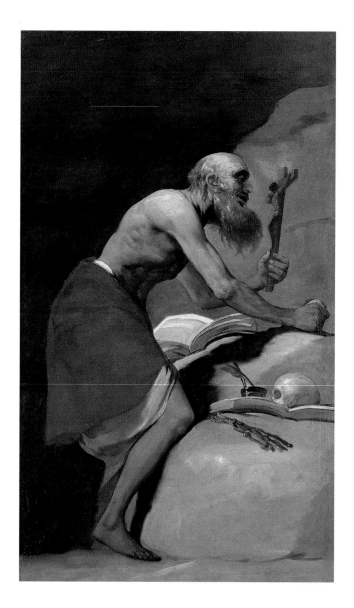

Francisco de Goya y Lucientes

Spanish, 1746–1828
SAINT JEROME IN PENITENCE,
1798
Oil on canvas
75 x 45 in. (190.5 x 114.3 cm)
F.1970.08

Goya's fervent Saint Jerome originally formed part of a series of the Four Fathers of the Church, along with Saint Ambrose [Cleveland Museum], Saint Gregory [Madrid, Museo Romantico], and Saint Augustine [Private Collection]. An early Christian scholar, Saint Jerome produced the Latin translation of the Bible. He lived the life of an ascetic for four years in the desert while studying and praying to free himself of worldly desire. Emaciated and scantily clad, he contemplates a crucifix in his harsh wilderness retreat. Around him lie his books and writing materials, as well as the scourge and skull (a symbol of death) that served as aids in spiritual contemplation. In his hand he holds the stone that he uses to beat his breast in penitence. ❖

Francisco de Goya y Lucientes

Spanish, 1746–1828
PORTRAIT OF DONA FRANCISCA
VICENTA CHOLLET Y CABALLERO,
1806
Oil on canvas
40½ x 31¾ in. (102.9 x 80.6 cm)
M.1981.7

In 1799, Goya was made First Court Painter to the King of Spain. For the next ten years he painted numerous official portraits of the royal family, and many portraits of subjects outside the circle at court. His works from this period are noted for their forceful and direct realism and display Goya's extraordinary skill as a colorist. Here the sitter is dressed in an elegant, glittering white gown, seated on a brocaded burgundy sofa, gently cradling a small dog in her lap. Her jewels glisten against the neutral dark background, and the red of the dog's elaborate collar echos the burgundy color of the sofa. The dog's tawny color is repeated in the subtle highlights on the sofa's frame. The dignified and placid aura of the portrait is reinforced by its pyramidal composition, made possible by the subject's stable and ample form. ❖

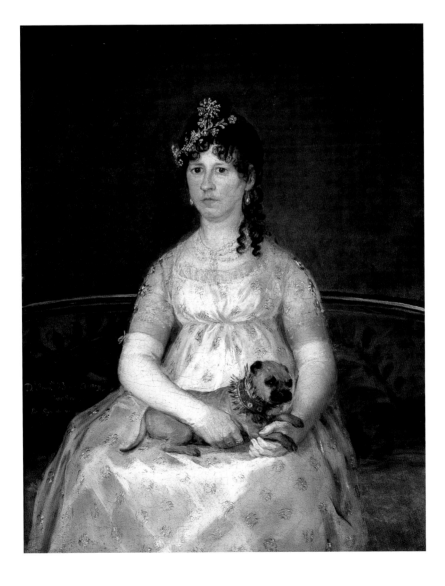

Jean-Baptiste-Camille Corot

French, 1796–1875
VENICE, THE PIAZZETTA: VIEW FROM
THE RIVA DEGLI SCHIAVONI, C. 1835
Oil on canvas
18⅜ x 27 in. (46.7 x 68.6 cm)
F.1973.27

Corot's second trip to Venice, in August and September of 1834, was the occasion for many radiant studies of that inspiring city. This view of the Piazzetta is one of four that Corot made of the small plaza near the Piazza San Marco. Although it displays a luminosity of color usually associated with works painted from life, it was probably made in the studio after his return to France. ❖

Jean-Baptiste-Camille Corot

French, 1796–1875
YOUNG WOMAN IN A RED BODICE
HOLDING A MANDOLIN, 1868–70
Oil on panel
18¼ x 14½ in. (46.4 x 36.8 cm)
M.1975.13.1

Corot was one of the most original and influential landscape painters of the nineteenth century, and his work helped to turn landscape painting into a serious subject after a century of neglect. This meditative young woman, painted in the studio against a landscape background, is typical of the many works Corot created in which a pensive figure dominates the composition. The silvery green landscape is characteristic of these studies, which use soft, atmospheric settings to evoke a poetic mood. This painting remained in Corot's own collection until his death. ❖

Honoré Daumier

French, 1808–1879
MOUNTEBANKS RESTING, 1870
Oil on canvas
21½ x 25¾ in. (54.6 x 65.4 cm)
M.1976.6

During his lifetime, Daumier was best known as a caricaturist and prolific graphic artist, producing more than 5,000 political cartoons. He began to paint seriously only in midlife. The theater as subject matter, both the actors and the audience, occupies an important place in Daumier's oeuvre. This depiction of resting mountebanks (traveling performers) reveals Daumier's interest in representing a behind-the-scenes view of the theater. Two adults and a child rest in their quarters as they wait between performances. The artist's starkly lit figures emerge from their dim background in a bold contrast of light and dark. ❖

Gustave Courbet

French, 1819–1877
APPLES, PEARS AND PRIMROSES
ON A TABLE, 1871–72
Oil on canvas
23½ x 28¾ in. (59.7 x 73.0 cm)
M.1999.2.1

Courbet began his painting career at a time when artists were strongly challenging the ideals of the French Academy. His hostility toward the academic system inspired the vigorous realism that is characteristic of his work. Additionally, Courbet was a man of strong political opinions. In 1871, he was convicted of aiding in the destruction of the Vendôme Column, an imperial monument, and sentenced to six months in the Sainte-Pélagie prison. While there, he began a series of still life paintings based on the fruit and flowers brought by his sister. At first glance, this arrangement appears to be a casually heaped pile of fruit. A closer inspection reveals a carefully composed arrangement that takes advantage of the varying sizes, colors, and textures of the fruit. The fully lit arrangement on the white cloth is further enhanced by the darkened background, and displays Courbet's exuberant, innovative handling of the paint. Although inscribed "Ste. Pélagie '71," Courbet probably painted the work after he left prison. He evidently wished, with this inscription, to publicize and protest the indignity of his imprisonment. ❖

Gustave Courbet

French, 1819–1877
CLIFFS AT ETRETAT, THE PORTE
D'AVAL, 1869
Oil on canvas
25¾ x 32 in. (65.4 x 81.3 cm)
F.1969.6.2

The Normandy coast was a popular tourist destination for Parisians, and the town of Etretat, with its dramatic cliffs, was a favorite with artists. Courbet painted La Porte d'Aval, the impressive opening in the cliff, at least eight times. The artist's technique challenged the prevailing standards of landscape painting held by the French Academy: indiscernible brushwork, smooth paint application, and a carefully organized composition. Instead, Courbet utilized the spatula and palette knife to modify texture, and manipulated color to suggest the spontaneity of natural light. All of these methods served as precursors to Impressionism. This particular landscape is a splendid example of Courbet's innovative style and vigorous brushwork. ❖

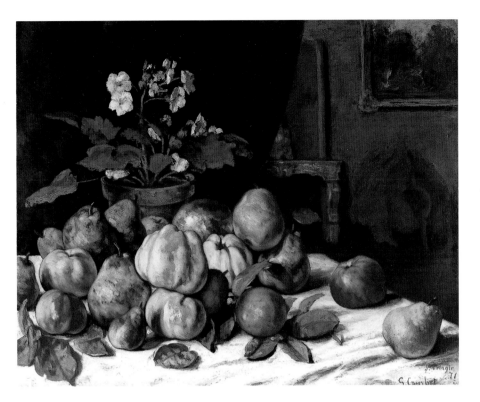

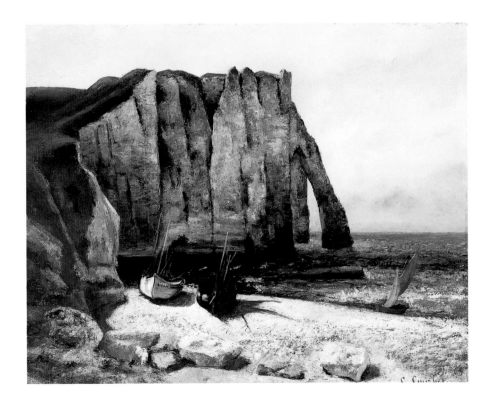

94

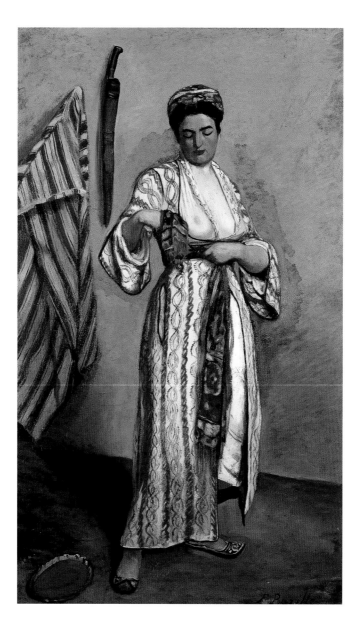

Jean-Frédéric Bazille

French, 1841–1870
WOMAN IN MOORISH COSTUME,
1869
Oil on canvas
39⅜ x 23⅜ in. (100 x 59.4 cm)
M.1997.2

Bazille was one of the most gifted of the young group of painters who were moving from Realism to Impressionism in the 1860s. Here the artist displays an interest in one of the Oriental themes that fascinated nineteenth-century painters and writers. These popular themes included exotic subjects that they imagined derived from French colonies in North Africa; women in harem costumes were among the most popular. This composition is a contrast of textures, as the woman's colorfully patterned costume stands out against the more neutral wall and floor. Bazille died shortly before his twenty-ninth birthday during a battle in the Franco-Prussian War. ❖

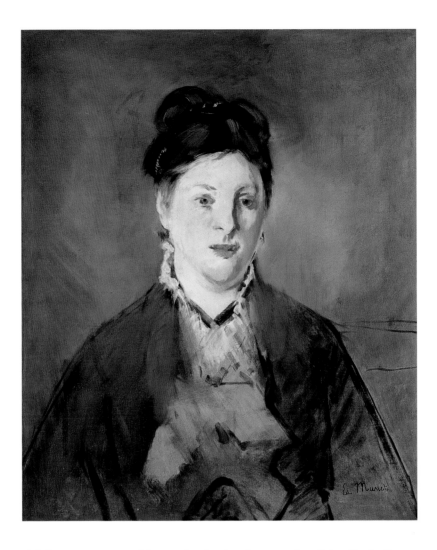

Edouard Manet

French, 1832–1883
PORTRAIT OF MADAME MANET,
1866
Oil on canvas
23⅞ x 20 in. (60.6 x 50.8 cm)
M.1973.4

Manet painted only a few portraits of his wife, the former
Suzanne Leenhoff. The daughter of a Dutch organist, she
was hired by the Manet family about 1850 to give piano
lessons to Edouard and his younger brother Eugène. In early
1852 her son Léon was born. It has never been established
that Manet was the father, yet he did become the child's
godfather. Manet and Suzanne had a clandestine relation-
ship, which ended in marriage only after the death of his
father in 1862. Suzanne's portraits show her to be a robust,
plain woman. She was most often described as being serene,
good-natured, and an accomplished pianist. Manet's assertive
handling of the paint surface and the simple directness of
his compositions led him to be regarded as the first modern
painter. This portrait is a good example of Manet's tech-
nique, in which he flattened form in a shallow space, relying
on the opposition of light and shadow with a minimum of
halftones and a palette dominant in blacks and grays. ❖

Edouard Manet

French, 1832–1883
THE RAGPICKER, c. 1865–1869
Oil on canvas
76¾ x 51¼ in. (194.9 x 130.2 cm)
F.1968.9

THE RAGPICKER is the largest of a group of seven monu-
mental paintings of single figures, set into undefined, neutral
backgrounds. Three, including this work, were inspired by
the Spanish artist Diego Velázquez' "Philosophers," Aesop
and Menippus, admired by Manet during his 1865 trip to
Madrid. The idea that wisdom and poverty were associated
was a popular belief in Manet's time. Beggars, ragpickers,
drunks, and peasants appeared as subjects in literature as
well as in painting. Manet said that Velázquez' backgrounds
were "made up of air which surrounds the subject." Elim-
inating perspective, Manet has made the floor and the wall
fade into each other. The figure rests in a two-dimensional
space that one critic scoffingly compared to a playing card.
Nevertheless, the skillfully placed still life of rubbish, spilling
off the canvas, firmly anchors the figure to the ground. ❖

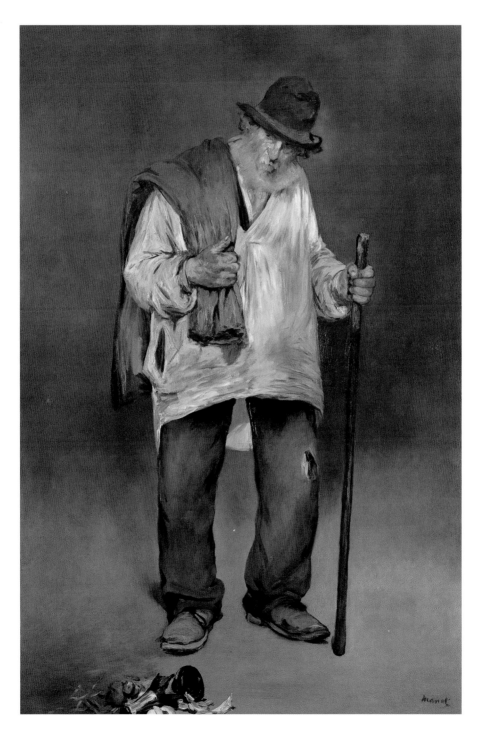

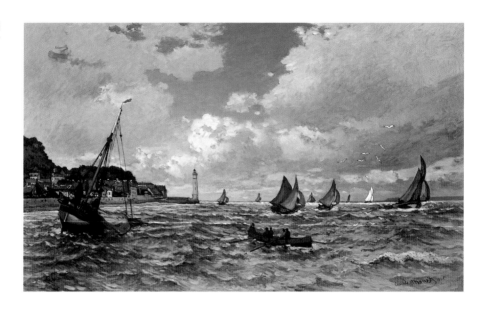

Claude Monet

French, 1840–1926
MOUTH OF THE SEINE AT
HONFLEUR, 1865
Oil on canvas
35 ¼ x 59 ¼ in. (89.5 x 150.5 cm)
F.1973.33.2

One of the two canvases Monet first exhibited in Paris, this painting elicited an enthusiastic critical response at the Salon of 1865. The artist had executed the work in his studio from smaller studies made directly from nature the previous summer. The geometry of the composition shows Monet's sound sense of structure. The boat at the left tilts its mast to the right, precisely anchoring the lower left corner of the canvas and forming a right triangle with the horizon line and the lighthouse. Every detail in the sky and water speaks of a blustery day, with one band of light on the horizon. Small repeated elements such as boats and lapping waves are consciously arranged and realized with sharp definition. The perfect arrangement of white gulls mirrors the shape of one sunlit boat in the distance. ❖

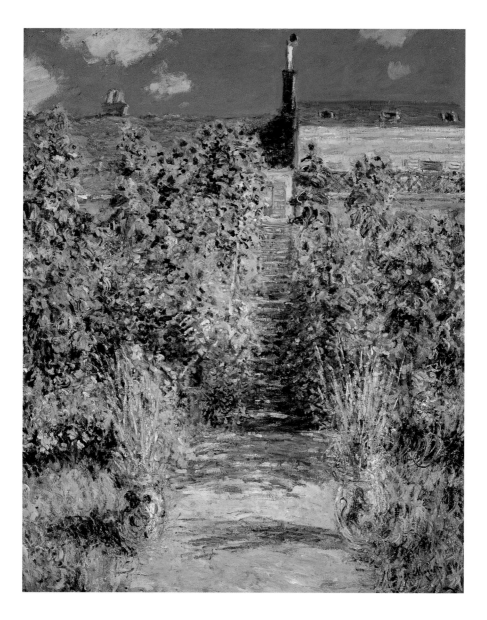

Claude Monet

French, 1840–1926
THE ARTIST'S GARDEN AT
VÉTHEUIL, 1881
Oil on canvas
39⅝ x 32 in. (100.6 x 81.3 cm)
F.1975.9

In 1881 Monet lived at Vétheuil, a small town on the banks of the Seine. His garden, filled with tall sunflowers, was terraced from the house down to the river. This view is one of four that Monet painted of the stairs and garden. Light bathes the scene, heightening all of the colors and penetrating even into the darkest shadows. These shadows are painted in blues, deep purples, and dark greens. Executed with short, energetic brushstrokes, the artist's garden resonates with the colors of summer. ❖

Pierre-Auguste Renoir

French, 1841–1919
THE ARTIST'S STUDIO, RUE SAINT-GEORGES,
1876
Oil on canvas
17¾ x 14½ in. (45.1 x 36.8 cm)
M.1978.13.1

Renoir's only studio group portrait records
an informal conversation among his friends
in his Montmartre studio. The central
figure holding a book and appearing to
lead the discussion is the art critic and
Renoir's biographer, Georges Rivière. The
bald, bearded man partially hidden to the
right is painter Camille Pissarro. Less defi-
nite are the identities of the other three
men. The animated, delicate brushwork
that dances over the surface is typical of
Renoir's works of this period. ❖

Pierre-Auguste Renoir

French, 1841–1919
The Pont des Arts, Paris,
c. 1867–68
Oil on canvas
24½ x 40½ in. (62.2 x 102.9 cm)
F.1968.13

Renoir's early view of Paris demonstrates why he was called a master of the urban landscape. His seemingly spontaneous technique is in fact a brilliantly constructed study in light, shadow, and perspective. Lively brushwork and contrasts in light and dark dance over the surface, constantly drawing the eye back to the brightly lit Quai Malaquais in the right foreground. The edges of this energetic patch of pavement bustle with the interplay of light and dark colors and shapes. The view is to the east. The Pont des Arts spans the Seine on the left; the stone bridge seen through its arches is the Pont Neuf. The viewer stands in the shade of the Pont du Carrousel, which is overhead and behind the picture plane, yet very much in evidence with its strong horizontal shadow running along the lower edge of the painting. The perspective is subtly reinforced by the foreground shadows made by the pedestrians walking on the overhead bridge in the afternoon sun. ❖

Camille Pissarro

French, 1830–1903
THE BOULEVARD DES FOSSES,
PONTOISE, 1872
Oil on canvas
18¼ x 22 in. (46.4 x 55.9 cm)
M.1975.20

Born in the Virgin Islands, Pissarro was educated in Paris,
where he began to study painting in 1855. This work is a
view of the small town where Pissarro lived from 1866 to
1883. Drawn in deep perspective, amplified by the rapidly
diminishing scale of the trees, the painting demonstrates
Pissarro's subtle and delicate tonal range. ❖

Berthe Morisot

French, 1841–1895
IN A VILLA AT THE SEASIDE, 1874
Oil on canvas
19¾ x 24⅛ in. (50.2 x 61.3 cm)
M.1979.21

This painting is one of two in which Morisot recorded the
holiday she spent with the Manet family on the English
Channel in the summer of 1874. During this holiday she
accepted the marriage proposal of Eugène Manet, the younger
brother of the painter. The seated figure is the artist's sister,
whose dark blue skirt is trimmed with white-edged flounces
like so many little waves. This painting was in the collection
of Edgar Degas. ❖

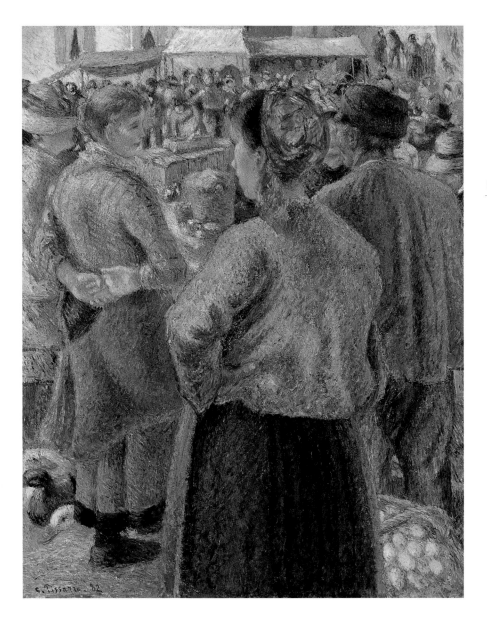

Camille Pissarro

French, 1830–1903
THE POULTRY MARKET AT
PONTOISE, 1882
Oil on canvas
31⅞ x 25⅝ in. (81.0 x 65.1 cm)
M.1984.2

Pissarro was an important force in the development of Impressionism, and the only artist to exhibit in each of the eight Impressionist exhibitions. Yet his paintings are generally not considered spontaneous; he usually constructed his meticulous compositions in his studio from sketches. A tour de force of animated and delicate brushwork, this painting is one of several studies of the brisk poultry market in Pontoise and well illustrates the highly keyed color palette Pissarro used at the time. His deftly placed brushstrokes anticipate Pointillism, which Pissarro named and used along with Seurat and Signac three years later. ❖

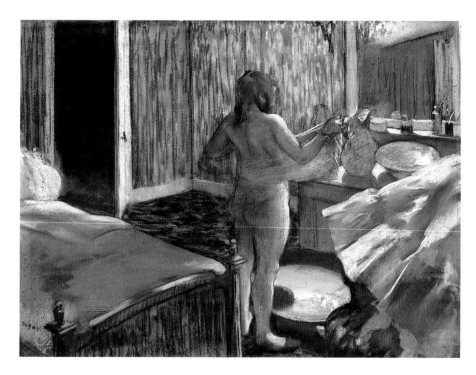

Edgar Degas

French, 1834–1917
WOMAN DRYING HERSELF
AFTER THE BATH, 1876–77
Pastel over monotype
18 x 23¾ in. (45.7 x 60.3 cm)
F.1978.4

A monotype is a print image produced by applying ink or paint directly onto a metal plate and transferring that design to paper. Although the procedure generally yields only a single impression, a second, lighter impression can sometimes be obtained. Quite often when Degas printed two impressions, he saved the first, leaving the image alone; the second, fainter impression he would rework, usually in pastel, as he did with this example. Here the artist has used light and shadow to define and enliven his composition. The light emanating from the almost unseen fixture above the dressing table illuminates a woman drying after her bath. We see only the edges of the light along her right side where it defines her form, otherwise lost in shadow. The burst of highlights on the spray of petticoats aptly balances the woman's dark shadow spilling onto the bed and acts as a foil for the rigid upright black of the open doorway. ❖

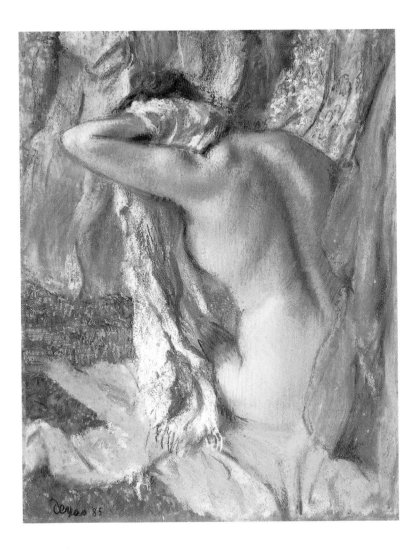

Edgar Degas

French, 1834–1917
AFTER THE BATH, c. 1890–95
Pastel on tracing paper mounted
on cardboard
26 x 20¾ in. (66.0 x 52.7 cm)
F.1975.2

Women bathing, grooming, or otherwise engaged in their personal hygiene populate many of Degas' works. They are often depicted combing or drying their hair, arms upraised, seen from the back. Degas brings to these compositions an intense interest in movement and gesture, enlivened by radiant pastel coloration. Degas remarked about his bathers, "These women of mine are honest, simple folk, unconcerned by any other interests than those involved in their physical condition." Nevertheless, scholars assert that in reality these women were prostitutes, and easily recognizable as such to Degas' contemporaries. It is believed that a bathtub, for instance, was a sign of the prostitute because of her need to demonstrate hygiene, and that the dressing gown and bed bolster this connection. The pastel was dated "1885" by another hand. Stylistically, a later date is more probable. ❖

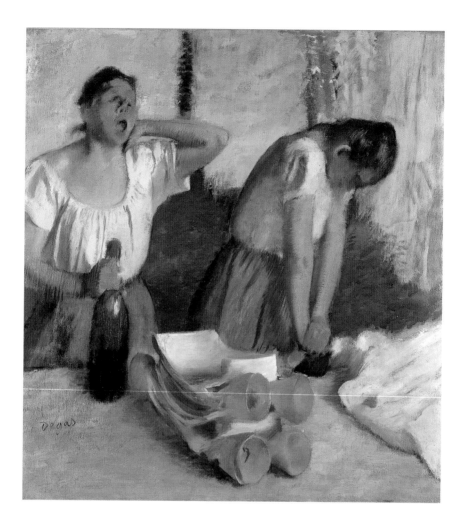

Edgar Degas

French, 1834–1917
WOMEN IRONING, c. 1884
Oil on canvas
32⅜ x 29¾ in. (82.2 x 75.6 cm)
M.1971.3

Paris was famous for its laundries, which served a large portion of the city and its suburbs. One could see laundry shops on every street, and many artists and writers used them as subjects. Degas, too, was fascinated with the profession, and over a thirty-year period he created twenty-seven works depicting laundresses, with many variations on the same poses. Writer Edmond de Goncourt extolled Degas' laundresses as "the most charming pretext for blonde and tender colors." Not all critics, however, appreciated these renderings. "Despite Degas' accurate and firm draftsmanship, his laundresses will never get my business," wrote Marius Chaumelin, "The laundry that they are ironing is repulsively dirty." In this canvas, the composition is a contrast in verticals and diagonals, anchored top and bottom by the pale blue-gray of the table, shirts, and hanging laundry. The women, too, are a study in contrasts: the one on the right presses her weight and rigid arms into her task while her companion pauses to stretch and massage her aching neck. ❖

Edgar Degas

French, 1834–1917
DANCERS IN THE WINGS, c. 1880
Pastel, gouache, distemper,
and essence on paper,
mounted to paperboard
27¼ x 19¾ in. (69.2 x 50.2 cm)
M.1977.6

Degas was intrigued with the ballet as subject matter, and
quite often with the performers behind the scenes. This
pastel illustrates the artist's innovative technique and distinc-
tive style. He used a variety of media, but the most striking
is his virtuoso use of pastel to achieve luminous colors and
diaphanous textures. This work also exemplifies Degas'
method of arranging his figures asymmetrically, allowing
one figure to partially block off another, or be cut off by
the picture frame. The composition is made up of at least
ten pieces of paper, which he added to enlarge the original
drawing of the rear figure. The most extraordinary addi-
tion is the narrow strip of paper along the right side, just
wide enough to include the dancer's eye. ❖

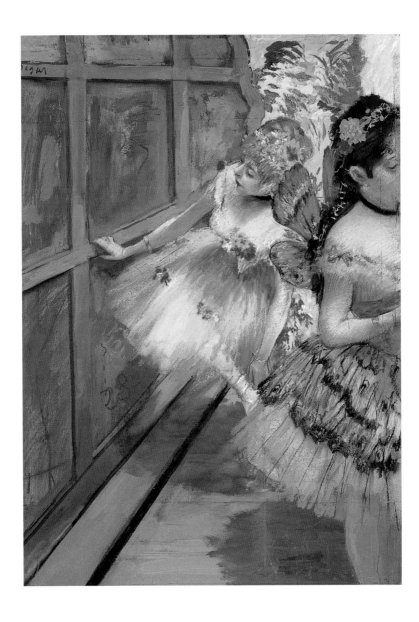

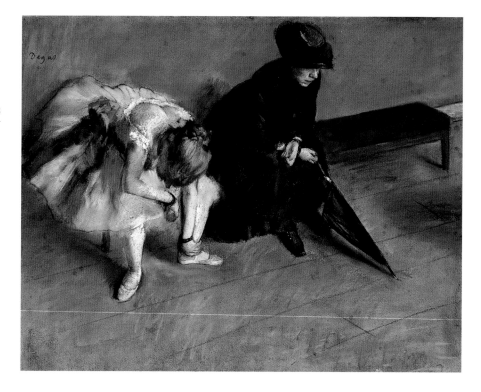

Edgar Degas

French, 1834–1917
WAITING, c. 1882
Pastel on paper
19 x 24 in. (48.3 x 61.0 cm)
M.1983.1
Jointly owned with the
J. Paul Getty Museum,
Los Angeles

A young ballet dancer is seated with her companion on a bench, perhaps in the foyer of an audition hall. The girl bends over, massaging her ankle, while the somberly dressed woman traces the pattern of the floorboards with her umbrella. Degas' genius in the application of pastel and his skill at compositional techniques are very much in evidence in this glowing design. Apart from the bench, wall, and floor, all superfluous details are suppressed. Degas has boldly put most of the action in the upper left triangular segment of the paper. The diagonals of the bench and floorboards are intersected by an opposite diagonal line running from the tip of the umbrella to the woman's leg, and along the back of the bent dancer. The simplicity of the composition is enhanced by a series of contrasts. The straight, tense triangular shape of the woman contrasts with the rounded, weary form of the ballerina. The dancer is dressed in frothy white and pale pastels, while her companion is encased in severe black, from which emerge only the bright spots of her hands and face. ❖

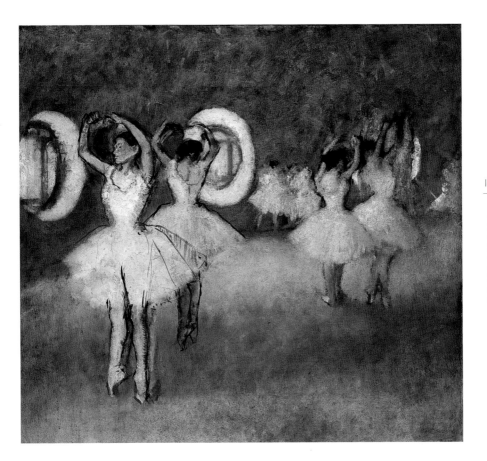

Edgar Degas

French, 1834–1917
DANCE REHEARSAL IN THE FOYER OF THE OPERA, 1895
Oil on canvas
34⅞ x 37¾ in. (88.6 x 95.9 cm)
M.1968.25

This luminous work is an ideal example of Degas' ability to vigorously manipulate oil paint and at the same time retain the luster and delicacy of his finest pastels. The thumbprints visible on the paint surface, especially on the foreground figure, indicate the extent to which he used his hands to fashion the medium. In his reworking of the legs and arms of the foreground dancers, he reinforced the changes with black and brown outlines rather than paint over the extra legs and arms. There is the merest impression of a room, with large windows defining the walls. The artist has deftly used diminishing sizes of figures to create the illusion of depth. His smallest figures in the background are quick dabs of paint. The fact that they don't seem to stand on the floor is irrelevant. ❖

Henri de Toulouse-Lautrec

French, 1864–1901
AT THE CIRCUS FERNANDO,
RIDER ON A WHITE HORSE,
c. 1887
Pastel and drained oil paint on
paperboard
23½ x 31⅞ in. (59.7 x 81.0 cm)
M.1978.13.2

The performer sits sidesaddle, both hands on the horn, as the horse gallops around the ring. The pastel medium contributes to the soft focus and iridescent rendering, and the sweeping diagonals reflect the swift movement of the horse. Without a ringmaster or clown present in the ring, the focus shifts exclusively to the rider, posed by the painter Suzanne Valadon. Toulouse-Lautrec placed only one top-hatted observer (the ringmaster?) in the stands, but his blurred face obscures the direction of his gaze, visually reinforcing the sense of movement and the velocity of the horse and rider. Economical touches of black define their features. The horse's white coat is articulated with green, lavender, and red shadows, and highlights of yellow reflect an unseen spotlight. The pastel is inscribed in the upper right "a mon ami Brua" (to my friend Brua[nt]). Aristide Bruant was a colorful singer and café owner who exhibited Toulouse-Lautrec's paintings. ❖

Henri de Toulouse-Lautrec

French, 1864–1901
RED-HEADED WOMAN IN
THE GARDEN OF MONSIEUR
FORET, 1889
Oil on cardboard
28⅛ x 22⅞ in. (71.4 x 58.1 cm)
F.1973.37

Toulouse-Lautrec took advantage of the verdant Montmartre garden of Monsieur Foret to paint at least four works. Two of them feature the same pensive woman with striking red hair—probably Carmen Gaudin, a favorite model of the artist's at that time. Toulouse-Lautrec has boldly used lavenders and greens to act as a foil and heighten the vivid impact of the woman's hair. The sumptuous color and exuberant brushwork create a delicate network, unified by the tan cardboard support that reveals itself across the surface. The effect of filtered and reflected sunlight is achieved by repeating the lavenders and greens in the model's dress and skin, and the angular fronds of spiky shrubbery echo the angles of her profile. The medium is oil, but the artist's use of clear, thin brushstrokes creates the effect of a quickly sketched pastel of rare beauty. ❖

Pierre Puvis de Chavannes

French, 1824–1898
THE YOUTH OF ST. GENEVIÈVE, 1879
Oil on canvas, triptych
53 x 99½ in. (134.6 x 252.7 cm)
M.1968.49

Puvis de Chavannes was the master of large-scale decorative painting. His immense canvases adorned many public and private buildings, and he established new ideals for mural decoration. In 1874, a campaign was launched to decorate the interior of the Panthéon, the National Shrine to French heroes. Puvis de Chavannes was appointed to create a mural cycle depicting the youth of St. Geneviève, patron saint of Paris. This triptych is a reduced version of the lower section of that cycle. The central panel depicts the moment when St. Germain of Auxerre and St. Loup of Troyes recognize Geneviève as divinely marked. The two side panels represent the imagined rural community of the saint's childhood. The artist's flat, slightly modeled figures and pale, chalky colors were a departure from naturalistic appearances. This work is typical of his simplification of form and dreamlike, poetic mood. ❖

Georges-Pierre Seurat

French, 1859–1891
THE STONE-BREAKERS, LE RAINCY,
C. 1882
Oil on canvas
14¾ x 17⅞ in. (37.5 x 45.4 cm)
M.1968.28

This early work introduces a technique that Seurat would soon fully develop, to become what is known as Pointillism. Whereas Impressionism was based on the effects of light and the use of pure color, Pointillism was a technique using ordered compositions of harmonious, juxtaposed dots of color. Seurat's Pointillist works are characterized by solid, formal compositions embellished with a highly complex, decorative painted surface. ❖

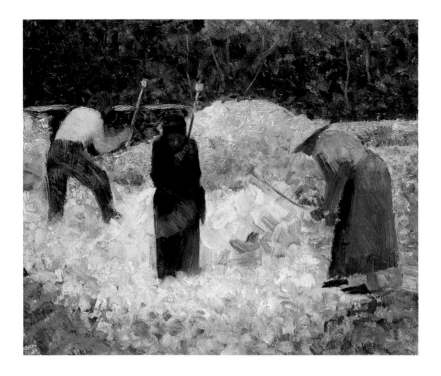

Paul Cézanne

French, 1839–1906
Farmhouse and Chestnut
Trees at Jas-de-Bouffan
 c. 1885
Oil on canvas
36 x 29 in. (91.4 x 73.7 cm)
M.1995.1

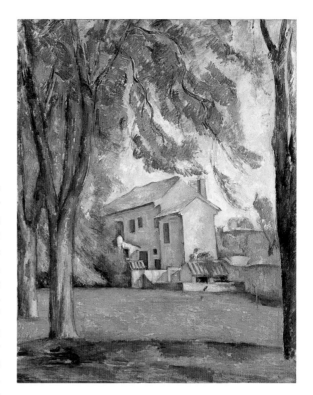

Cézanne's work formed the foundation of twentieth-century artistic principles. His ideas became fundamental to Cubist artists who were inspired by his taut arrangements of volumes, subtle harmonies, and rigorous ordering. Jas-de-Bouffan, meaning "habitation of the winds" in the Provençal language, was the Cézanne family estate near Aix. This view demonstrates the artist's subtle compositional methods. The lines defining the trees and house are loosely drawn, allowing each element to merge with the surrounding environment. The modulation of the whole composition creates another set of visual tensions. The apparent orderly progression of the space backwards is contradicted by patches of creamy white unpainted canvas, bringing us back to the reality of the artist's materials. ❖

Paul Cézanne

French, 1839–1906
Tulips in a Vase, c. 1890–92
Oil on paper, mounted on board
28½ x 16½ in. (72.4 x 41.9 cm)
M.1976.12

Tulips in a Vase demonstrates the artist's interest in the purely physical, optical qualities of painting. While the brushstrokes describe the object, they also deny the space the tulips inhabit. The flowers and the leaves are not clearly separated from their environment. The background itself comes forward over the table and around the edges of the distorted vase. The effect of Cézanne's active, vigorous sense of order in the application of each individual brushstroke is such that the eye is continually drawn to the painted surface. The tension between this attraction and the tendency for the eye to respond to the illusion of the vase of tulips is one of Cézanne's foremost accomplishments. ❖

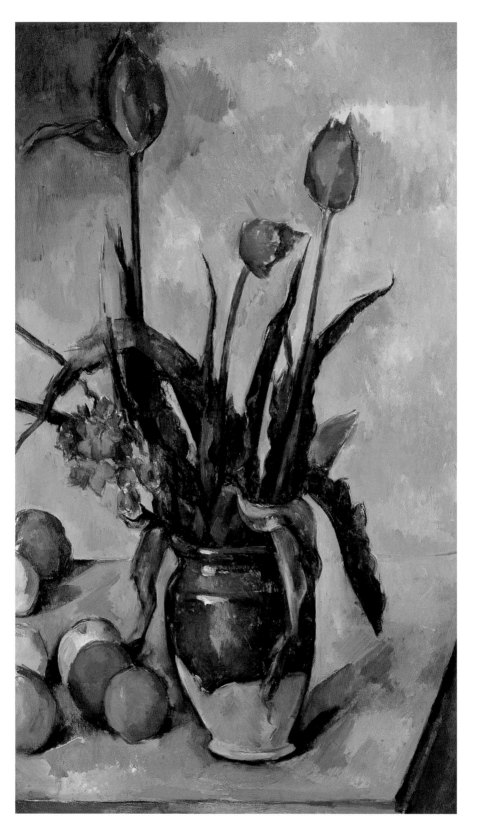

Vincent van Gogh

Dutch, 1853–1890
PORTRAIT OF THE ARTIST'S
MOTHER, 1888
Oil on canvas
15½ x 12¼ in. (39.4 x 31.1 cm)
M.1968.32

Van Gogh based this portrait on a black-and-white photograph of his mother. In a letter to his brother Theo, the artist reported, "I am doing a portrait of Mother for myself. I cannot stand the colorless photograph, and am trying to do one in a harmony of color, as I see her in my memory." Van Gogh has used narrow brushstrokes to define the volumes and shapes. The subject is strongly outlined and thrust forward to the surface of the picture plane. There is no pictorial background, but rather pure color. ❖

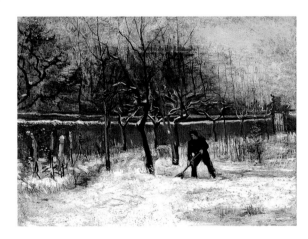

Vincent van Gogh

Dutch, 1853–1890
THE PARSONAGE GARDEN IN
THE SNOW (WINTER), 1885
Oil on canvas, mounted on
panel
23 x 31⅛ in. (58.4 x 79.1 cm)
F.1969.39.2

In December 1883 van Gogh moved from The Hague to Nuenen, where his father was parson. There he stayed with his parents until the spring of 1885, using a barn as his studio. This painting is a view of the large garden adjoining the parsonage. The artist's limited palette is dominated by earth tones, black, and shades of gray, which is typical of this early period, and we sense the harshness of a bitterly cold and overcast Dutch winter day. ❖

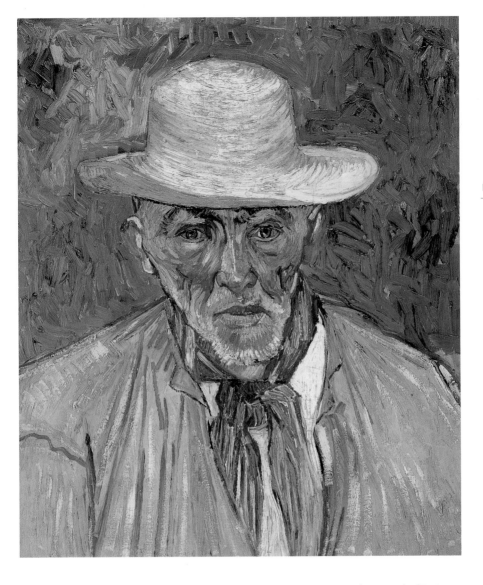

Vincent van Gogh

Dutch, 1853–1890
PORTRAIT OF A PEASANT, 1888
Oil on canvas
25⅜ x 21½ in. (64.5 x 54.6 cm)
M.1975.6

This is one of two portraits van Gogh painted of Patience Escalier. An old gardener and shepherd, Escalier was chosen as a subject partly because he reminded van Gogh of his own father. In two letters of August 1888, van Gogh wrote to his brother Theo: "I wanted to paint a little old peasant, who very much resembles our father in features.... Behind the head, instead of painting the ordinary wall of the mediocre room, I paint infinity, a plain background of the richest, most intense blue I can conceive, and by this single combination of the bright head against the rich blue background, I get a mysterious effect, like a star in the depths of an azure sky." Van Gogh believed that this portrait was one of a small group that marked his break from the principles of Impressionism. Instead of using color to achieve a greater naturalism, van Gogh used color subjectively to express emotion. ❖

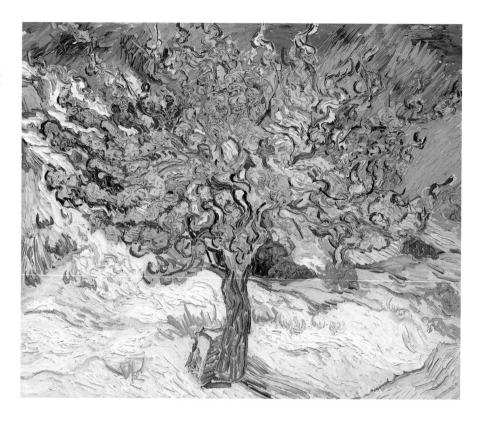

Vincent van Gogh

Dutch, 1853–1890
THE MULBERRY TREE, 1889
Oil on canvas
21¼ x 25⅝ in. (54.0 x 65.1 cm)
M.1976.9

In the spring of 1889 van Gogh committed himself to an asylum at Saint-Rémy in an effort to recover from his illness. During his lucid periods, between periodic attacks of what seems to have been epilepsy, he was constantly working, creating dazzling compositions of vigorous brushwork and energetic spontaneity. This painting was of particular interest to van Gogh, who wrote about it three times in letters to his brother and sister, commenting that he believed it was the best of his mulberry tree paintings. ❖

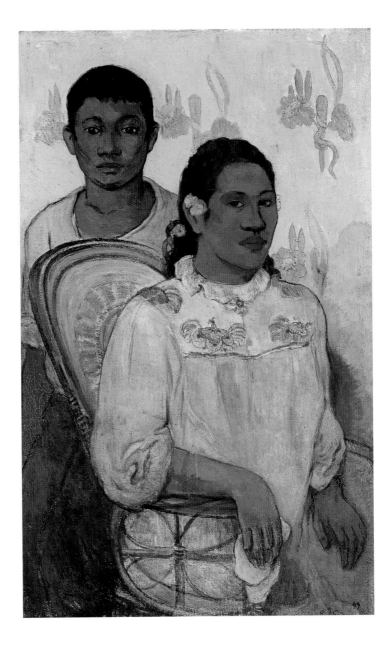

Paul Gauguin

French, 1848–1903
TAHITIAN WOMAN AND BOY,
1899
Oil on canvas
37¾ x 24⅜ in. (94.6 x 61.9 cm)
M.1976.8

In 1883, Gauguin resigned from his career as a stockbroker and abandoned his family to pursue a vocation as a painter. His fascination with the exotic and his distaste for the strictures of modern "civilization" led him to Tahiti in 1891. Other than a brief return to Paris in 1893, he remained in the South Seas until his death. In TAHITIAN WOMAN AND BOY, Gauguin's vision of the simplicity and beauty of primitive life is expressed in the broad descriptions of the faces and the flat application of lush, warm colors. The stillness of the composition and the formal arrangement of the figures, however, recall traditional portraiture. ❖

Edouard Vuillard

French, 1868–1940
THE FIRST FRUITS, 1899
Oil on canvas
96 x 170 in. (243.8 x 431.8 cm)
F.1973.33.1

Vuillard was a founding member of the Nabis (the Hebrew word for "prophets" or "Illuminati"), a group that included Paul Sérusier, Maurice Denis, and Pierre Bonnard. They favored a decorative style of painting, and freely altered form and colors to suit their expressive needs. Vuillard chronicled the intimate and everyday scenes of people and places he knew and loved. Although he is known for his interior scenes, with this monumental painting, Vuillard has moved out-of-doors. In THE FIRST FRUITS, the decorative pattern takes precedence over the objects represented and unifies the painted surface. The visual impression is

rich and tactile, recalling the art of tapestry. Plants and
figures form the many patterns and textures that merge
subtly from one to the other on the surface, and the deco-
rative borders further reinforce the tapestry analogy. The
myriad shades of earth tones and green are packed into
tight, flat patterns, and every form reveals itself solely through
color. FIRST FRUITS dates from the end of the most produc-
tive and important decade of Vuillard's career. It depicts a
view of Etang-la-Ville, and formed part of the decorative
scheme for the dining room of Adam Natanson, whose
family founded the avant-garde journal *Revue Blanche*. ❖

Henri Rousseau

French, 1844–1910
EXOTIC LANDSCAPE, 1910
Oil on canvas
51¼ x 64 in. (130.2 x 162.6 cm)
F.1971.3

Henri Rousseau was a customs inspector who did not begin to paint until after the age of forty. His fame rests on his magical landscapes with their vivid, lush vegetation, exotic flowers, and wild animals. He called these landscapes his "Mexican pictures," fostering the romantic myth that in his youth he had served in the army in Mexico. In fact, he received his inspiration from the Paris botanical garden and zoo. Although considered a "primitive," Rousseau was greatly admired by the young avant-garde painters, including Picasso and Braque. ❖

Henri Matisse

French, 1869–1954
ODALISQUE WITH TAMBOURINE
(HARMONY IN BLUE), 1926
Oil on canvas
36¼ x 25⅝ in. (92.1 x 65.1 cm)
M.1966.7

Matisse is widely considered to be one of the greatest colorists of his age. ODALISQUE WITH TAMBOURINE was painted in Nice, where Matisse was experimenting with light as an organizing principle for his compositions. The image of the odalisque (a concubine of a Near Eastern harem) has a rich history in French painting from the time of Ingres and Delacroix. It became the primary theme of Matisse's work during the 1920s. His single undulating dancer in motion forms a robust arabesque. The red patterns in the blue background seem to be swelling and contracting in rhythm with the silent music that moves her. ❖

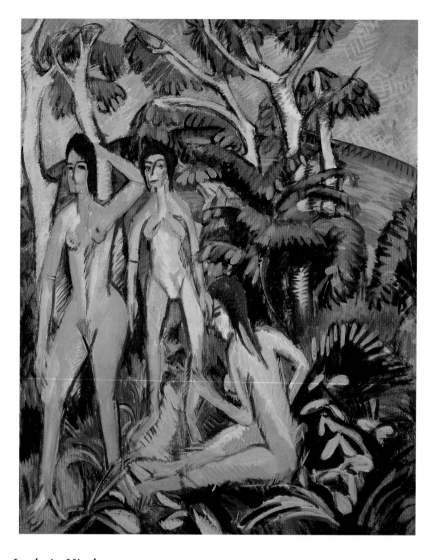

Ernst Ludwig Kirchner

German, 1880–1938
BATHERS BENEATH TREES, FEHMARN, 1913
Oil on canvas
59½ x 47½ in. (151.1 x 120.7 cm)
M.1994.1

Kirchner, one of the great leaders of German Expressionism, was a painter, graphic artist, sculptor, and photographer. He co-founded the artists' group Die Brücke (The Bridge), intended to be a bridge to a new international position for German art. In 1913 Kirchner was at the height of his powers. That summer he returned from Berlin to the little island of Fehmarn (between Germany and Denmark), which Kirchner said was replete with South Sea opulence. There he was able, in his words, to achieve a lasting union of Man with Nature. The nudes and the lush landscape are painted with jagged and angular brushstrokes suggestive of both tribal and gothic forms. Scale and perspective are distorted to heighten expressive force. Verticals and diagonals are set against, and emphasized by, the irrational curve of the horizon. Kirchner volunteered for service at the beginning of World War I, but suffered a nervous breakdown in 1915. After the war he returned to painting. In 1937 his art was declared degenerate by the Nazis; he committed suicide the following year. ❖

Amedeo Modigliani

Italian, 1884–1920
PORTRAIT OF THE ARTIST'S WIFE,
JEANNE HÉBUTERNE, 1918
Oil on canvas
39¾ x 25⅞ in. (101.0 x 65.7 cm)
M.1975.13.2

Modigliani is best known for his lyrical, attenuated figures and his solid construction of form, which give his works a particularly identifiable style and elegance. Enhanced by a manipulation of line, they are reminiscent of Botticelli's elegant figures, and also recall the elongated shapes of medieval art. The sitter is Jeanne Hébuterne, the young woman who shared the artist's life from 1918 until his death and her suicide in 1920. Modigliani's representation is all sinuous curves and ovals. Her pale, graceful hands are set off against the dark of her clothes, their gesturing curves breaking the hard edge of the straight vertical line behind her chair. The face is a pink oval with a prominent nose set between small eyes, characteristically without pupils. Their blue-grey color is echoed in the wall behind her and enhances their hollow, mask-like vacancy. ❖

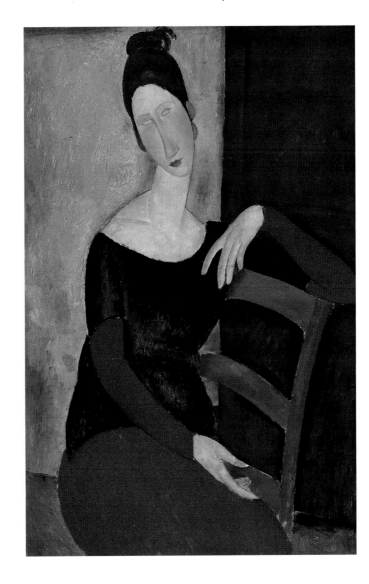

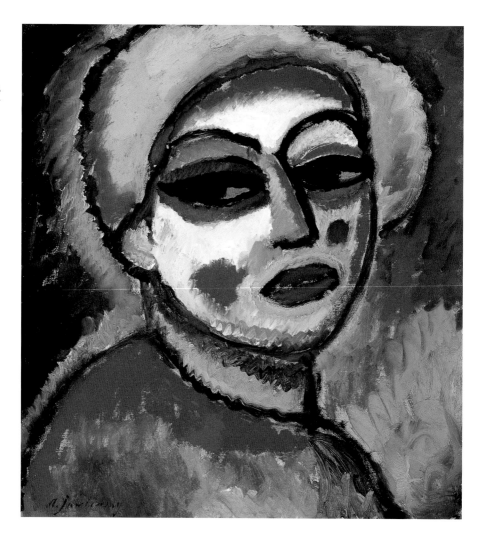

Alexei Jawlensky

Russian, 1864–1941
BLONDE, 1911
Oil on cardboard
21⅛ x 19⅜ in. (53.7 x 49.2 cm)
P.1953.566
The Blue Four Galka Scheyer
Collection

Jawlensky's heads from this period are enclosed in small, almost square formats. He often crowds or cuts off the tops of the heads, thereby making the faces even more pronounced and immediate. He reduces the illusion of three-dimensionality by applying broad patterns of decorative color to his backgrounds as well as to his figures. The luxurious colors, bold brushwork, and voluptuous expression of the subject all contribute to the sensuous richness of the composition. He has enclosed his palpable brushstrokes and powerful, glowing paint in broad outlines, further flattening the surface and emphasizing a bold, striking countenance. ❖

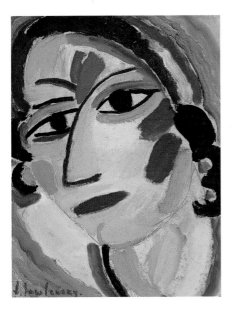

Alexei Jawlensky

Russian, 1864–1941
MYSTICAL HEAD: GALKA, 1917
Oil and pencil on cardboard
15½ x 12 in. (39.4 x 30.5 cm)
P.1968.1
The Blue Four Galka Scheyer Collection

The magnificent collection of Jawlensky paint-
ings came to the Norton Simon Museum
from the collection of Emmy (Galka) Scheyer,
a lifelong friend and promoter of the artist's
work. A 1915 visit to an exhibition of Jawlensky's
paintings prompted Scheyer to meet the artist;
in 1917 she spent several months with his
family in Switzerland, where she served as a
model for his new group of portraits. Jawlensky
frequently talked about the spiritual language
of painting. This head, with its tilted pose,
its prominent eyes, brow, and line of the nose,
as well as its richness of surface, is reminis-
cent of the religious imagery of the artist's
Russian youth. Scheyer returned to Germany
in 1919; it was during this period of separa-
tion that Jawlensky wrote to her of a dream
he had experienced in which she had appeared
to him in the form of a bird. From that time
on, Jawlensky referred to her as "Galka," the
Russian word for blackbird. ❖

Alexei Jawlensky

Russian, 1864–1941
VARIATION: OURS, 1918
Oil on textured wove paper
14⅜ x 10¾ in. (36.5 x 27.3 cm)
P.1953.140
The Blue Four Galka Scheyer Collection

Shortly after the outbreak of World War 1,
Jawlensky fled to Switzerland, settling in St.-
Prex on Lake Geneva. For a time he worked
on a series of landscapes in a smaller, vertical
format, inspired by the view from his window.
He called these works "Variations on a Land-
scape Theme," and "songs without words."
Jawlensky's VARIATIONS are colored, almost
abstract meditations upon a few unchanging
forms distilled from tree shapes. They clearly
foreshadow the icon-like quality of his later
work, with its eternal repetition of medita-
tive signs. Jawlensky's serial images have been
compared to those of Monet, who painted
compositions in various weather conditions
and times of day. Monet was interested in
the effects of light and nature, and essentially
painted what he saw. Jawlensky, on the other
hand, took his inspiration from nature but
did not limit himself to a description of visual
perception. ❖

Paul Klee

Swiss, 1879–1940
IDOL FOR HOUSE CATS, 1924
Watercolor, oil transfer
drawing, and lace collage on
chalk-primed muslin
mounted on thin cardboard
15⅜ x 19¾ in. (39.1 x 50.2 cm)
P.1953.57
The Blue Four Galka Scheyer
Collection

Klee had a great fondness for cats. He had many cats for pets, and made them subjects in his pictures. Klee's wit is evident in both the subject and the technique. The idol is an image of totemic feline detachment. Its full face with large staring eyes is a perfect sacred icon of the pampered house cat. Yet this aloofness is mitigated by a decorative black lace mantilla and the cats pursed, prim, heart-shaped mouth. While one can trace influences and associations, Klee's work is not identifiable with any school. His singular style of abstraction and ornamentation, whimsy and melancholy, was influenced by his music, his travels, his self-education as an artist, and his own unique sense of humor. ❖

Paul Klee

Swiss, 1879–1940
THE TREE OF HOUSES, 1918
Watercolor, gouache, and
India ink on chalk-primed
gauze on wove papers,
mounted on cardboard
9⅝ x 7⅞ in. (24.4 x 20.0 cm)
P.1953.25
The Blue Four Galka Scheyer
Collection

Drafted into the German Army in 1916 at the age of thirty-seven, Klee was transferred to the air force reserves. He was later assigned a desk job at a flight training school, which enabled him to paint in his spare time. His son recalled that Klee's penchant for incorporating unusual materials in his work extended to painting on aircraft canvas that he had salvaged. TREE OF HOUSES typifies Klee's experiments with a variety of materials and techniques. Here he has painted over strips of gauze and paper, creating a rich, tactile surface. A fanciful apartment complex emerges out of a forest, its various levels connected by ladders. Blue and red stars decorate the sky; a large but delicate bird hovers in the upper left. Below, a solitary figure begins his ascent. ❖

Paul Klee

Swiss, 1879–1940
REFUGE, 1930
Oil and watercolor on plaster
grounded gauze mounted on
cardboard
21½ x 13¾ in. (54.6 x 34.9 cm)
P.1953.65
The Blue Four Galka Scheyer
Collection

Although known for its wit and buoyancy, Klee's work shows
a wide and complex range of emotions. Here a "figure,"
consisting of a head with an arm and a leg, is frozen in
space, swimming through an opaque, heavy atmosphere.
An amorphous black shape is floating on the left; is this the
reason for the figure's terrified expression? Overhead hovers
a form that may be a mountain or a tent, either the sought
haven that is the refuge or the threat from which the figure
flees. In contrast to the scene's ominous overtones, the domi-
nant colors are soft pinks, mauves, and gray-blues; the prin-
cipal components are defined with a delicate brush-stroked
hatching in brown watercolor, which belies the terrified (or
terrifying) expression of the main figure. ❖

Paul Klee

Swiss, 1879–1940
POSSIBILITIES AT SEA, 1932
Encaustic and sand on canvas
38¼ x 37⅝ in. (97.2 x 95.6 cm)
P.1953.67
The Blue Four Galka Scheyer
Collection

Klee transformed spatial elements into dynamic movement freed from gravity. Here he uses the stylistic device of a ruled construction he called "kinetic variations" to represent a red and white sailboat that floats on the waving water between the sun and the moon. Klee frequently used arrows to facilitate the reading of a composition. He explained that his symbolic arrows were the expressive movements of thought, associated with the essential aspect of the human spirit. Here they act as both formal markers emphasizing and balancing certain parts of the composition, and as forces of nature (wind and gravity) at work on the boat. As the title suggests, this dynamism is only possible on the water. ❖

Pablo Picasso

Spanish, 1881–1973
WOMAN WITH A GUITAR, 1913
Oil on canvas
39⅜ x 32⅛ in. (100.0 x 81.6 cm)
P.1953.073
The Blue Four Galka Scheyer
Collection

Cubism became the most influential style of art during the first half of the twentieth century. Pablo Picasso and Georges Braque developed this new style as an exploration of the visual properties of form. They began to represent space as tangible, as something of substance. The resulting technique was to superimpose multiple viewpoints on the canvas, depicting people and objects from several angles within the same painting. Picasso has reduced this composition to flattened planes and a somber color scheme, emphasizing the two-dimensionality of the canvas. ❖

Juan Gris

Spanish, 1887–1927
STILL LIFE WITH A POEM, 1915
Oil on canvas
31¾ x 25½ in. (80.6 x 64.8 cm)
M.1968.8.1

In 1906 Gris moved to Paris and entered the circle of Picasso and Braque, who taught him the principles of Cubism. He particularly excelled in bold color and in the technique of collage. The Cubists sought to reduce objects to their simplest forms, yet always retained an element of representation in their pictorial space. Here, the composition is a masterfully painted illusion of the textures of wood and cloth. Gris was a close friend of contemporary poets, and translated symbolist poems. At the bottom of this painting, he has copied a poem by Pierre Reverdy. ❖

Liubov Popova

Russian, 1889–1924
THE TRAVELER, 1915
Oil on canvas
56 x 41½ in. (142.2 x 105.4 cm)
M.1967.11

In the early twentieth century, for the first time in history, avant-garde women artists such as Liubov Popova became influential artistic forces. Coming from an educated and wealthy family, she studied Cubism and non-objective art in Paris between 1912 and 1914. THE TRAVELER was painted in 1915, when Popova was already deeply committed to a style of non-objective art. However, we still can discern recognizable forms linking the painting to the objective world—a woman wearing a yellow necklace and carrying a bright green umbrella travels down a street. Glimpses of a railing, green grass, and a flag suggest the scenery around her. The stenciled letters, an inheritance from the Cubist paintings of Braque and Picasso, are traditionally two-dimensional and help to emphasize the flatness of the picture plane. ❖

Georges Braque

French, 1882–1963
ARTIST AND MODEL, 1939
Oil and sand on canvas
51⅛ x 70⅞ in.
(129.9 x 180.0 cm)
M.1976.5

In the 1930s, Braque began a series of extensive interior views occasionally inhabited by figures. Here a mixture of sand and paint roughens the surface, lending it a dense, tactile quality. The skillful organization of patterns, colors, and textures achieves the effect of tapestry. Braque has retained such Cubist devices as overlapping planes, superimposed forms, and geometrical abstractions. His treatment of light and space is, however, almost naturalistic. The calligraphic patterns of the wallpaper are echoed in the delineation on the model's abdomen as well as in the rounded contours of the easel. ❖

Georges Braque

French, 1882–1963
STILL LIFE WITH MUSICAL
INSTRUMENTS, 1918
Oil on canvas
25½ x 36¼ in. (64.8 x 92.1 cm)
M.1986.2

After his return from military service in 1917, Braque devised his own freer, more decorative application of the Cubist idiom. The red polka dots, playful wood graining, and musical notes scratched into the surface move Braque from the intellectual vision of his earlier paintings to a more tactile, sensuous experience. Appropriately, this delightful composition was formerly in the collection of dancer and choreographer Léonide Massine. ❖

Lyonel Feininger

American, 1871–1956
THE TUG, 1937
Oil and pencil on canvas
16 x 19 in. (40.6 x 48.3 cm)
P.1992.2.1
Gift of Mrs. Matilda H.
Rummage

The sails of the large ship, the building on the shore, and even the smoke from the tugboat's smokestack are all flattened into geometric patterns of color. Powerful diagonals lend a sense of dynamism. The most striking example is the tugboat's smoke, which draws the eye along until it intersects with another line created by the many-sailed ship that it tows.

Feininger did not paint directly from life. Instead, he made sketches while studying a scene, in this case on the Baltic Sea. Later in his studio, he utilized these sketches as well as his memory to construct a composition that pleased him. He painted THE TUG in 1934; three years later, when adding a few finishing touches, he signed and dated it 1937. ❖

Lyonel Feininger

American, 1871–1956
NEAR THE PALACE, 1915
Oil on canvas
39⅝ x 31½ in. (100.6 x 80.0 cm)
M.2000.1.1

In this painting, Feininger's use of color reminds one of a Gothic stained glass window. The semi-translucent shades appear as though seen through water. The composition remains rigorously ordered, structured through the use of space and the overlay of angular, atmospheric shapes and planes that became the hallmark of his style. In 1919 Feininger wrote about this painting: "The absolutely straight right angle form of all objects in the picture and the elimination of the natural perspective, as well as the unworldly color are a strict consequence of my emotional state at the time because of the war. NEAR THE PALACE is the *first* of a series of pictures in similar

composition and form. The form speaks of escape in a world of abstract peace. This picture could almost be called happy since later pictures have even more expression of my melancholy." ❖

Kurt Schwitters

German, 1887–1948
MERZ 289. ERFURT, 1921
Collage with pasted paper, cloth, watercolor, and pencil on heavy wove paper
8½ x 6⅝ in. (21.6 x 16.8 cm)
P.1953.314
The Blue Four Galka Scheyer Collection

Schwitters founded the Dadaist movement in Hanover in 1923. He called the movement Merz (something cast-off, like junk). About the process of making art, Schwitters wrote: "Because the medium is unimportant, I take any material whatsoever if the picture demands it...I call the world view from which this mode of artistic creation arose Merz....The meaning of the concept Merz alters with the change in the insight of those who continue to work with it." ❖

Lázló Moholy-Nagy

American, born in Hungary, 1895–1946
AL 3, 1926
Oil, industrial paints, and pencil on aluminum
15¾ x 15¾ in. (40.0 x 40.0 cm)
P.1953.293
The Blue Four Galka Scheyer Collection

Moholy-Nagy was head of the Metal Workshop at the Bauhaus when he met Galka Scheyer, and in August 1928 he gave this painting to her. The larger circle had been blue originally, but Moholy-Nagy was experimenting at that time with a spraying apparatus, and some of his paints eventually faded. Scheyer returned the painting to him in 1938, requesting that he repaint the blue color. "I must confess," he wrote to her, "that I like the picture much better as it is now....the results seem to me not unsatisfactory and I would be happy if you would agree with me." ❖

Vasily Kandinsky

Russian, 1866–1944
HEAVY CIRCLES, 1927
Oil on canvas
22½ x 20½ in. (57.2 x 52.1 cm)
P.1953.216
The Blue Four Galka Scheyer
Collection

Kandinsky explained in 1930 what the circle meant to him: "Why does the circle fascinate me? It is: 1. the most modest form, but asserts itself unconditionally, 2. a precise, but inexhaustible variable, 3. simultaneously stable and unstable, 4. simultaneously loud and soft, 5. a single tension that carries countless tensions within it. The circle is the synthesis of the greatest oppositions. It combines the concentric and the eccentric in a single form, and in equilibrium. Of the three primary forms [triangle, circle, square], it points most clearly to the fourth dimension." ❖

Vasily Kandinsky

Russian, 1866–1944
OPEN GREEN, 1923
Oil on canvas
38¼ x 38¼ in. (97.2 x 97.2 cm)
F.1971.4

A prolific artist, writer, and theoretician, Vasily Kandinsky did not apply his full energies to art until he was thirty years old. At the Bauhaus in the 1920s, Kandinsky was director of the mural painting workshop and later taught analytical drawing. His painting style in this period is characterized by an architectural sensitivity, as his characteristically precise forms and emerging geometric style developed in a context that welcomed his artistic and theoretical activities. Kandinsky taught form and color theory, and wrote about the character of color, saying that "absolute green is the most peaceful color there is: it does not move in any direction, has no overtones of joy or sorrow or passion, demands nothing, calls out to no one." ❖

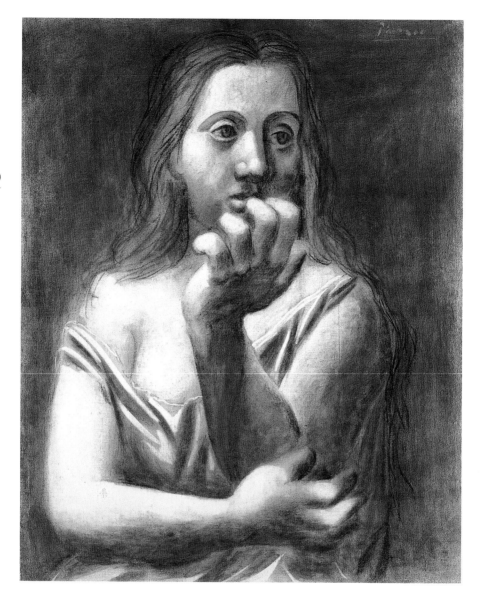

Pablo Picasso

Spanish, 1881–1973
BUST OF A WOMAN, 1923
Oil and black chalk on canvas
39¼ x 32 in. (99.7 x 81.3 cm)
M.1970.5.16

By the early 1920s Picasso had looked back to classical antiquity for new inspiration. He painted a number of single women, dressed in simple, quasi-antique dress, who achieve the power and dignity of classical heroines. Lost in thought, this massive, statuesque young woman seems to have been carved from marble. The signature in the upper right is the only dab of color. Picasso's BUST OF A WOMAN displays a profound psychological complexity. The monochromatic palette, and even the figure's faraway gaze, suggest serenity. Yet her larger-than-life arms and splayed hands, pushed into the foreground in an uneasy and bulky pinwheel, emphasize an underlying anxiety. ❖

Pablo Picasso

Spanish, 1881–1973
WOMAN WITH A BOOK, 1932
Oil on canvas
51⅜ x 38½ in. (130.5 x 97.8 cm)
F.1969.38.10

In early 1932, Picasso painted a number of large canvases of women, brightly colored and elaborately drawn in heavy dark lines that flow into great sweeping curves. His model for these paintings was his mistress, Marie-Thérèse Walter, who in this picture rests in a comfortable armchair and pauses from her reading. As the book falls from her hand, her fingers echo its pages like an opening fan. She is dressed in a blue kimono, with black lace undergarments. The rainbow hues are locked in a web of black lines that create a strong curved rhythm throughout the painting. ❖

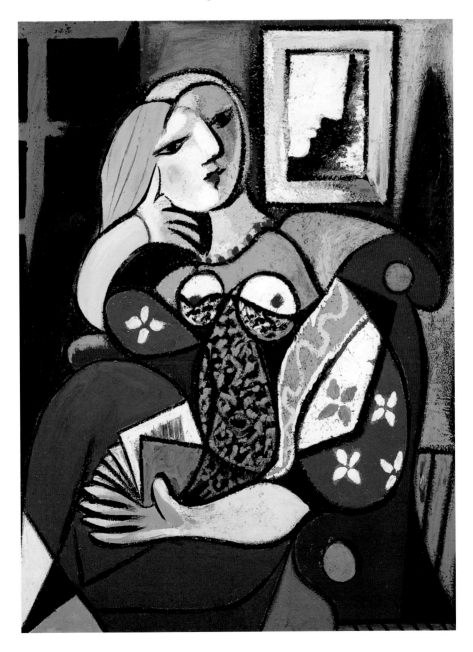

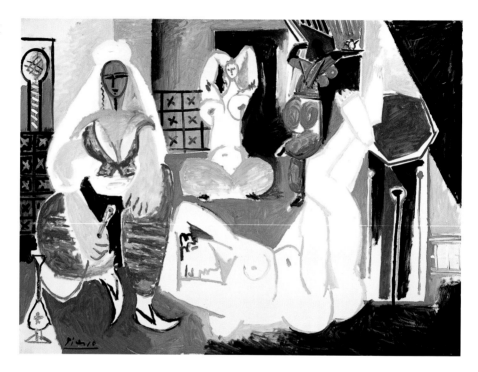

Pablo Picasso

Spanish, 1881–1973
WOMEN OF ALGIERS I, 1955
Oil on canvas
38⅛ x 51⅛ in. (96.8 x 129.9 cm)
M.1986.3

The 1950s saw Picasso at work on a monumental group of paintings, each one a variation of Delacroix' WOMEN OF ALGIERS. While painting this series, Picasso said to his dealer Kahnweiler, "I wonder what Delacroix would say if he saw these paintings." Assured that he would probably understand, Picasso continued, "Yes, I think so. I'll tell him: 'You thought of Rubens and you made Delacroix. And I, thinking of you, I'm making something else.'" ❖

Diego Rivera

Mexican, 1886–1957
THE FLOWER VENDOR, 1941
Oil on canvas
48 x 48 in. (122 x 122 cm)
P.1980.2.3
Gift of Mr. Cary Grant

Rivera entered art school at a very young age and moved to
Europe in 1907. There he was deeply affected by the great
Italian muralists and contemporary French painters. Returning
home in 1921, he became a painter of murals, and over the
next several years the direction of Mexican art changed dramat-
ically under his leadership. During the 1930s, Rivera painted
a number of large murals in the United States and had a major
influence on American art, as the federal government began
to fund the painting of large murals in public buildings. The
theme of a flower vendor, dwarfed by a massive display of
flowers, was one that Rivera painted many times. ❖

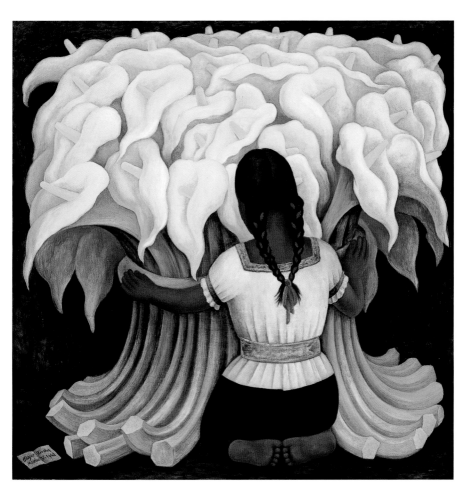

Richard Diebenkorn

American, 1922–1993
BERKELEY #24, 1954
Oil on canvas
68¾ x 57 in. (98.4 x 144.8 cm)
P.1967.26
Gift of Mr. and Mrs. Robert A. Rowan

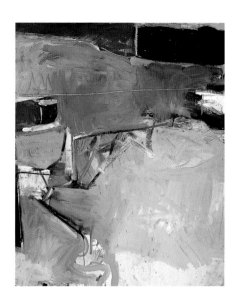

American painter and printmaker Richard Diebenkorn is recognized for his powerful abstract and figurative compositions. BERKELEY #24 is part of the artist's noted series of about sixty abstract expressionist paintings he created from 1953 to 1955 while he was living in Berkeley, California. Diebenkorn looked to his environment for inspiration for this series, and created works that are both referential and abstract. In each of the "Berkeley" paintings, the light and landscape of the Bay Area are reflected through organic forms and rich colors. ❖

Sam Francis

American, 1923–1994
BASEL MURAL I, 1956–58
Oil on canvas
151¾ x 237⅜ in. (385.5 x 602.9 cm)
P.1967.24
Gift of the Artist

BASEL MURAL I was the left panel of a monumental triptych commissioned for the staircase of the Kunsthalle in Basel, Switzerland. Francis combined his interests in light, distance, nonlinear time, and abstraction to create a series of murals that were weightless in their lyrical, organic forms. BASEL MURAL I gives the viewer a sense of upward movement as it also pulls the eye back towards the edges. The mural remains infused and invigorated by a unique synthesis of weightlessness and ambient light. ❖

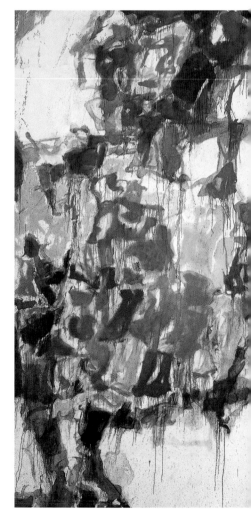

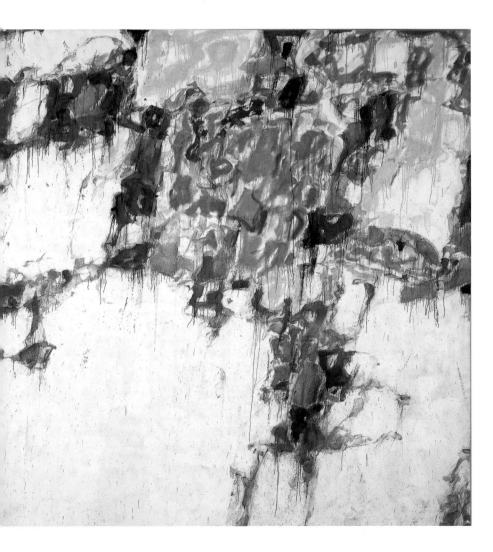

Wallace Berman

American, 1926–1976
UNTITLED, 1967
Verifax collage
48 x 45½ in. (121.9 x 115.6 cm)
P.1967.11
Gift of Mr. & Mrs.
Thomas Terbell, Jr.,
Mr. & Mrs. Allen O. Smith,
David H. Steinmetz III,
Margaret T. Cunningham,
and Mr. & Mrs. John S.
Ferrier

Berman is widely considered to be the father of the assemblage movement, which emerged in California during the late 1950s. Closely tied to the Beat culture, assemblage artists used found and discarded objects to create works of art. Berman is best known for his verifax collages, in which he used a predecessor of the copy machine to reproduce images from newspapers and magazines before placing them onto board. This sepia-toned collage is a carefully articulated grid that shows the image of a handheld transistor radio repeated in cinematic fashion. In the center of each of the radios are ghostly images and symbols including animals, Hebrew letters, and identifiable personalities from popular culture. ❖

Edward Ruscha

American, b. 1937
Annie, Poured from Maple
Syrup, 1966
Oil on canvas
55 x 59 in. (139.7 x 149.9 cm)
P.1966.06
Gift of the Men's Committee

Ruscha's mixture of high and low art stems from his early career in the commercial world of advertising. Born in Omaha, Nebraska, Ruscha moved to Los Angeles in 1956, where he began studying at the Chouinard Institute. Annie, Poured from Maple Syrup plays with both the popularity of the cartoon character Little Orphan Annie and the possibility of mischievously writing her name in maple syrup. Fascinated by words and their meanings, Ruscha uses text itself as subject matter. A visual record of the 1960s American preoccupation with advertising and the media, Annie captures a time gone by, tinged with a sense of humor. Round type, accompanied by small bursting bubbles bordering the edges, wades against the hypnotic yellow background, rendering the pictorial image syrupy and almost edible. ❖

Roy Lichtenstein

American, 1923–1997
BIG MODERN PAINTING, 1967
Oil and magna on canvas,
three panels
120 x 360 in. (304.8 x 914.4 cm)
P.1967.22A–C
Gift of the Artist and
Mr. Leo Castelli

At the height of the Abstract Expressionist movement, Roy Lichtenstein countered it with comic strips, romance novels, household ads, supermarkets, and plastic flowers as the basis for his imagery. Utilizing the benday dot technique as his principal formula, he created the shadow effect often observed in newspapers, displaying an irreverence for contemporary values while parodying commercial signs and symbols. BIG MODERN PAINTING is an example from the artist's "Modern" series, begun in 1966. This body of work takes a nostalgic look back at Art Deco, a distinct artistic style popular in America and Europe during the 1920s and 1930s. The "Modern" works contain the most significant and recurring design elements characteristic of this period, including circles, semicircles, squares, and triangles. ❖

Ellsworth Kelly

American, b. 1923
RED ORANGE WHITE GREEN BLUE, 1968
Oil on canvas, 5 panels
120 x 120⅜ in. (304.8 x 305.7 cm)
P.1968.14a–e
Museum Purchase, Fellows Acquisition Fund

Kelly has always been fascinated with color and the visual
relationships that exist between colors. RED ORANGE WHITE
GREEN BLUE was created during the height of Kelly's explo-
ration into the color spectrum, a theme that he revisited for
nearly two decades, spanning from 1953 to 1972. His exhaus-
tive twenty-year investigation resulted in a body of work
composed of multi-paneled monochrome paintings of
various sizes and colors. Each work, with its solid bands of
color juxtaposed next to others, evokes a different mood. ❖

Frank Stella

American, b. 1936
Hiraqla Variation iii, 1969
Fluorescent acrylic on oval canvas
120 x 240 in. (304.8 x 609.6 cm)
P.1969.127
Gift of the Artist

Frank Stella's work of the 1960s focused on the arrangement
of flat color stripes repeated in geometric patterns to create
an all-over, non-illusionistic surface. As part of his unfin-
ished "Protractor Series," begun in 1967, Hiraqla Varia-
tion iii was conceived as one of thirty-one curvilinear canvas
formats in three different designs. Ranging from interlaces,
rainbows, and fans, the paintings were inspired by ancient
circular planned cities. In this example, the viewer sees the
artist's trademarks of control and rationality often found
in 1960s Minimalism. Shapes are defined by horizontal and
vertical lines that intersect while forming two outer fan
patterns and a kaleidoscope center. ❖

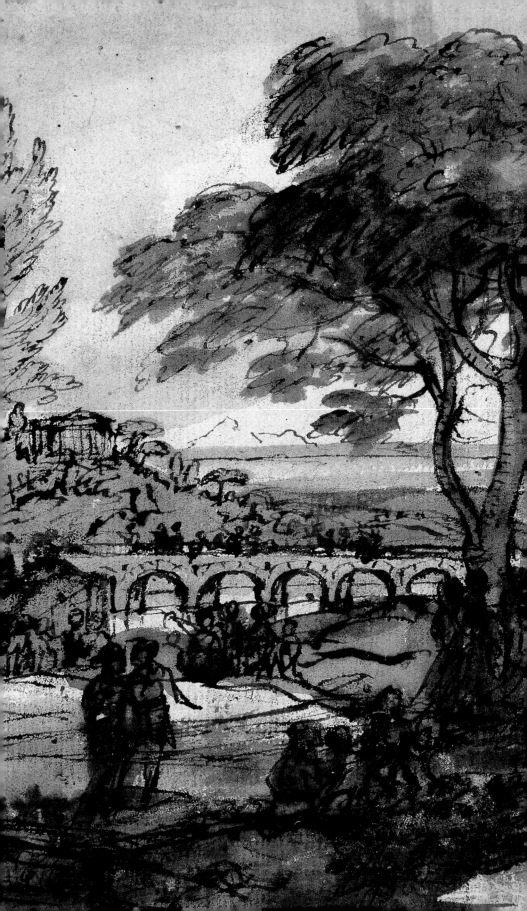

PRINTS

and

DRAWINGS

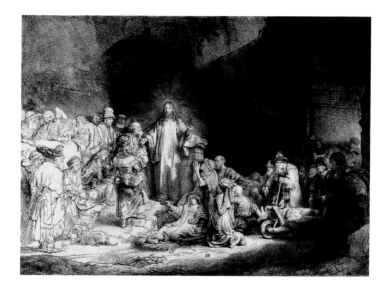

Rembrandt van Rijn

Dutch, 1606–1669
THE HUNDRED GUILDER PRINT,
c. 1649
Etching and drypoint on ivory-colored Japanese paper, State II
11⅛ x 15½ in. (28.3 x 39.4 cm)
M.1985.3

THE HUNDRED GUILDER PRINT depicts Christ surrounded by the sick and receiving the children. Its popular title derives from a story that the print fetched 100 guilders at an auction. The subject is not a single Biblical text but rather an extended account of Christ's ministry. This magnificent print is a study in the contrasts of light and shadow, and of active and passive participants. The harmonious outcome is unified by luminous tonal passages that are further resolved into light and dark halves, with Christ as the anchor both visually and metaphorically. ❖

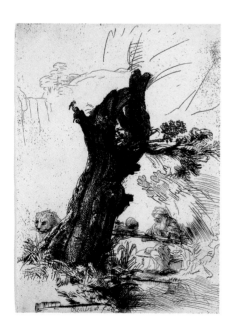

Rembrandt van Rijn

Dutch, 1606–1669
ST. JEROME BESIDE A POLLARD WILLOW, 1648
Etching, drypoint, State II
7³⁄₁₆ x 5 ⁵⁄₁₆ in. (18.3 x 13.5 cm)
M.1977.32.077

This work has the fresh and immediate quality of a pen sketch. Only the tree, which suggests direct study from nature, has been conceived in etching. The saint, lion, and other details were completed in drypoint. With deft, rapid strokes of the drypoint needle, he indicated the bank of the stream beside the saint as well as the reeds and grasses growing along its opposite bank. In the distance, rising peaks sketched with great economy provide a sense of enclosure for the composition. ❖

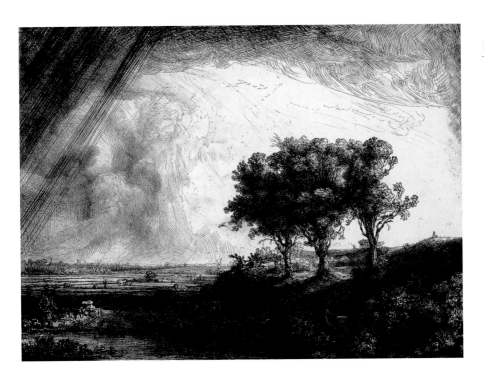

Rembrandt van Rijn

Dutch, 1606–1669
THE THREE TREES, 1643
Etching, drypoint, burin, Only state
8⅛ x 11 in. (20.6 x 27.9 cm)
M.1977.32.062

Rembrandt's largest landscape etching, THE THREE TREES
is a wide vista of Dutch scenery, depicted in dramatic
contrasts of light, sun, clouds, and rain. There is a wealth
of natural and human details—the cart full of peasants on
the skyline, an artist sitting sketching on a hillock, lovers
hidden in the foliage in the right-hand corner, and a fish-
erman and his wife on the far side of the pond. ❖

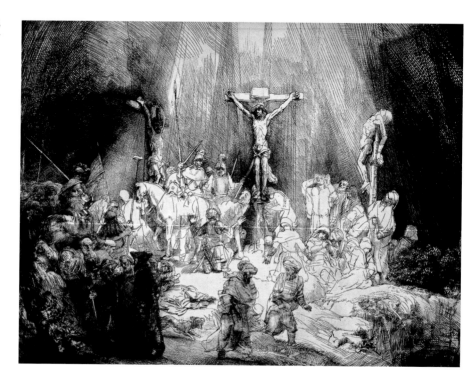

Rembrandt van Rijn

Dutch, 1606–1669
CHRIST CRUCIFIED BETWEEN
THE TWO THIEVES:
"THE THREE CROSSES," 1653
Drypoint, burin, State III
13⅛ x 17¼ in. (33.3 x 43.8 cm)
M.1979.26

In depicting the moment of Christ's death, Rembrandt has taken as his source the Gospel of St. Luke: "When the centurion saw what had taken place, he gave praise to God and said, 'This was a great and good man.'" [Luke 23:47] To the left of the cross, mounted Roman soldiers watch impassively as the centurion recognizes the divinity of Christ and falls to his knees in adoration. Various onlookers react to the drama of the harrowing event. A dramatic light illuminates the crucified Christ, keeping the somber blackness at bay. The good thief, on the cross to the right, is bathed in heavenly light; the bad thief is veiled in the gloom. Rembrandt's powerfully evocative use of light and dark makes this one of his most expressive religious images. ❖

Rembrandt van Rijn

Dutch, 1606–1669
JAN LUTMA, THE ELDER, GOLDSMITH AND
SCULPTOR, 1656
Etching, State I
7⅝ x 5⅝ in. (19.4 x 14.3 cm)
P.1961.36
Museum Purchase with funds donated by
Mrs. Edward C. Crossett

Jan Lutma was a highly regarded goldsmith
and jeweler, and shared Rembrandt's passion
as an art collector. Rembrandt depicts him
seated, in a pensive mood, and holding one
of his works. On the table to his left lie the
instruments of his profession—a chasing
hammer, punches, and a small silver dish.
Dense passages of etching and drypoint,
chiefly in the clothing, chair, and table, contrast
with the highlights that pick out his features
and call attention to the hand holding his
work. By leaving a thin film of ink over the
plate in the first state, Rembrandt imparts a
softer, tonal effect to the whole. ❖

Rembrandt van Rijn

Dutch, 1606–1669
WOMAN WITH THE ARROW (CLEOPATRA), 1661
Etching, drypoint, burin; State II
8¹⁄₁₆ x 5¹³⁄₁₆ in. (20.5 x 14.8 cm)
M.1977.32.115

Characteristic of his later prints, Rembrandt
employed three working methods to achieve
his desired results. After laying out the basic
composition in etching, he used drypoint to
emphasize the contour lines and articulate
the folds of the woman's chemise. He also
created varied tonal effects by leaving a thin
film of ink on the surface of the copper plate
prior to printing. Those surface tones are
most evident on her knee and in the left
portion of the print. The rich tonal exchange
of the background contrasts with the high-
lights directed to the right side of her body.
The combination acknowledges the sculp-
tural form of the nude but does not detract
from the gentle merging of her left side into
the shadows. ❖

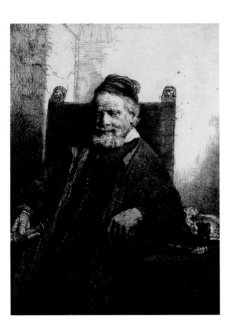

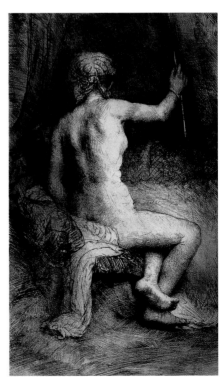

Diirper intxoet yux florum.
dr adé a ge wpe
199 ofe7 995 ft

Root en geel van Leyden,
wo ge

Admerael Der Admirael, de gulde,
dr adé a ge wpe
12 afg—f 120 —
127 afg—f 1330 —
229 afg—f 1300 —

Latmis

158

Anonymous

Dutch, 17th century

THE GREAT TULIP BOOK
Opaque watercolor on paper
12⅛ x 7⅞in. (30.8 x 20.0 cm)
M.1974.08.1–158
Opposite, clockwise from top left:
PÙRPER INT WIT VAN JEROEN,
ROOT IN GEEL VAN LEYDEN,
LATOUR, ADMIRAEL DER
ADMIRAELS DE GOUDA
Below: KAMELOT VAN WENA

A mercantile passion for tulips, known as "Tulipomania," arose in Holland in the early seventeenth century. Native to Turkey, the tulip was introduced into Europe in 1554 and quickly became popular in Holland. The insatiable demand for the beautiful, rare bulbs reached its height in 1636, when prices soared and flower merchants enjoyed great wealth. This album of watercolors was used by a wealthy Dutch merchant and grower to show his clients the various varieties of tulip bulbs available for purchase. Inscriptions on the watercolors record the name of each variety, often the grower himself or a wealthy client, as well as the weight and price of each bulb. ❖

Claude Gellée, called
Claude Lorrain

French, 1600–1682
HILLY COUNTRYSIDE, c. 1640
Pen and shades of brown
wash on paper
8⁹/₁₆ x 12⁷/₁₆ in. (21.7 x 31.6 cm)
M.1970.7.11

Claude Gellée, called
Claude Lorrain

French, 1600–1682
ESTHER ON HER WAY TO
AHASUERUS, 1657–59
Black chalk, pen, brown wash,
and white heightening on paper
7½ x 10³/₁₆ in. (19.1 x 25.9 cm)
M.1970.7.41

Claude was one of the great masters of the ideal landscape. He developed a style that was not as heroic or classical as Poussin's, but capable of expressing both a more poetic mood and a livelier sense of the variety and beauty of nature. In his drawings as well as his paintings, Claude achieved unparalleled subtlety in his treatment of atmosphere and light. The light usually emanates from the area of the sky just above the horizon so that we seem to look directly into it; spreading forward and outward through the composition, it permeates the whole landscape with its radiance and links foreground and background in a continuous spatial unity. The result is the idyllic, pastoral mood that so aptly characterizes Claude's landscapes. ❖

Claude Gellée, called
Claude Lorrain

French, 1600–1682
CLASSICAL LANDSCAPE, 1640–45
Graphite, brown wash, and white
heightening on brown paper
8⅛ x 11½ in. (20.6 x 29.2 cm)
M.1970.7.22

Claude Gellée, called
Claude Lorrain

French, 1600–1682
STUDY FOR AENEAS AND THE
CUMEAN SIBYL, 1669
Black chalk, pen, and brown
wash on paper
7⅝ x 9⅝ in. (19.4 x 24.4 cm)
M.1970.7.56

Jean-Honoré Fragonard

French, 1732–1806
DRAWINGS AFTER THE
ITALIAN MASTERS, 1760–61
Black chalk on paper

After five years of study in Rome, the young Fragonard began an extensive journey throughout Italy with Jean-Claude Richard, the Abbé de Saint-Non. The abbott commissioned the artist to make copies of the masters in each city they visited, and gained access to the masterpieces in churches and in important collections. The twenty-eight-year-old artist made more than 200 drawings for his patron during their travels, and Saint-Non later engraved and published many of them. The largest single group of drawings recording this Italian journey, 139 of them, are in the Norton Simon Foundation collection. The drawings form a virtual inventory of the treasures in churches, museums, and private collections of the day. While one can recognize the work of the masters in the student's copies, Fragonard continually reveals his own style and personality. ❖

STUDY AFTER
GIOVANNI BATTISTA TIEPOLO:
THE MEETING OF ANTHONY
AND CLEOPATRA FROM
THE VECCHIA COLLECTION,
VICENZA
17¾ x 13 in. (45.1 x 33.0 cm)
F.1970.03.083

STUDY AFTER IL CORREGIO:
MADONNA AND CHILD WITH
SAINTS JEROME AND MARY
MAGDALENE FROM THE
ACCADEMIA DE BELLE ARTI,
PARMA
17¾ x 13 in. (45.1 x 33.0 cm)
F.1970.03.060

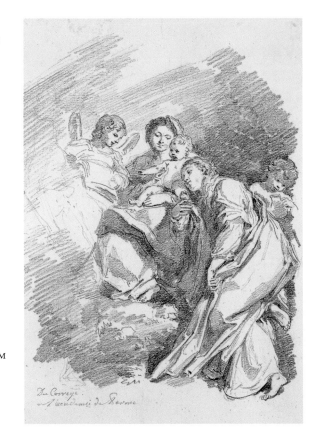

STUDY AFTER
GUIDO CAGNACCI:
TARQUIN AND LUCRETIA FROM
THE PALAZZO ZAMBECCARI,
BOLOGNA
13 x 17¾ in. (33.0 x 45.1 cm)
F.1970.03.053

Francisco de Goya y Lucientes

Spanish, 1746–1828
She Is Timid About Taking
Her Clothes Off, 1796–97
India ink wash on paper, with
sepia ink pen inscription on
recto
9⅛ x 5⅝ in. (23.2 x 14.3 cm)
M.1974.04.2A

Part of a larger, now dispersed, sketchbook called the MADRID ALBUM, these drawings reveal a period of thematic and stylistic transition in Goya's work. The first section of the album examines the popular eighteenth-century subjects of courtship and amorous love. An abrupt shift occurs halfway through the sketchbook, however, as satiric social commentary begins to penetrate Goya's drawings. The style of these later sketches reveals the influence of English caricature, with its exaggerated forms and irreverent depictions. In like manner, Goya executed drawings ridiculing the foibles of Spanish society and criticizing religious traditions. Goya took up these same themes in the Caprichos series, for which he received international attention. ❖

Francisco de Goya y Lucientes

Spanish, 1746–1828
MASQUERADES OF HOLY WEEK
IN THE YEAR '94, 1796–97
India ink wash on paper
9⅛ x 5⅝ in. (23.2 x 14.3 cm)
M.1974.04.2B

Francisco de Goya y Lucientes

Spanish, 1746–1828
Los Caprichos, 1799

Plate 16: For Heaven's Sake: and It
Was Her Mother
Etching, aquatint, and drypoint, First Edition
8 x 6 in. (20.3 x 15.2 cm)
M.1978.2.1.16

Los Caprichos was Goya's first important
series of prints. These satirical caricatures
boldly attack the attitudes, morals, and behav-
iors of the church, the Inquisition, the govern-
ment, and the royal family, though Goya
himself referred to them as merely "a collec-
tion of whimsical subjects." The series sold
poorly and Goya was forced to remove them
from the market after only two days. Ironi-
cally, the plates and remaining prints were
given to the king in 1803 in exchange for a
pension for Goya's son. ❖

Plate 43: The Sleep of Reason
Produces Monsters
Etching and aquatint, First Edition
8 x 6 in. (20.3 x 15.2 cm)
M.1978.2.1.43

Originally intended as the frontispiece for
Goya's famous series of etchings, Los Capri-
chos, this image is celebrated as one of the
most important visual statements of the Age
of Enlightenment, or Age of Reason. In this
print, Goya appears as the artist asleep in his
chair. Owls, bats, and lynxes swarm around
him, suggesting the irrational world of dreams.
Goya explained: "When abandoned by Reason,
Imagination produces impossible monsters:
united with her, she is the mother of the arts
and the origin of their wonders." Goya viewed
Spain as a country divorced from reason, and
he inhabited Los Caprichos with the monstrous
creatures that result from such an action. ❖

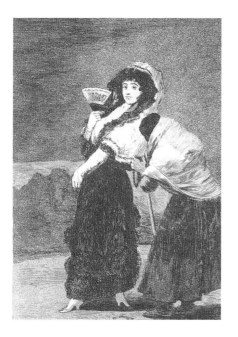

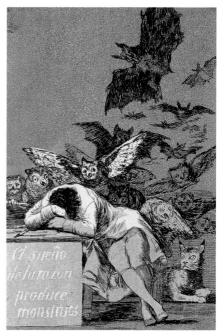

Francisco de Goya
y Lucientes

Spanish, 1746–1828
LA TAUROMAQUIA, 1816

PLATE 12: THE RABBLE
HAMSTRING THE BULL WITH
LANCES, SICKLES, BANDER-
ILLAS AND OTHER ARMS
Etching, burnished aquatint,
and drypoint, First Edition
17½ x 12½ in. (44.5 x 31.8 cm)
M.1974.II.I.12

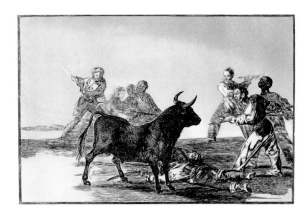

PLATE 20: THE AGILITY AND
AUDACITY OF JUANITO
APIÑANI IN THE RING AT
MADRID
Etching and aquatint,
First Edition
17½ x 12½ in. (44.5 x 31.8 cm)
M.1974.II.I.20

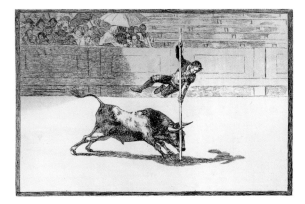

Goya's images of the Spanish bullfight are full of drama,
tension, and violence. The bullfight takes place in an enclosed
space, surrounded by rows of transfixed visitors. It offers
certain death for the bulls, but also possible death for their
human opponents in the ring. Goya's extensive painted and
etched images of bullfights are powerful, psychological
studies of the conflict between men and animals, and his
bulls are often given more nobility than the men who
surround them. ❖

Francisco de Goya y Lucientes

Spanish, 1746–1828
Los Proverbios, 1864

Plate 1: Feminine Folly,
(Heavier than a dead
Donkey)
Etching and aquatint,
First Edition
13⅛ x 19½ in. (33.3 x 49.5 cm)
M.1976.17.1

Plate 3: Ridiculous Folly
(To go amongst the
Branches, or to talk
through one's Hat)
Etching, aquatint and
drypoint, First Edition
13¼ x 19⅛ (33.7 x 49.2 cm)
M.1976.17.3

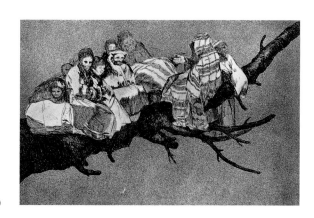

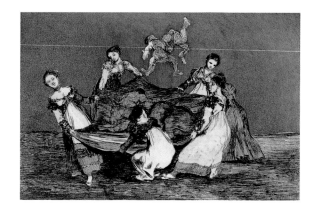

Los Proverbios are among Goya's most ambiguous and enigmatic works. Probably made about 1816, some of the works were inscribed by Goya with titles referring to *disparates*, or follies. They were not published during his lifetime, probably because of their pointed social commentary. At the time of their publication in 1864, they were titled Los Proverbios because the subjects corresponded to commonly known proverbs of the period. ❖

Francisco de Goya y Lucientes

Spanish, 1746–1828
THE DISASTERS OF WAR, 1863

PLATE 13: BITTER TO BE
PRESENT
Etching, lavis, drypoint, burin
and burnisher, First Edition
9½ x 12¾ in. (24.2 x 32.4 cm)
F.1968.3.13

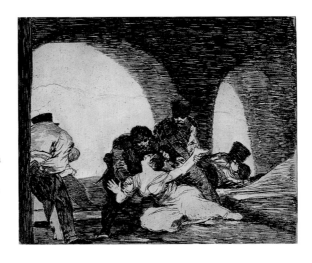

PLATE 15: AND THERE'S NO
HELP FOR IT
Etching, drypoint, burin and
burnisher, First Edition
9½ x 12¾ in. (24.2 x 32.4 cm)
F.1968.3.15

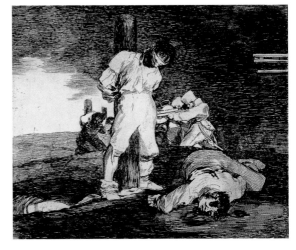

DISASTERS OF WAR is a commentary on the brutality and senselessness of war. Begun during the Napoleonic invasion and occupation of Spain (1808–1814), and published posthumously in 1863, this series of prints raises the visual horrors of war to a new level. Goya's imagery is visually more modern than the earlier depictions of violence found in the prints of Dutch and French artists. Here graphic scenes of torture, rape, mutilation, and execution confront the viewer with the physicality and psychology of human suffering. Goya is perhaps the first Western artist to capture the terrorism of war in the modern age. ❖

Vincent van Gogh

Dutch, 1853–1890
THE BACK GARDEN OF
SIEN'S MOTHER'S HOUSE,
THE HAGUE, 1882
Graphite, black ink, and
white gouache on paper,
mounted to paper
18¼ x 23⅞ in. (46.4 x 60.6 cm)
M.1980.05

Van Gogh settled in The Hague in the winter of 1880, installing himself in a studio with financial help from his brother Theo. In January 1882 he began living with Clasina (Sien) Hoornik; this drawing is a view of her mother's backyard and garden. The drawing was part of a group commissioned by van Gogh's art dealer uncle, C.M. van Gogh, who wanted six detailed views of The Hague. In spite of its brilliant use of perspective and high degree of finish, the drawing was not well received by his uncle. "Did I really think," van Gogh wrote, "that such drawings could possess the slightest commercial value?" ❖

Vincent van Gogh

Dutch, 1853–1890
PORTRAIT OF DR. GACHET, 1890
Etching on paper, Proof
9⅞ x 6⅜ in. (25.1 x 16.2 cm)
F.1976.11

Dr. Gachet, the patron and friend of many artists, was the one who introduced van Gogh to the etching process. This portrait was executed one afternoon at the doctor's house at Auvers. Gachet's son described the incident: "The conversation…covered many questions, among them engraving…. After lunch in the open air in the courtyard, and with their pipes lit, Vincent was given an etching needle and a prepared copper plate, and accepted with enthusiasm that his new friend should be the motif." This expressive portrait is van Gogh's only-known etching. ❖

Edgar Degas

French, 1834–1917
Dancer Rehearsing: Study for
"The Rehearsal", c. 1878
Charcoal heightened with white on gray paper
17¾ x 11⅞ in. (45.1 x 30.2 cm)
M.1977.05

This work is a study for The Rehearsal, now
found in the Fogg Art Museum. The drawing's
horizontal and vertical lines indicate that it
was squared for transfer to canvas. ❖

Edgar Degas

French, 1834–1917
Dancer Fixing Her Shoe, 1885
Charcoal and white pastel on grey paper
17⅝ x 12¼ in. (44.8 x 31.1 cm)
M.1978.23

Degas' study of the ballet extended not only
to dancers on the stage and in rehearsal halls,
but to single figures in all aspects of move-
ment and rest. Degas used the seated, bending
dancer in numerous drawings and frequently
incorporated the subject in finished, multi-
figured compositions. He explored this theme
in endless variations, yet the quality and
spontaneity of his draughtsmanship never
faltered. ❖

Pablo Picasso

Spanish, 1881–1973
THE MOULIN ROUGE, 1901
China ink on paper
12¾ x 19½ in. (32.4 x 49.5 cm)
M.1979.34

Picasso was twenty years old when he drew this ink sketch of Parisian nightlife. His debt to Toulouse-Lautrec is evident not only in his handling of the brush, but also in the subject matter and the bold placement of his figures. ❖

Pablo Picasso

Spanish, 1881–1973
STILL LIFE WITH BOTTLE OF
MARC, 1911
Drypoint, Edition of 100,
No. 23
19¾ x 12 in. (50.2 x 30.5 cm)
N.1977.11.001

Picasso's Cubist prints parallel his development as a painter. In his work depicting multiple-viewpoint images and reproducing objects as multifaceted units, he found the directness and freedom of drypoint well suited to his objectives. This major Cubist print was commissioned by Picasso's dealer Daniel-Henry Kahnweiler and published in 1912. ❖

Pablo Picasso

Spanish, 1881–1973
BLIND MINOTAUR GUIDED BY MARIE-
THÉRÈSE WITH PIGEON ON A STARRY
NIGHT, DECEMBER 1934–JANUARY 1935
Aquatint, scraper, drypoint, and burin
9¾ x 13¾ in. (24.8 x 34.9 cm)
F.1969.46.097

This print is plate 97 from the VOLLARD SUITE, a series of 100 etchings published by Ambroise Vollard in 1939. Comprising most of Picasso's printmaking output from the 1930s, the prints represent the culmination of his classical style. The Minotaur has been called the symbol of unconscious impulses. The artist's lover, Marie-Thérèse, is the young girl who guides the Minotaur, who is blinded by natural light. The autobiographical symbolism refers to Picasso's love for Marie-Thérèse, which leads him on in his blindness. ❖

Pablo Picasso

Spanish, 1881–1973
WOMAN WITH A HAIRNET, 1956
Lithograph, 4th state, Bon à tirer
26 x 19¾ in. (66.0 x 50.2 cm)
F.1983.20.50

This study of Françoise Gilot is a reworking of a lithograph Picasso made in 1949, entitled WOMAN WITH GREEN HAIR. In this final state he has reworked the green color. ❖

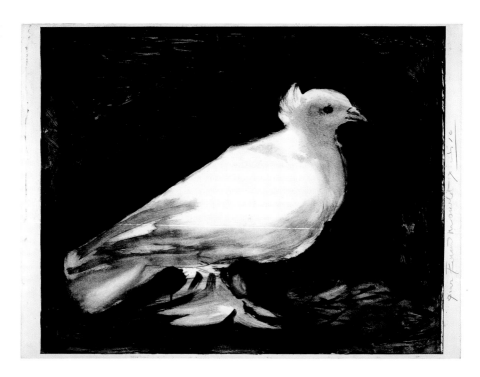

Pablo Picasso

Spanish, 1881–1973
THE DOVE, JANUARY 9, 1949
Lithograph, in wash on zinc,
Bon à tirer, Dedicated to
Mourlot
21½ x 27½ in. (54.6 x 69.9 cm)
M.2001.1.17

THE DOVE comes from the estate of lithographer Fernand Mourlot, who was the first to encourage Picasso to master the process of lithography. The artist was fascinated with the medium, and constantly experimented with changing and refining his compositions. The use of a zinc plate here, rather than the traditional lithographic stone, allowed Picasso to achieve a remarkable yet subtle range of tones using gray and black washes. After World War II, it was chosen for a poster and it became widely known as the dove of peace. Along the right margin Picasso has signed and dedicated it "Bon à tirer pour Mourlot." This print is the final proof, and the inscription is the artist's instruction to the printer, "Bon à tirer," or "ok to print." ❖

Pablo Picasso

Spanish, 1881–1973

The Norton Simon Museum is noted for its collection of Picasso's graphic works. Among them are prime examples of the artist's progressive suites—groups of lithographs reworked several times to create a successive group of images. Outstanding among these progressive suites is the series entitled LE TAUREAU, or THE BULL, a sequence of states beginning with a realistic representation of a bull and ending with a stunning simplification of that form. In this group alone, Picasso clearly demonstrates why he is both a classical master draughtsman and the revolutionary creator of modern art. ❖

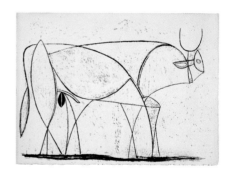

THE BULL, DECEMBER 5, 1945
Lithograph, 1st state, 1 of 18 Artist Reserved Proofs
12¾ x 17⅜ in. (32.4 x 44.1 cm)
M.1977.08.3.01

THE BULL, DECEMBER 12, 1945
Lithograph, trial proof, between 1st and 2nd state
12⅞ x 19¾ in. (32.7 x 50.2 cm)
M.1977.08.3.02

THE BULL, DECEMBER 24, 1945
Lithograph, 5th state, 1 of 18 Artist Reserved Proofs
12½ x 17¼ in. (31.8 x 43.8 cm)
M.1984.1

THE BULL, JANUARY 5, 1946
Lithograph, 9th state, 1 of 18 Artist Reserved Proofs
12 x 17 in. (30.5 x 43.2 cm)
M.1977.08.3.09

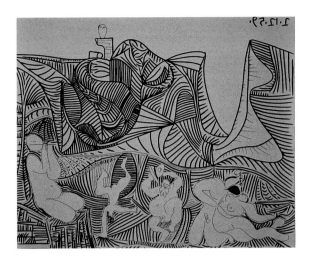

Pablo Picasso

Spanish, 1881–1973
BACCHANAL WITH OWL,
DECEMBER 2, 1959
Linocut, Edition of 50, No. 14
24¼ x 29½ in. (61.6 x 74.9 cm)
M.1975.26.4

The linocut is a relief printing process identical to that of the woodcut, except that the printing surface is linoleum. In the 1950s Picasso pioneered a new graphic technique for the multicolor linocut. Rather than make a separate linoleum block for each color, Picasso invented an elimination process to create color linocuts by cutting away and printing from the same block until a multicolored edition was completed. Because linoleum provides little resistance to the cutting tools, the linocut often has more movement and spontaneity of line than other forms of relief processes. ❖

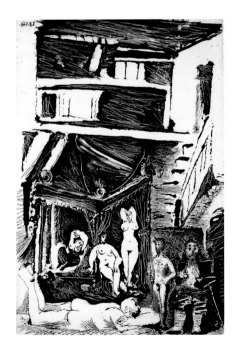

Pablo Picasso

Spanish, 1881–1973
OLD MAN THINKING OVER HIS LIFE,
MAY 28, 1968
Sugar-lift aquatint, Edition of 50, No. 44
19½ x 13¼ in. (49.5 x 33.7 cm)
M.1970.4.3.47

This print is part of the "347 Series," a group of 347 prints that the 87-year-old Picasso made between March and August of 1968. Although not titled by Picasso, the works were given descriptive titles by Brigitte Baer in her catalogue. This one is described as "Old Man Thinking over His Life: Gallant Youth, Maturity as a Famous Painter, Work Created in the Slums Now Enthroned Beneath a Canopy." ❖

Paul Klee

Swiss, 1879–1940
BLOSSOMS AND GRAINS, 1920
Watercolor, inks, and pencil on laid paper,
mounted on cardboard
11¼ x 7⅝ in. (28.6 x 19.4 cm)
P.1953.054
The Blue Four Galka Scheyer Collection

This work belongs to a series of intricate
drawings in which lines are knotted together
in the manner of a fisherman's net. Throughout
the composition, which resembles a sheet of
music, wavy lines seem to represent the
dangling threads of knots or the wispy roots
of plant forms. ❖

Vasily Kandinsky

Russian, 1866–1944
SMALL WORLDS VI, 1922
Woodcut on wove paper
14⁵/₁₆ x 12³/₈ in. (36.4 x 31.4 cm)
P.1963.14.19

Kandinsky was a professor at the Bauhaus in
the 1920s. His first contribution to the school's
printing workshop was a portfolio entitled
SMALL WORLDS. This group of twelve prints
included lithographs, etchings, and wood-
cuts. Ten years later, Kandinsky reminded
Galka Scheyer of the portfolio's high quality:
"All copies were printed under my contin-
uous guidance…the entire execution is first
class." Many of the elements Kandinsky was
using in his paintings are present in this
woodcut. In addition to the geometric shapes
and strong diagonals, there is the suggestion
of ships sailing over waves in both the lower
left and right. ❖

Richard Diebenkorn

American, 1922–1993

These untitled compositions are examples from a rare set of 26 drawings Diebenkorn produced during the early years of his career. Created in the abstract expressionist tradition, these works exhibit a deliberate and impulsive application of line and color. The artist's passion for improvisational jazz music is reflected in the spontaneity of his gestures. ❖

UNTITLED #1, c.1950
Gouache on paper
10¾ x 13⅞ in.
(27.3 x 35.2 cm)
P.1965.017.2.05A
Gift of Mr. & Mrs. Paul Kantor

UNTITLED #3, c.1950
Gouache on paper
10¾ x 13⅞ in.
(27.3 x 35.2 cm)
P.1965.017.2.04A
Gift of Mr. & Mrs. Paul Kantor

Sam Francis

American, 1923–1994
SAM FRANCIS SUITE, 1965
Lithograph on Rives BFK paper,
Edition of 100, No. 2
Printed at Gemini Ltd. by Kenneth Tyler
23½ x 15¾ in. (59.7 x 40.0 cm)
P.1966.21.08
Gift of the Pasadena Art Alliance

Francis's lithographs are as unconstrained as his giant canvases.
After Francis was introduced to the medium in 1959, lith-
ography provided him with an additional vehicle suited to
the gestural nature of his working methods. Exchanging
paint for liquid tusche, his prints display drips, splashes,
and spatters of brilliant color that often define the limits
of a dominant white space. Francis's dedication and love
for lithography culminated in the early 1970s when he
founded his own print studio in Santa Monica. ❖

Clinton Adams

American, 1918–2002
FIGURE IN GREEN, 1969
Lithograph
22 x 24 in. (55.9 x 61 cm)
P.1971.7.144
Anonymous Gift

Clinton Adams spent a large portion of his artistic career advancing the status of lithography in this country. He assisted June Wayne in founding the Tamarind Lithography Workshop, and served as its first Associate Director. As an artist and teacher, Adams maintained a fresh approach, continuing to create innovative works that combined drafting skills with a painter's eye for color. His lithographs hover on the edge between abstraction and representation, often containing elements of landscape fused with fragmented glimpses of the human figure. Organic and sensuous, his compositions are articulated with precision and refinement. ❖

Ellsworth Kelly

American, b. 1923
DARK BLUE AND RED, 1964
From SUITE OF 27 COLOR
LITHOGRAPHS
Lithograph
Artist's Proof, 1 of 6
23⅝ x 35¼ in. (60 x 89.5 cm)
P.1969.021
Gift of the Artist

SUITE OF TWENTY-SEVEN COLOR LITHOGRAPHS was Kelly's first major print series. Initiated in 1964, this acclaimed suite is composed of several sequences of bold and colorful forms that were prominently featured in his paintings during that period. Due to its smaller scale of printing, lithography provided Kelly with the means to exhaustively indulge in the exploration of color and shape relationships. Abstracting forms from his real world observations, Kelly contemplated juxtapositions of figure and ground while simultaneously emphasizing physical size, mass, scale, and edge. As such, he continually manipulates our traditional notions of visual perception. ❖

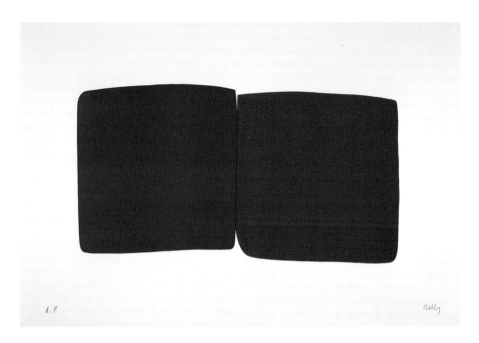

A. P. Kelly

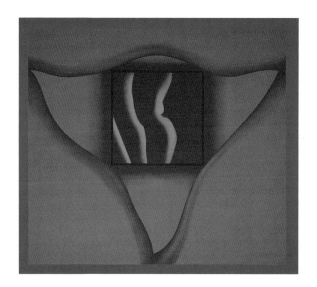

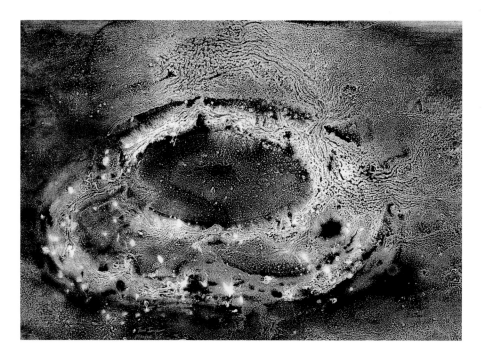

June Wayne

American, b. 1918
AT LAST A THOUSAND I, 1965
Lithograph
24 x 34 in. (61.0 x 86.4cm)
P.1969.092.207
Anonymous Gift
© June Wayne/Licensed by
VAGA, New York, NY

In 1960 Wayne founded the Tamarind Lithography Work-shop in Los Angeles, bringing artists from all over the world to work with master printers. Such inspired collaborations resulted in the resurrection of lithography as an important artistic medium in America. AT LAST A THOUSAND I is a testament to Wayne's virtuoso drawing and a devout inter-pretation of the metaphysical and universal moods of man. Her allusive forms refer to space, time, and location chal-lenging us to decipher their enigmatic codes. ❖

Edward Ruscha

American, b. 1937
HOLLYWOOD IN THE RAIN, 1969
Lithograph
2 x 8⅛ in. (5.1 x 20.6 cm)
P.1971.7.186
Anonymous Gift

A young leader in the California Pop movement, Ruscha moved to Los Angeles from Oklahoma City in 1956. His journey west on Route 66, past all of its roadside markers, had a profound impact on the artist. In addition to his serial images of gas stations and apartment buildings, Ruscha's early work focused on the signs and logos of noted places in his new hometown, including the world-famous Hollywood sign. In HOLLYWOOD IN THE RAIN, this symbol of the American Dream for celebrity reaches sharply across an indistinct landscape; the image's illumination recalls the klieg lights employed by motion picture studios. ❖

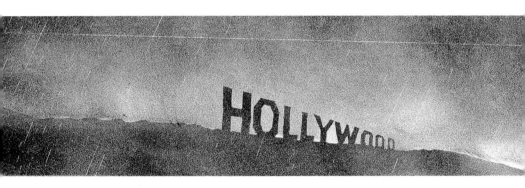

Robert Rauschenberg

American, b. 1925
CARDBIRD III, 1971
One of seven collaged and screen-printed cardboard wall reliefs, Edition of 75, No. 26
36 x 36 in. (91.4 x 91.4 cm)
P.1972.03.3
Anonymous Gift
© Robert Rauschenberg/ Licensed by VAGA, New York, NY

From the outset of his career, Rauschenberg displayed a remarkably free and unconventional approach toward techniques and materials. Beginning in the 1950s, Rauschenberg incorporated discarded objects from everyday life into his paintings, referring to these works as "Combine Paintings." The assemblages evolved from the artist's desire to reconcile what he viewed as a discrepancy between everyday experience and art. CARDBIRD III is one of seven wall reliefs that were generated out of this same concern. Each of the works in this series replicates a discarded and disassembled cardboard box, helping to further blur the boundaries between different mediums. Although they appear to be indistinguishable from the original object, the boxes have been reproduced down to the shipping tape and the tiniest rip and tear. The artist even collaged authentic stamps, bills, and sealing tape onto the screen prints. ❖

Vija Celmins

American, b. 1938
UNTITLED, 1970
Lithograph
20¼ x 29¼ in. (51.4 x 74.3 cm)
P.1972.08.239
Anonymous Gift

Celmins moved to Los Angeles in 1962 and quickly became known for her depictions of banal household items. In the late 1960s, however, Celmins moved away from Pop-inspired subject matter towards Photorealism, as exemplified in this striking work. The ocean view is one that the artist enjoyed outside her Venice studio and had printed at the Tamarind Lithography Workshop. The pristinely rendered surface of the water has become the vehicle for a visually tantalizing contrast between illusionistic space and the flat surface of the plane. ❖

Katsukawa Shunshō

Japanese, 1726–1792
THE ACTOR SEGAWA KIKUNOJO II, C. 1770
Color wood-block print
13 x 5⅞ in. (33 x 14.9 cm)
P.1975.2.6
Gift of Mrs. Edward C. Crossett

Kabuki theater is a component of the ukiyo-e ("pictures of the floating world") art movement, which was devoted to the worldly and hedonistic pleasures of urban life in eighteenth-century Edo (modern-day Tokyo). Katsukawa Shunshō was one of the leading artists of this movement and excelled at depicting actors on stage. In many plays, a narrator presented the action of the story which was then mimed in dance form by male actors, who played both the male and female roles. In this print, the famous actor Segawa Kikunojo II (1741–1773) plays the role of a young woman strolling along the banks of a stream. ❖

Andō Hiroshige

Japanese, 1797–1858
KINGFISHER AND IRIS, C. 1840
Color wood-block print
13⅛ x 4⅛ in. (33.3 x 11.1 cm)
P.1966.20.095
Gift of Mrs. Audrey Steele Burnand, 1966

The depiction of subjects from nature, including flowers, birds and other animals, was a popular genre of Japanese wood-block prints. Not based on scientific observation, these prints sought to evoke a poetic and aesthetic connection between the two elements. The haiku poem in the upper left reads:

> *Preening his feathers*
> *in a watery mirror--*
> *kingfisher in flight.*

❖

Andō Hiroshige

Japanese, 1797–1858
FUJI FROM OZUKI-NO-HARA,
KAI, 1858
Color wood-block print
14⅝ x 9⅞ in. (37.1 x 25.1 cm)
P.1975.2.71
Gift of Mrs. Edward C.
Crossett

Hirsohige's famous series, THE
THIRTY-SIX VIEWS OF MOUNT
FUJI, was the last set of wood-
block prints he created. The
series is comprised of various
views of Japan's most famous
mountain. This print is number
thirty-one in the series and
provides a panoramic view of
the cosmic mountain as seen
from a tranquil meadow dotted
with lush wildflowers and a
meandering stream. ❖

Katsushika Hokusai

Japanese, 1760–1849
YŌRŌ FALLS IN MINO
PROVINCE, C. 1832
Color wood-block print
14⅞ x 10¼ in. (37.8 x 26.1 cm)
P.1963.14.23

The series TRAVELS AROUND THE
WATERFALLS, captured a number
of the famous and picturesque
waterfalls in Japan. A group of
people are shown at the bottom
standing and looking up at the
torrential falls while others rest
in a small grass hut. Hokusai,
who was a pupil under Katsu-
kawa Shunshō, was one of the
most innovative and prolific
artists of his time. ❖

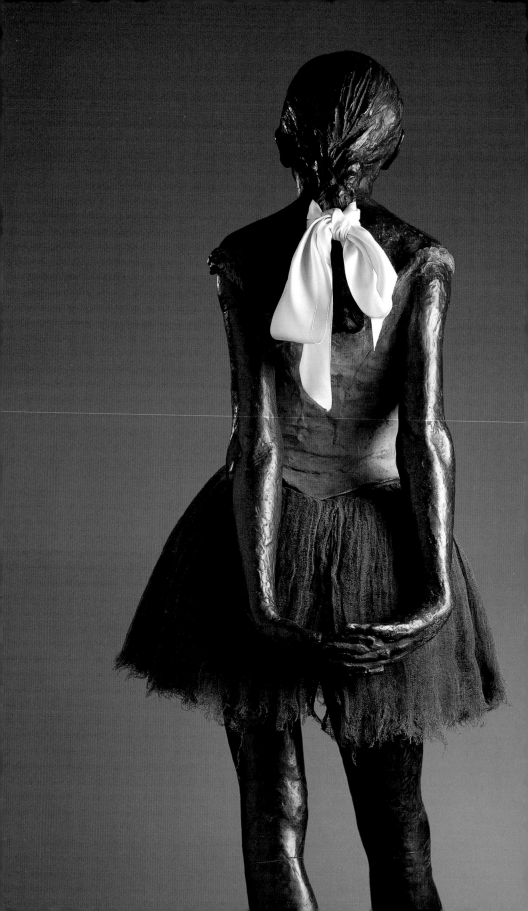

SCULPTURE

Pisan School

Italian
THREE ANGEL MUSICIANS,
14th century
Marble
Left: ANGEL PLAYING ZITHER
20 x 5⅛ in. (50.8 x 13 cm)
F.1965.1.115
Center: ANGEL PLAYING BAGPIPE
20 x 6½ in. (50.8 x 16.5 cm)
F.1965.1.114
Right: ANGEL PLAYING TIMBRELS
19¾ x 5½ in. (50.2 x 13.3 cm)
F.1965.1.113

According to the stylistic tradition of fourteenth-century Pisan sculpture, these three angels most likely joined a group of other musician and singing angels atop pinnacles surrounding an altarpiece dedicated to Christ or the Virgin Mary. In paintings of the time, musician angels are frequently found in depictions of the glorification of Christ or the Coronation of the Madonna. The detailed carving of the folds in the dress of the angels, especially that of the timbrel player, reflects the influence of French Gothic art. The differences in their facial expressions and drapery suggest the hand of several sculptors. ❖

Desiderio da Settignano

Italian, 1428–1464
THE BEAUREGARD MADONNA, C. 1455
White Carrara marble
20 X 16 in. (50.8 X 40.6 cm)
F.1965.1.108

Desiderio da Settignano's sensitive treatment of women and children is evident in this beautifully carved marble relief. His incredible facility and control in carving marble gave him assurance in dealing with the special problems of relief sculpture. Here delicate gradations suggest the strongly felt volumes. The artist's precise and sensitive lines are drawn with a calligraphic skill that seems to animate the surface of the marble. ❖

Claude Michel, called
Clodion

French, 1738–1814
A BACCHANTE SUPPORTED BY BACCHUS
AND A FAUN, 1795
Terracotta
20 in. (50.8 cm)
F.1965.1.105

Claude Michel, known as Clodion, was one of the most creative and technically gifted French sculptors of the second half of the eighteenth century. While he was skilled at executing monumental sculpture in marble, his genius was expressed most fully in his small terracottas. In this exuberant ensemble, a young Bacchante, or female follower of Bacchus, is playfully carried aloft by the god of wine and a faun. Clodion fuses the movement and energy of the Baroque seventeenth century with antique themes in a lighter, more delicate, and more subtly sensual style than that of his contemporaries. ❖

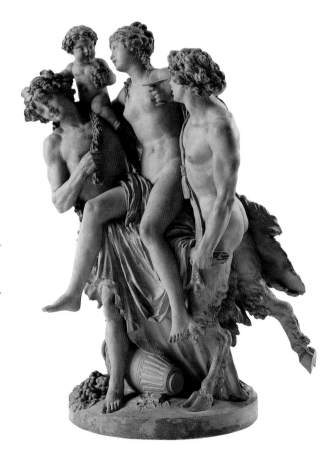

Edgar Degas

French, 1834–1917
LITTLE DANCER AGED FOURTEEN, 1878–81
Bronze, *Modèle* cast
38 x 13⅜ x 13¹⁵/₁₆ in. (96.5 x 34 x 35.4 cm)
M.1977.2.70

The original wax model of the LITTLE DANCER AGED FOUR-
TEEN was exhibited in the sixth Impressionist Exhibition
of April 1881, presenting to the Parisian public an extraor-
dinary new conception of sculpture. Degas dressed the wax
figure in a silk bodice, gauze tutu, and fabric slippers, with
a satin ribbon in her real hair wig. The wig, slippers, and
bodice were covered with a layer of wax to help unite them
with the rest of the work, while preserving their special
texture. His model, Marie von Goethem, was a student of
the Ballet de l'Opera and worked as an artist's model. Accus-
tomed to representations that idealized human forms, the
public had a mixed reaction to the graphic portrayal of an
adolescent dance student, dressed in real clothing. Degas
never publicly exhibited the figure again, and returned the
LITTLE DANCER to his apartment, where it remained until
his death in 1917. ❖

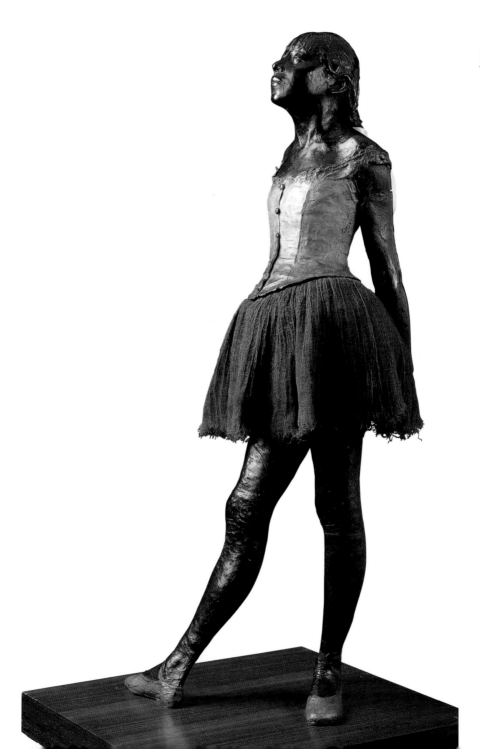

Edgar Degas

French, 1834–1917

THE SIMON MASTER BRONZES

Degas was the only member of the Impressionist circle to generate a major body of sculpture. He sculpted his figures from a soft modeling material composed chiefly of wax. He preserved these wax sculptures in his studio for many years, and they were found shortly after his death in 1917. It was left to Degas' heirs and executor to oversee the casting of these wax originals into bronze. At the Hébrard foundry in Paris, a special studio was built for the difficult and delicate work of reproducing these waxes in bronze. The seventy-one unique Simon *modèles* are the original bronzes cast from Degas' waxes, and served as the foundry models to reproduce all of the subsequent sets. ❖

Left: THE TUB, 1889
Bronze, No. 26, *Modèle* cast
8 $^{11}/_{16}$ x 17 $^{15}/_{16}$ x 16 $^{9}/_{16}$ in.
(22.1 x 45.6 x 42.1 cm)
M.1977.02.53

Below: STUDY IN THE NUDE
FOR THE DRESSED BALLET
DANCER, 1878–79
Bronze, No. 56, *Modèle* cast
28 $^{9}/_{16}$ x 13 $^{9}/_{16}$ x 11¾ in.
(72.5 x 34.4 x 29.8 cm)
M.1977.02.36

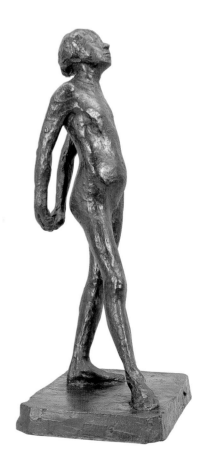

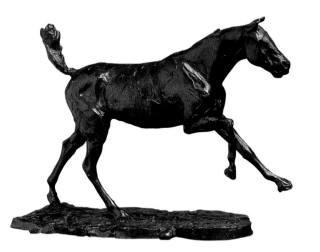

Left: Horse Galloping on the Right Foot, 1881–90
Bronze, No. 47, *Modèle* cast
12-3/8 x 16½ x 3½ in.
(31.4 x 41.9 x 8.9 cm)
M.1977.02.40

Below, left: Grande
Arabesque, Second Time,
1885–90
Bronze, No. 15, *Modèle* cast
17 3/16 x 24¾ x 11⅛ in. (43.7 x
62.9 x 28.3 cm)
M.1977.02.05

Below, right: Fourth
Position over the Left
Leg, 1882–95
Bronze, No. 5, *Modèle* cast
22½ x 13⅜ x 14 5/16 in.
(57.2 x 33.9 x 36.3 cm)
M.1977.02.10

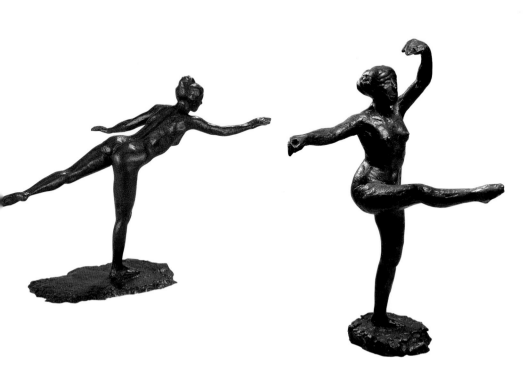

Auguste Rodin

French, 1840–1917
THE THINKER, 1880
Bronze, Edition of 12,
Cast No. 11
79 x 38 x 59 in.
(200.7 x 96.5 x 149.9 cm)
M.1970.2

Rodin's most famous work, THE THINKER was first exhibited in 1888. The image is not that of a passive dreamer, but of a man actively engaged in creative thought. Thinking has been expressed not only through the meditative attitude of the body, but through the effort of every muscle. As Rodin said, "What makes my Thinker think is that he thinks not only with his brain, with his knitted brow, his distended nostrils and compressed lips, but with every muscle of his arms, back and legs, with his clenched fists and gripping toes." During the last 100 years, the sculpture has become an international symbol for art and education, and the world's best known image of mental activity. ❖

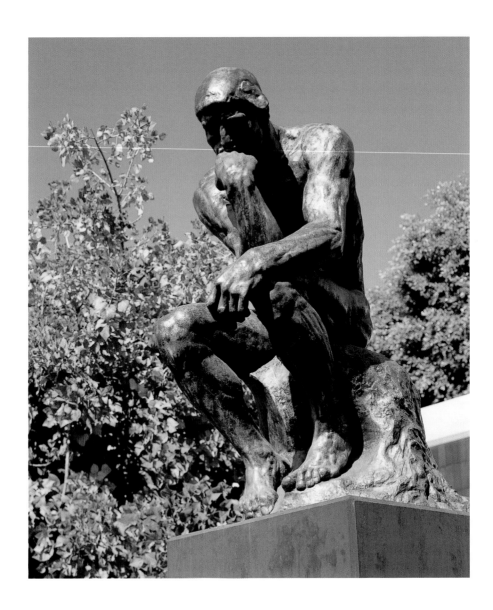

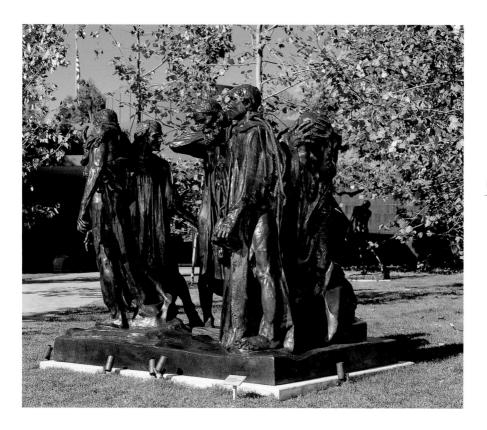

Auguste Rodin

French, 1840–1917
THE BURGHERS OF CALAIS, 1884-95
Bronze, Edition of 12, Cast No. 10
82½ x 93½ x 70¾ in.
(209.6 x 237.5 x 179.7 cm)
M.1968.04

THE BURGHERS OF CALAIS depicts an episode from the Hundred Years' War. In 1347, after the city of Calais had been under siege for eleven months, six prominent citizens offered their lives to the English king, Edward III, in return for his promise to spare the city. Upon hearing of their bravery, Queen Philippa interceded and obtained their release. In 1884, Rodin was commissioned by the city of Calais to produce a monument honoring the six burghers. Rodin rejected the established conventions of public sculpture and portrayed the men not as glorious heroes, but as six troubled and isolated individuals brought together by their anguish and common purpose. He depicted the emaciated figures departing, dressed in tattered sackcloth, to surrender themselves to the English army, heightening the emotional impact by accentuating heavy movements and dramatic gestures. Rodin emphasized not the splendor of the occasion, but the poignant quality of human suffering: reluctant heroes struggling with their final conflicting thoughts of fear, indecision, anguish, and resolve. He distanced himself from the traditional interpretation of public monuments by removing his figures from their elaborate "triumphal" pedestal and placing them directly on the ground, explaining, "I had thought that placed very low, the group became more familiar, and made the public enter more into the aspect of misery and of sacrifice." Although the monument committee criticized the work for not glorifying the Burghers, Rodin prevailed. THE BURGHERS OF CALAIS is justly recognized as the sculptor's masterpiece. ❖

Pablo Picasso

Spanish, 1881–1973
HEAD OF A WOMAN, 1909
Bronze, Edition of 9, Cast No. 3
16¼ x 9½ x 10¼ in. (41.3 x 24.1 x 26.0 cm)
M.1969.07

Picasso and Braque developed the Cubist paradigm of capturing the essence of an object by showing it through multiple viewpoints simultaneously. This portrait of Fernande Olivier was one of the first attempts to translate Cubist innovations into sculpture. ❖

Wilhelm Lehmbruck

German, 1881–1919
INCLINED HEAD OF "THE KNEELING WOMAN," 1911
Plaster
18½ x 17½ x 11½ in. (47.0 x 44.5 x 29.2 cm)
M.1967.15

Lehmbruck admired the sculpture of Rodin and visited his studio, but the French sculptor's influence over him diminished as Lehmbruck developed his own style. THE KNEELING WOMAN, modeled in 1911, marked a major stylistic shift in his work. The elongated body and pensive expression became characteristic of his figures. Lehmbruck created not only full figures but also partial figure "details" that are concentrated statements of a completed work. In its serene grace and eloquent gesture, the head expresses the essence of the larger, whole figure. ❖

Jacques Lipchitz

French, 1891–1973
THE FIGURE, 1926–30
Bronze, Edition of 7, Cast No. 2
83¼ x 38½ x 28½ in. (211.5 x 97.8 x 72.4 cm)
M.1967.22

Born in Lithuania, Lipchitz settled in Paris
in 1909, where he became friends with Gris,
Archipenko, and Modigliani, and lived next
door to Brancusi. His meeting with Picasso
in 1913 influenced the course of his artistic
development. Lipchitz responded to the
sculptural potential inherent in Cubist theory,
and became the foremost Cubist sculptor of
the era. Shortly before he began work on THE
FIGURE, Lipchitz experimented with small
works he called "transparents." He described
himself as "playing with space, with a kind
of open, lyrical construction that was a reve-
lation to me." His most famous work, THE
FIGURE, was partly inspired by the tribal art
that he collected. Indeed, the bronze has a
powerful presence not unlike that of totemic
figures. In 1941 Lipchitz moved to the United
States, where he spent the rest of his life. ❖

Constantin Brancusi

Romanian, 1876–1957
BIRD IN SPACE, 1931
Bronze, with limestone base
73 in. h. (185.4 cm); Limestone base 8½ in. h. (21.6 cm),
8¾ in. diameter (22.2 cm)
F.1972.8

Brancusi, Europe's most influential sculptor of the 1920s, was trained as a carpenter and stonemason. He studied sculpture at the Art Academy of Bucharest, and moved to Paris in 1904. BIRD IN SPACE embodies Brancusi's belief that "What is real is not the external form, but the essence of things." BIRD IN SPACE represents the essence of flight. A recurring theme in Brancusi's sculpture is that of the bird. Over a period of years, through elongation and simplification, all superficial likenesses to the bird were eliminated so that what remains is soaring form. The Maharaja of Indore (1907–1961) purchased BIRD IN SPACE when he visited Brancusi's studio, probably in late 1933. At that time he also commissioned from the artist two additional birds of similar size and style, one in black marble and one in white marble. The three were to adorn a proposed, but never completed, temple of meditation in Indore. The sculpture stayed with the family until the early 1970s, when it was acquired by The Norton Simon Foundation. ❖

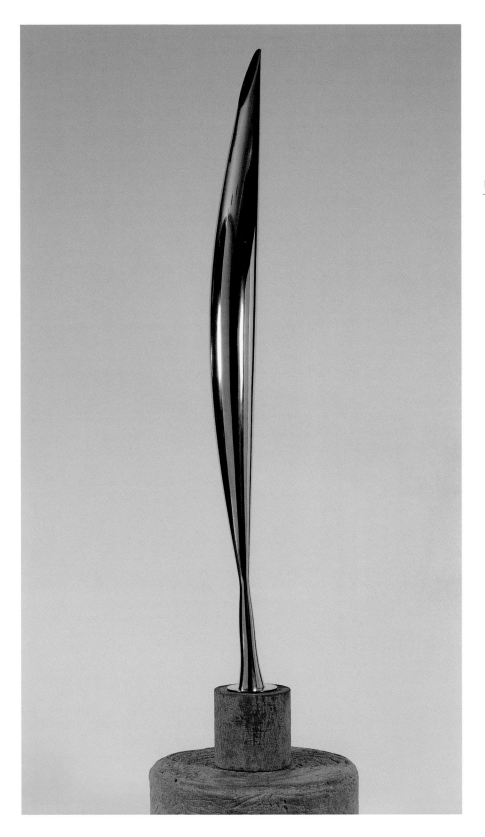

Aristide Maillol

French, 1861–1944

Below: STANDING BATHER
WITH RAISED ARMS, 1930
Marble
62½ in. (158.8 cm)
M.1968.02

Right: RIVER, 1938–43
Lead, Artist's Proof
82¾ in. (210.2 cm)
M.1970.5.12

Drawing inspiration from the sculpture of Greek and Roman antiquity, Maillol based his subject matter almost exclusively on the female figure. His work most often depicts standing or sitting nudes in serene, harmonious poses. His marble STANDING BATHER is representative of these classical figures. In striking contrast is RIVER, one of Maillol's most dynamic and innovative compositions. Based on the idea of a fallen victim which symbolizes the horrors of war, RIVER is a product of the artist's late years, when he created a group of monumental figures that were cast in lead. Precariously perched on a small rectangular base, the animated figure is in the act of being swept away by unseen forces, her hands raised in what can be seen as a gesture of either defense or submission. Norton Simon purchased RIVER from Dina Vierny, Maillol's last model and the model for this work. ❖

Marino Marini

Italian, 1901–1980
HORSEMAN, 1947
Bronze
39½ x 18½ x 25 in.
(100.3 x 47.0 x 63.5 cm)
M.1968.08.2

Throughout the 1940s and 1950s, Italian sculptor Marino Marini developed the theme of the horse and rider. Marini's abstracted HORSEMAN of 1947 is reflective, quiet, and in control as he remains firmly seated, his stretched, downcast arms reach between his legs and land gently on the animal's back. As the rider exalts in his newly finished journey, head tilted backward to look skyward, his companion grazes calmly beneath him. Marini's later horses became wilder and his riders more exhausted. In addition to the equestrian theme, Marini maintained an enduring interest in *pomonas*, or plump figures of women. For both subjects, his technique included painting the images first and then sculpting them in bronze or wood. ❖

Isamu Noguchi

American, 1904–1988
THE WHITE GUNAS
(ABSTRACT SCULPTURE), 1946
White marble
65½ x 25½ x 15½ in.
(166.4 x 64.8 x 39.4 cm)
P.1974.4
Purchased with funds
donated by the National
Endowment for the Arts and
the Fellows Acquisition Fund

Noguchi was born in Los Angeles, then spent his early child-hood in Japan, where his father was a professor and poet. After finishing his academic studies in America, Noguchi went to Paris in 1927. There he worked as Brancusi's appren-tice and was inspired by the spirit of Surrealism. During the 1930s and 1940s he achieved an international reputa-tion as a sculptor and designer. Noguchi's creative activi-ties were animated by the philosophies of both East and West. THE WHITE GUNAS is an expression of the three gunas (strands or qualities) in the Samkhya philosophy of India: tamas (darkness or motionlessness), rajas (desire or passion), and sattva (luminous goodness or clear thinking). The spir-itual goal is to attain a state of balance so that all three qual-ities are in equilibrium. Then, and only then, is the philosopher "illuminated" by entering into a oneness with the three gunas, all of which have become luminously white. ❖

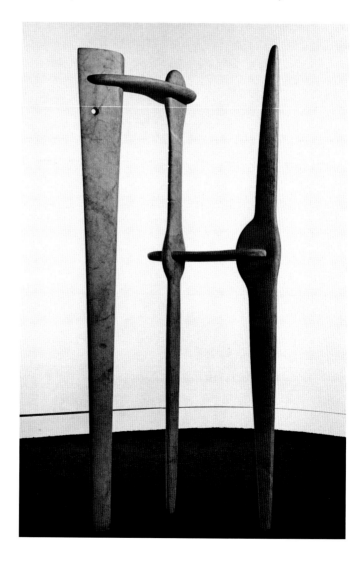

Alberto Giacometti

Swiss, 1901–1966
TALL FIGURE IV, 1960
Bronze, Edition of 6,
Cast No. 1
106½ X 12 X 22 in.
(270.5 X 30.5 X 55.9 cm)
M.1965.1

Giacometti was born in the Italian-speaking part
of Switzerland to a family of artists. He joined the
Surrealist circle in Paris in 1929 and remained an
active member of the group until the mid-1930s.
His inspiration came from many sources, but
primarily from the Cubist-inspired sculpture of
Brancusi, Lipchitz, and Duchamp. Giacometti is
best known, however, for the tall, extremely elon-
gated figures he began to produce after World War
II. The sculptures are characterized by their unlikely
combination of form and material. The rugged,
forbidding texture of the bronze surface contrasts
markedly with the attenuated and seemingly fragile
shapes of the figures. The artist's astonishingly
thin, tall figures were commonly believed to embody
an existential intention that was prevalent following
the devastations of World War II. Giacometti, on
the other hand, asserted that his sculptures paid
tribute to the traditions of ancient Greek and
Egyptian art. Perhaps it is this ambiguity and
tension that makes these figures so compelling.
TALL FIGURE IV is one of his last works in this
series. ❖

Henry Moore

English, 1898-1986

Below: KING AND QUEEN, 1952–53
Bronze, Edition of 4 + 1
64½ x 56 x 35 in.
(163.8 x 142.2 x 88.9 cm)
M.1976.03

Right: TWO-PIECE RECLINING FIGURE NO. 9, 1968
Bronze, Edition of 7,
Cast No. 2
56½ x 96 x 52 in.
(143.5 x 243.8 x 132.1 cm)
M.1970.4.1

Henry Moore is widely considered to be the greatest sculptor of the twentieth century. In the years following World War II he gained an international reputation with his monumental outdoor figurative works. Although not massive in scale, KING AND QUEEN nonetheless conveys an effortless monumentality, and typifies Moore's preference for highly simplified biomorphic shapes. His two barefoot figures rest on a bench for a throne, their noble forms free of all extraneous detail save their crowns. His later TWO-PIECE RECLINING FIGURE NO. 9 exemplifies Moore's belief that more abstract forms could possess great spiritual vitality: "In this way I can present the human psychological content of my work with the greatest directness and intensity." ❖

Barbara Hepworth

English, 1903–1975
ASSEMBLY OF SEA FORMS, 1972
White marble mounted on a
stainless steel base
42½ in. h. (108.0 cm);
72 in. diameter (182.9 cm)
M.1974.12.1

Barbara Hepworth and Henry Moore were the two most important British sculptors of the twentieth century. Hepworth continued the semi-abstract tradition of Arp and Brancusi, investing her organic shapes with intense personality and vitality. ASSEMBLY OF SEA FORMS is one of her last major works. Hepworth thought of sculpture as "a vehicle for projecting our sensibility to the whole of existence," and believed that each of her works was a "perception of the holiness of life and the universe."

The Sea Forms are individually titled:
Back row: SEA MOTHER and SEA KING
Center row: SHELL, SEA FORM AND YOUNG, and
ROLLED SEA FORM
Front row: EMBRYO and SEA BIRD. ❖

Marcel Duchamp

French, 1887–1968
BOTTLE RACK, 1963 Replica of the
1914 Paris Original
A ready-made bottle-dryer of galvanized iron
28⅜ x 14 in. (72.1 x 35.6 cm)
P.1968.28
Gift of Mr. Irving Blum, in memory of the Artist

Duchamp experimented with many artistic move-
ments, including Cubism, Dada, and Surrealism.
His ready-mades are his most readily recognizable
works and held great importance for the develop-
ment of the twentieth-century avant-garde. An
everyday object chosen and then signed by the
artist, BOTTLE RACK demonstrates the more impor-
tant tenets of the ready-made. The artist has made
a rack meant for drying bottles an artwork simply
by adding his name to the object. Although the
original was first conceived in Paris in 1914 and
then lost, four replicas exist. ❖

Joseph Cornell

American, 1903–1972
HOTEL DU NORD (LITTLE DÜRER)
Painted box, metal ring and chain, wood blocks,
and printed paper
13 x 12¼ x 4 in. (33.0 x 31.1 x 10.2 cm)
P.1967.10
Purchased with funds donated by the
Charles and Ellamae Storrier-Stearns Fund and
Fellows Acquisition Fund
Art © The Joseph and Robert Cornell Memorial
Foundation/Licensed by VAGA, New York, NY

A master of assemblage, Joseph Cornell is best known
for his intricate shadow boxes. Through their enig-
matic narratives and ephemeral nature, these minia-
ture stages reflected Cornell's interest in Symbolism
and Surrealism. Among other things in this painted
white interior, we see copies of anonymous fifteenth-
century French portraits of a child with clasped hands
and two reproductions of works by Dürer. Though
HOTEL DU NORD suggests European influences, Cornell
never visited Europe. Throughout his career he remained
an autodidact uninfluenced by the larger art world. ❖

Bruce Conner

American, b. 1933
COUCH, 1963
Cloth-covered couch with
wood frame, figure, cloth,
paint, and wax
32 X 70¾ X 27 in.
(81.3 X 179.7 X 68.6 cm)
P.1969.005
Museum Purchase with funds
donated by Mr. David H.
Steinmetz III and an
Anonymous Foundation

Bruce Conner's COUCH renders a once-ordinary object into a dark vision. On the paint-splattered settee, a disintegrating skeletal figure leans its head against the armrest. The cloth-covered couch, with its wood frame, figure, and paint, speaks equally of darkness and light as well as of life and death. What we might normally turn away from in horror, in a gallery space suddenly captures our attention. Born in McPherson, Kansas, Conner arrived in California in 1957 and became a noted figure in the California assemblage movement. He was moved by a sense of impending doom the year he created this artwork, brought on by the assassination of John F. Kennedy as well as the potential fallout from the 1960s Cuban Missile Crisis. ❖

George Herms

American, b. 1935
THE LIBRARIAN, 1960
Wood box, papers, brass bell,
books, and painted stool
57 x 63 x 21 in.
(144.8 x 160.0 x 53.3 cm)
P.1969.091
Gift of Molly Barnes

A poet, painter, sculptor, and performance artist, Herms is best known for his carefully articulated assemblages made from discarded objects. Herms was among the noted artists associated with the post-war Beat Generation and became one of the originators of the California Assemblage movement. His first assemblage or "junk sculpture" was created in 1957. Three years later, he began a series of assemblages based on real people and places. THE LIBRARIAN is among Herms' best-known "life-forms." Composed of decaying books and other unconventional materials, this anthropomorphic sculpture was inspired by a librarian who had introduced the young Herms to the writings of Joseph Conrad. Conrad had an enormous influence on the artist, as did the librarian who made the books available to him. ❖

Robert Rauschenberg

American, b. 1925
GREEN SHIRT, 1965–1967
Neon and painted metal
119 x 240 x 10½ in.
(302.3 x 609.6 x 26.7 cm)
P.1969.141
Gift of the Artist
© Robert Rauschenberg/
Licensed by VAGA,
New York, NY

During the 1950s Robert Rauschenberg rose to prominence for his "combine" paintings, which included objects from the "real world" and painted abstractions. Employing an atypical medium, GREEN SHIRT depicts a combination of subjects and objects from ordinary life, with references to "high" and folk art traditions. A green shirt, oversized tie, and bicycle collaborate with the Rubens-inspired woman at her mirror and the small, wandering pigs to blur, and then deconstruct the boundaries of looking at "real art" and experiencing "real life." GREEN SHIRT is in harmony with Rauschenberg's oft-quoted objective "to act in that gap between art and life." ❖

Claes Oldenburg

American, b. 1929
GIANT SOFT KETCHUP BOTTLE
WITH KETCHUP, 1966–67
Painted canvas filled with
polyurethane foam
100 X 52 X 40 in.
(254.0 X 132.1 X 101.6 cm)
P.1969.002
Museum Purchase with funds
granted by the National
Endowment for the Arts and
the Pasadena Art Alliance

Oldenburg has based his artistic career on quoting elements from our consumer culture. GIANT SOFT KETCHUP BOTTLE WITH KETCHUP is an example of the artist's noted series of "soft sculptures." Debuting in New York in the early 1960s, these radical innovative sculptures helped launch the Pop Art movement in this country. Mundane subjects such as food products and bathroom items were chosen for their usual and multifarious associations, and then blown up in size to monumental proportions. These works play off the disjunction between the familiarity of the objects and the shocking shift in scale. By replacing the original texture of the objects with soft materials, Oldenburg emphasized the sculpture's human, often sexual, characteristics. ❖

Andy Warhol

American, 1928–1987
BRILLO BOXES, 1969
Acrylic silkscreen on wood
20 x 20 x 17 in. (50.8 x 50.8 x 43.2 cm)
each of 100 boxes
P.1969.144.001–100
Gift of the Artist

Considered the quintessential Pop artist, Andy Warhol began his career in New York in the 1950s as a commercial illustrator. In 1962 he began using the process of screen printing and produced images of consumer products. Warhol's BRILLO BOXES were introduced in 1964 when a New York art gallery was filled with some 400 wooden boxes made to look exactly like the cartons of Brillo Soap Pads and other products found in supermarkets. When asked about the genesis of these boxes, Warhol replied: "Well…I'd done all the Campbell's Soup Cans in a row on the canvas, and then I got boxes made to do them on a box-—but that looked funny because it didn't look real—I just had the boxes already made up though. They were brown and looked just like boxes, so I thought it would be great just to do an ordinary box." The 100 Brillo Boxes in the Museum's collection are replicas of the 1964 originals. They were made to order by Warhol in Pasadena for his 1970 retrospective exhibition at the Pasadena Art Museum (now the Norton Simon Museum). ❖

Carl Andre

American, b. 1935
144 Pieces of Aluminum, 1967
Aluminum, 144 units
144 x 144 x ⅜ in.
(365.8 x 365.8 x 1 cm)
P.1969.093
Anonymous Gift
Art © Carl Andre/Licensed
by VAGA, New York, NY

Andre began his sculpting career as a follower of Brancusi, and as such was influenced by Brancusi's use of found and unaltered materials, as well as the blurred distinction between a sculpture and its base. Andre developed the notion that sculpture was neither form nor structure, but rather "place," and focused on the relationship between the work and its site. As a proponent of Minimalism, he stressed the austerity, mass production, and technology found in 144 Pieces of Aluminum, with its interchangeable, prefabricated, repetitive aluminum plates. Typical of the floor pieces Andre made after 1965, the work is meant to be walked on as well as seen, in order that the viewer might experience the differences between the floor and the artwork. ❖

Donald Judd

American, 1928–1994
Untitled, 1966
Galvanized iron and painted aluminum
40 x 190 x 40 in. (101.6 x 482.6 x 101.6 cm)
P.1966.15 a–e
Gift of Mr. and Mrs. Robert A. Rowan
Art © Donald Judd Foundation/Licensed
by VAGA, New York, NY

Judd's work was central to the Minimalist art movement. Working with solid geometric forms, he designed factory-made sculptures in repetitive units based on mathematical systems. He strove to remove the artist's presence from the work, and like Carl Andre, was concerned with the interrelationships between a sculpture's physical form and its surrounding space. ❖

Robert Irwin

American, b. 1928
UNTITLED, 1967–68
Acrylic lacquer on formed acrylic
plastic [with central band]
54 in. diameter (137.2 cm)
P.1969.65
Museum Purchase, Fellows
Acquistion Fund

During the early 1960s Robert Irwin was concerned with
Minimalism's interest in flatness and monochromic, hard-
edged forms. Irwin's disc paintings of 1966–69 erase the
distinction between painting and sculpture. The subtly
sprayed, convex discs are lit with low-intensity spotlights,
which dematerialize their edges. Free-floating apparitions
without visible support, the discs fuse with their background
and the surrounding ambience. These works invite viewers
to contemplate an indefinite, glowing composite of light
and shadow that suggests pure energy rather than form or
image. ❖

PHOTOGRAPHY

André Kertész

American, 1894–1985
UNDERWATER SWIMMER,
ESZTERGOM, AUGUST 31, 1917
Gelatin silver print
7 x 9⅝ in. (17.8 x 24.4 cm)
PH.1973.15
Museum Purchase, Fellows
Acquisition Fund

While serving in the Austro-Hungarian army during World War I, Kertész made photographs of soldiers' lives away from the front. UNDERWATER SWIMMER, ESZTERGOM depicts a man receiving pool therapy for a battle wound. The refractions in the pool water make the swimmer appear headless and compositions such as this one led to his later work with distorted images created with curved mirrors. Born in Hungary, Kertész worked as a photojournalist in Paris in the 1920s and 30s, where he influenced photographers such as Cartier-Bresson and Brassaï. He came to New York in 1936 for what was to be a one-year assignment, but ended up living and working in the United States for the remainder of his life. ❖

Imogen Cunningham

American, 1883–1976

GLACIAL LILY, 1926–1927
Gelatin silver print mounted on
cardboard
9⅜ x 8½ in. (23.8 x 21.6 cm)
PH.1971.143
Gift of the Artist to the Blue
Four Galka Scheyer Collection

MAGNOLIA BUD, c. 1925
Gelatin silver print mounted on
cardboard
9⅜ x 7½ in. (23.8 x 19.1 cm)
PH.1971.148
Gift of the Artist to the Blue
Four Galka Scheyer Collection

Cunningham took her first photo-
graph in 1901, beginning one of the
longest careers in the history of
photography. She worked for nearly
eight decades, continuing up until
shortly before her death in 1976.
The close-up precision inherent in
the seemingly ordinary MAGNOLIA
BUD and GLACIAL LILY gives credence
to Cunningham's belief that aesthetic
pleasure "comes from finding beauty
in the commonest things." She is
best known for the sharply focused
botanical forms that she produced
in the 1920s. These immaculately
lit, bold close-ups of plants and
flowers yield images that are rendered
almost abstract. ❖

Edward Weston

American, 1886–1958

PEPPER, 1930
Gelatin silver print
7½ x 9½ in. (19.1 x 24.1 cm)
PH.1953.609e
The Blue Four Galka Scheyer
Collection

KELP, 1930
Gelatin silver print
7½ x 9⅝ in. (19.1 x 24.4 cm)
PH.1953.609d
The Blue Four Galka Scheyer
Collection

Opposite:
DUNES, OCEANO, 1936
Gelatin silver print
7⅝ x 9⅝ in. (19.4 x 24.4 cm)
PH.1953.609a
The Blue Four Galka Scheyer
Collection

Weston was one of the most influential photographers of the twentieth century. These three prints date from the 1930s, when his favorite themes were landscapes, nudes, and extreme close-ups of shells and vegetables. The precision with which he controlled light and the richness of his tonal structures has never been exceeded. On August 1, 1930, Weston recorded in his daybook that his assistant had brought him a "glorious new pepper." On August 3, he wrote that she "keeps tempting me with peppers... .While experimenting with one of these...I tried putting it in a tin funnel for background. It was a bright idea, a perfect relief for the pepper and adding reflected light to important contours." Weston took a number of photographs in Carmel in March 1930 after a storm. He wrote in his daybook the next day, "Yesterday I made photographic history: for I have

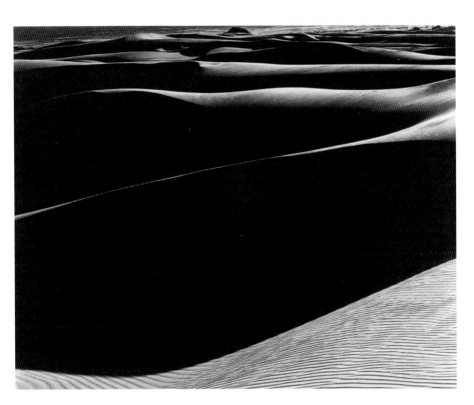

every reason and belief that two negatives of kelp done in the morning will someday be sought as examples of my finest expression and understanding." Weston probably first met Galka Scheyer in 1927, and it was she who told him about the sand dunes in Oceano, California, located near Pismo Beach. The dunes, with their organic shapes, perfectly suited Weston's interest in the beauty of unadorned form. This image is inscribed on the reverse: "To Galka, who first told me about the Dunes." ❖

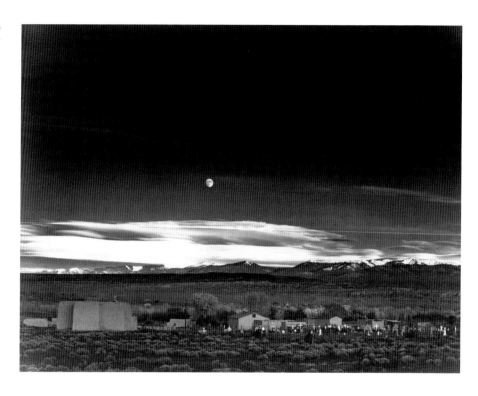

Ansel Adams

American, 1902–1984
MOONRISE, HERNANDEZ,
NEW MEXICO, 1941
Gelatin silver halide print
10⅜ x 13 ⁹/₁₆ in. (26.4 x 34.4 cm)
PH.1969.76
Gift of the Artist

One of Adams' most celebrated images, this work captures the intense, emotional response he experienced while watching the rising moon illuminate the small town of Hernandez, New Mexico. One critic noted that Adams' photographs "transcend the simple description of objects and landscape; they depict transient aspects of light, atmosphere and natural phenomena." Such an observation is certainly true of this enchanted image, in which an otherwise ordinary evening in a seemingly deserted city has been transformed into a powerful, mystical moment in time. ❖

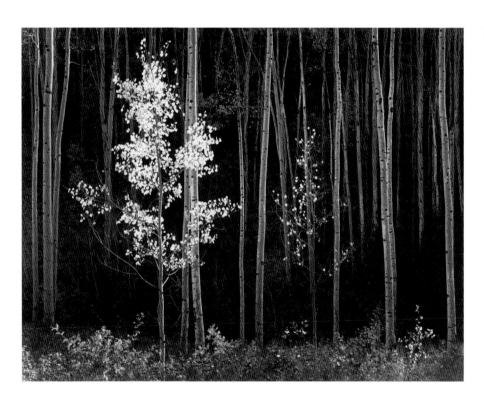

Ansel Adams

American, 1902–1984
ASPENS, NEW MEXICO, 1958
Gelatin silver print
10⅛ x 13 in. (25.7 x 33.0 cm)
PH.1969.75
Gift of the Artist

Adams is famous for his dramatic photographs of the natural world, saliently reflected in ASPENS, NEW MEXICO. Adams developed the "zone system," a method that controls and links exposure and development in order to more accurately express the photographer's intended vision—here to better capture the blackness of the aspen forest, and the white crispness of the leaves. Inspired by the landscape of the American West, Adams established the standard by which nature photography has been judged for the past sixty years. ❖

Manuel Alvarez Bravo

Mexican, 1902–2002

OPTIC PARABLE, 1931
Gelatin silver print
9⅜ x 7¼ in. (23.8 x 18.4 cm)
PH.1971.050
Museum Purchase through the
Florence V. Burden Foundation

PUBLIC FOUNTAIN, 1934
Gelatin silver print
9½ x 7½ in. (24.1 x 19.1 cm)
PH.1971.076
Museum Purchase through the
Florence V. Burden Foundation

Bravo became interested in photography at the age of twenty. His prolific career began in the thriving artistic climate of post-revolutionary Mexico alongside artists Diego Rivera, José Clemente Orozco, and David Alfaro Siqueiros. Bravo's interest in Surrealist aesthetics and imagery is reflected in his photographs, which capture vignettes from everyday life replete with symbolic and metaphoric messages. Fellow photographer Paul Strand described Bravo's work as "rooted firmly in his love and compassionate understanding of his own country, its people, their problems and their needs…He is a man who has mastered a medium which he respects meticulously and uses to speak with warmth about Mexico." ❖

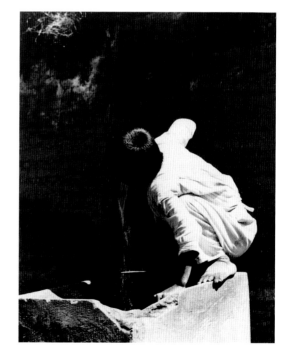

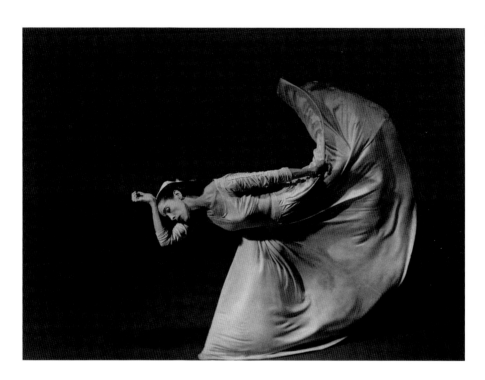

Barbara Morgan

American, 1900–1992
MARTHA GRAHAM—LETTER
TO THE WORLD, 1940
Gelatin silver print
14⅝ x 19⅝ in. (37.1 x 49.8 cm)
PH.1972.01
Gift of the Artist

Morgan studied painting at UCLA, but an Edward Weston exhibition influenced her decision to make a career in fine arts photography. She is best known for her series of photographs of American Modern dancers, and this is perhaps her most celebrated image. Morgan began the series in 1935 with Martha Graham and her company, working in the photographer's studio rather than onstage or in the rehearsal hall. The works are not records of a performance. Instead, each dance was conceived for the camera, with each action condensed to its most meaningful and eloquent gesture. Morgan described these photographs as metaphors, created to catch the symbolic image that epitomized the dance or dancer. ❖

Diane Arbus

American, 1923–1971
A Man and Wife at Home in a Nudist
Camp One Morning in New Jersey,
1963
Gelatin silver print
12⅞ x 12⅝ in. (32.7 x 32.1 cm)
PH.1970.005
Museum Purchase, Men's Committee
Fund

Arbus is recognized for her unflinching,
confrontational style. Although she began
her career in the world of commercial fashion
photography, in the early 1960s she began
making portraits of the mentally handicapped,
the homeless, and other marginalized people,
in their day-to-day surroundings. In this
work, the viewer catches a brief glimpse into
the normally unseen lives of nudists. Far from
shocking, the rotund woman and man, in
their sunlit living room, comfortably gaze at
the camera. Both individuals, nude except
for their footwear, smile in the midst of their
otherwise very ordinary living room. ❖

Roy De Carava

American, b. 1919
Man on Subway Stairs, 1952
Gelatin silver print
12⅞ x 8½ in. (32.7 x 21.6 cm)
PH.1970.038
Gift of Mr. Shirley C. Burden, in memory
of Flobelle Fairbanks Burden

De Carava began his career studying painting
and printmaking, but in the late 1940s, decided
to devote himself to photography. He received
a Guggenheim Fellowship in 1952, which
enabled him to produce a series of photographs
of everyday life in Harlem, the work for which
he became best known. In his Fellowship appli-
cation he proposed a look at Harlem from
inside its homes, but many of his images convey
life on the streets of New York as well. From
this period comes his Man on Subway Stairs,
one of several subway photographs, and char-
acteristic of his urban photographs that appear
to have been taken by chance. The photo-
graph conveys De Carava's brilliant handling
of natural light and ordinary settings. ❖

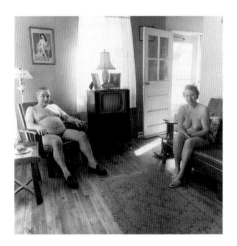

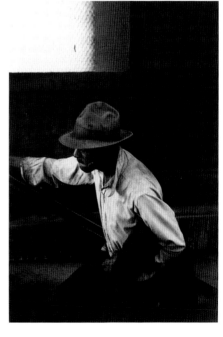

Frederick Sommer

American, 1905–1999

UNTITLED, 1961
Gelatin silver print
13¼ x 8 ¹¹/₁₆ in. (33.7 x 22.1 cm)
PH.1965.1.01
Gift of the Artist

PARACELSUS, 1959
Gelatin silver print
13 ¹⁵/₁₆ x 10 ³/₁₆ in. (35.4 x 25.9 cm)
PH.1965.1.05
Gift of the Artist

Sommer was a painter and landscape architect before he became interested in photography. During the mid-1950s, he began a series of camera-less photographs. To create these images, Sommer made a synthetic negative by painting cellophane with oil paint and placing it onto sensitized paper. Under surface tension, the opacity of the oil produced an image that, when suspended between two plates of glass, could be used as a negative to print a photograph. PARACELSUS, with its remarkable distribution of tones and textures, is suggestive of a gleaming, armored torso. In the early 1960s, Sommer began a series of luminous soft-focus nudes, radiant images revealing a dynamic balance of the rational and the intuitive. ❖

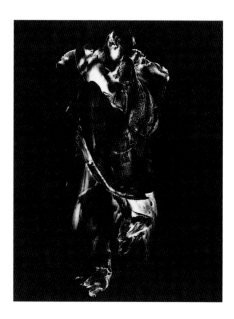

Minor White

American, 1908–1976

Sequence 16: Steely the
Barb of Infinity #7, 1960
Gelatin silver print
9½ x 7⅛ in. (24.1 x 18.1 cm)
PH.1970.046
Gift of Mr. Shirley C.
Burden, in memory of
Flobelle Fairbanks Burden

Sequence 16: Steely the
Barb of Infinity #9, 1960
Gelatin silver print
9⁷/₁₆ x 6⅞ in.(24.0 x 17.5 cm)
PH.1970.048
Gift of Mr. Shirley C.
Burden, in memory of
Flobelle Fairbanks Burden

One of the most important photographers of America's post-war period, White was an artist, theoretician, educator, editor, and critic. In 1946, he met Alfred Stieglitz and embraced his concepts of "straight" photography and "Equivalence." Straight photography was an aesthetic idea based on the direct recording of images without manipulative techniques. White extended the idea of Equivalents technically and conceptually. He believed that when a photograph functions as an Equivalent, "the photograph acts as a symbol or plays the role of a metaphor for something that is beyond the subject photographed." In the 1940s White began organizing his photographs into "sequences." Single prints are arranged in series so that each photograph borrows significance from the others to make a unified statement, encouraging an interpretation beyond the scope of a single image. White organized the photographs in terms of the emotions and feelings produced by the images and the relationships between them. These prints are from a series called "Sequence 16." Influenced by Charles Baudelaire's quotation, "There is no more steely barb than that of the Infinite," White also titled the series Steely the Barb of Infinity. ❖

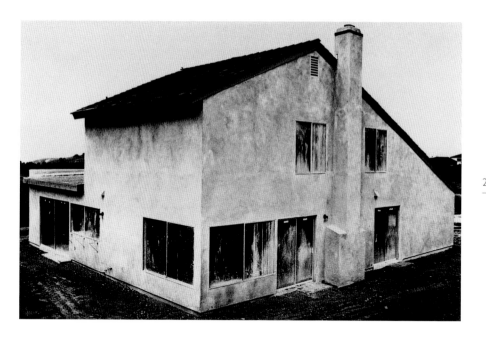

Lewis Baltz

American, b. 1945
TRACT HOUSE #4, 1971
Gelatin silver print, Edition of 12, No. 3
5¾ x 8⅞ in. (14.6 x 22.5 cm)
PH.1971.095
Gift of the Artist

A photographer concerned with America's changing topography, Baltz is best known for his controlled and emotionally detached views of the urban landscape. His photographs record public spaces, residential homes, construction sites, business developments, and their environments. This image is from the artist's TRACT HOUSES series, a haunting group of twenty-five photographs that meticulously document the banal details of suburban housing sites under construction in the Southern California area. The abstracted views of the residential tract homes present close-ups of architectural details such as large concrete walls, sliding aluminum windows, and large dirt yards, as well as wider shots that capture entire houses. Void of human figures, his images comment on the vacancy and loss of individuality in mass society. Individually and as a single body of work, the TRACT HOUSES combine formal elegance with a sense of underlying apathy, and focus upon the sepulchral quality of prefabricated housing. ❖

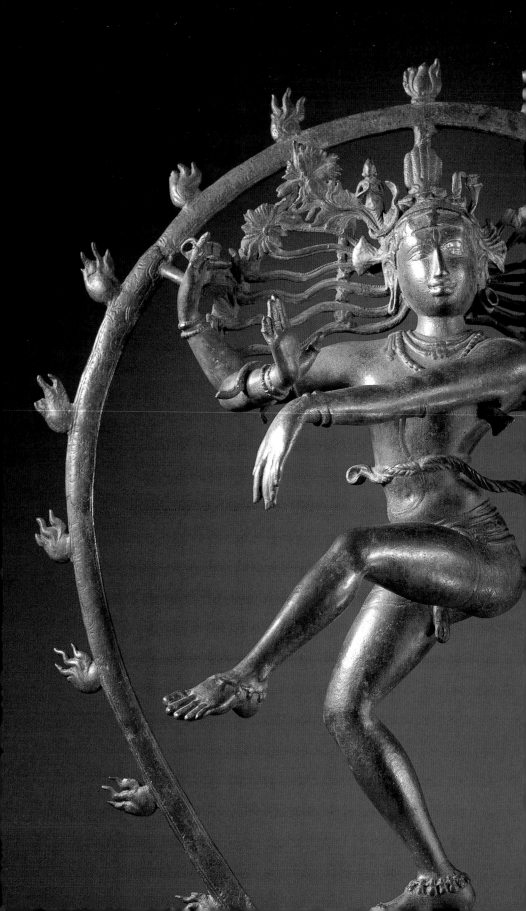

ASIAN ART

India

Uttar Pradesh (Kausambi)
A GODDESS OF ABUNDANCE,
1st century B.C.E.
Reddish terracotta
5½ in. (14.0 cm)
P.1996.1.3
Gift of Pratap and Chitra Pal
in honor of Norton Simon

This terracotta plaque depicts an elegantly ornamented goddess of abundance or a nature spirit known as a *yakshi*. The heavy bunch of fruits and foliage hanging from her right hand emphasizes her connection with fertility and the natural world. The surface abrasions on her face indicate that the plaque was handled and may have had a votive function. ❖

India

Madhya Pradesh (Bharhut)
RAILING PILLARS

Left: GODDESS AND AMOROUS
COUPLE, c. 100 B.C.E.
Sandstone
58 x 11 x 8¼ in.
(147.3 x 27.9 x 21.0 cm)
F.1972.11.1

Right: THE GREAT DEPARTURE OF
SIDDHARTHA, c. 100 B.C.E.
Sandstone
54 x 9 x 11 in.
(137.2 x 22.9 x 27.9 cm)
F.1972.55

These pillars once belonged to the great Buddhist stupa at Bharhut. The pillar on the left features a large female fertility figure, or *yakshi*, in the upper register, whose close association with nature is emphasized by the fruit-laden mango tree that she grasps, symbolizing fertility and abundance. Her left hand points to a loving couple (*mithuna*) in the lower register, an auspicious motif symbolic of prosperity and progeny. The pillar on the right relates the story of Prince Siddhartha (who becomes Buddha Shakyamuni) departing from his father's palace. Renouncing his life of luxury, he leaves his family and wanders as an ascetic in search of enlightenment, which he eventually attains. When Bharhut was built, the Buddha was not represented as a human figure. Instead, his presence is indicated by the footprints marked with lotus flowers in the upper right edge of the pillar and the parasol atop the horse's back. ❖

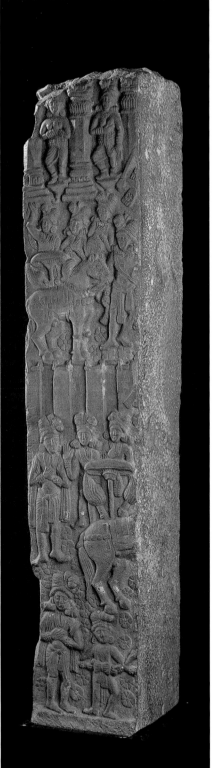

Pakistan

Ancient Gandhara
BUDDHA SHAKYAMUNI, c. 200
Schist
75 in. (190.5 cm)
F.1975.4.2

This impressive sculpture portrays the classic type of standing Buddha figures popular during the Kushan Period (1st–3rd century) in what is today Pakistan and neighboring Afghanistan. Characteristic of the Gandharan school, the Buddha's monastic robes bear a strong resemblance to a Greek toga, with prominent folds concealing much of the Buddha's body. Likewise, the head and facial features are classically rendered, and the hair is depicted as wavy strands that form an elegant pattern covering his cranial bump of wisdom (*ushnisha*). ❖

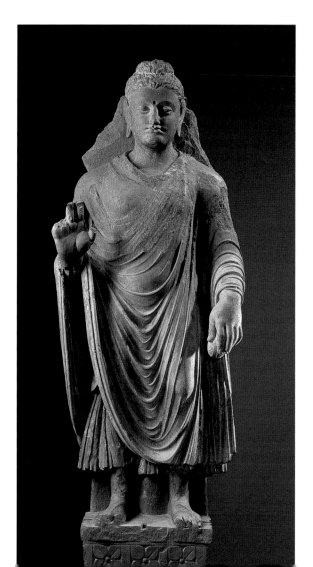

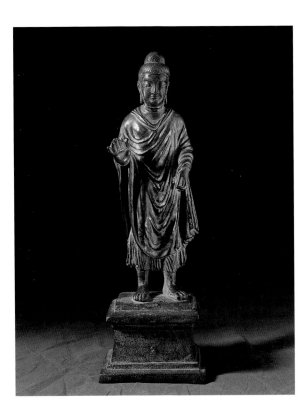

Afghanistan or Pakistan

Ancient Gandhara
BUDDHA SHAKYAMUNI,
5th–6th century
Brass
15⅝ in. (39.7 cm)
N.1979.22

Although a large number of stone carvings have survived from ancient Gandhara, relatively few metal images remain. This small image closely follows the iconography and style of colossal stone Buddha figures, but its function was much different. Small portable metal images served as votive offerings at monasteries, personal icons, and sacred souvenirs for pilgrims. ❖

Pakistan

Ancient Gandhara
SIDDHARTHA MEDITATING BELOW THE
JAMBU TREE, 3rd century
Schist
23 in. (58.4 cm)
F.1975.17.29

As a young prince, Siddhartha (the given name of Buddha) was taken into the fields to witness a plowing contest. He observed men sweating and exerting themselves and saw birds swooping down from the sky devouring insects. He soon became overwhelmed by these events, as they reflected the misery of human life and the inevitability of death. Siddhartha left the contest and wandered until he found a wood apple (*jambu*) tree. He sat beneath the tree and entered into a trance. This event was a precursor to his subsequent meditation under the bodhi tree. ❖

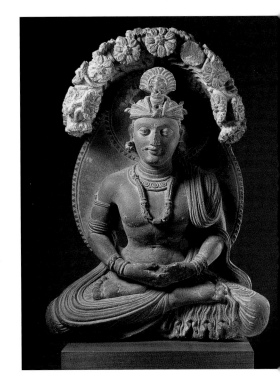

Pakistan

Ancient Gandhara
THE BUDDHA APPROACHING
THE BODHI TREE, 2nd–3rd century
Schist
16½ in. (41.9 cm)
F.1975.14.5

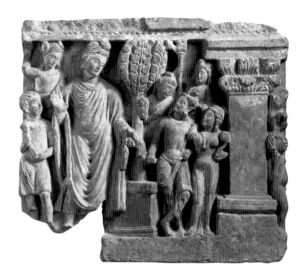

In this panel, the importance of the Buddha is signified by the fact that he is much larger than the other figures in the scene. This relief shows the Buddha selecting a tree under which to meditate and become enlightened. After the Buddha selects a mango tree, divine attendants lead him to a bodhi tree. The couple to his left point to the grass seat that awaits him under the tree. ❖

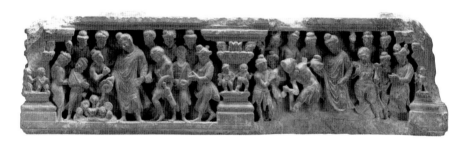

Pakistan

Ancient Gandhara
BUDDHA SUBDUES THE SERPENT AND CONVERTS
URUVILVA KASYAPA, 2nd–3rd century
Schist
8½ x 29¾ in. (21.6 x 75.6 cm)
F.1975.14.6

This narrative panel probably once adorned a Buddhist stupa and depicts one of the many miracles performed by the Buddha. In this particular story, Buddha visits the hermitage of Uruvilva Kasyapa and spends the night in a fire temple inhabited by dangerous snakes. The panel on the left shows a tamed snake jumping into the Buddha's begging bowl, while the panel on the right depicts Kasyapa recoiling in fear and disbelief at what he has seen. ❖

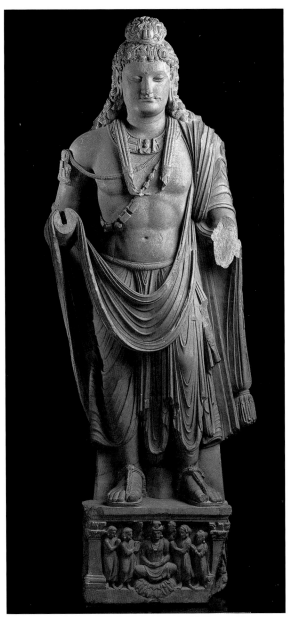

Pakistan

Ancient Gandhara
BODHISATTVA MAITREYA,
2nd–3rd century
Schist
69 in. (175.3 cm)
F.1975.4.1

A bodhisattva is a divine being who has attained enlight-
enment but forsakes the goal of nirvana in order to help
others on the path. The Bodhisattva Maitreya is known as
the Buddha of the future, or the Buddha-to-be, and is
commonly portrayed as a regal teacher. Whereas Indian
deities are usually unshod, classically influenced bodhisattvas
often wear sandals. Modeled upon a mortal princely figure,
the bodhisattva wears ornaments and protective charms.
However, his elongated earlobes, the dot between his eyes
(*urna*), and his cranial bump (*ushnisha*) reveal his super-
natural nature. ❖

Pakistan

Ancient Gandhara
AN ATLAS-LIKE WINGED
FIGURE, 3rd century
Schist
15¾ in. (40.0 cm)
F.1975.17.17

Winged male figures such as the one in this superb example were used to support the bases of structures such as stupas. While the figure is modeled on the classical figure of Atlas, who was condemned to support the globe with both arms, the Indian version is given wings and raises only one arm. ❖

India

Uttar Pradesh (Mathura)
NIMBUS FRAGMENT WITH CELES-
TIALS AND BODHI TREE, c. 100
Mottled red sandstone
21¾ x 39 in. (55.2 x 99.1 cm)
F.1975.16.1

This sandstone fragment was once part of a nimbus, or halo, surrounding Buddha Shakya-muni as he sat beneath a bodhi tree, recognizable by its distinctive heart-shaped leaves. The tree is actually a fig tree (*Ficus religiosa*), but became known as a bodhi tree because the Buddha reached enlightenment (*bodhi*) after meditating beneath one for forty-nine days. The two flying male figures are celestials bearing garlands as offerings to the Buddha. ❖

India

Uttar Pradesh (Mathura)
COLUMN FROM A BUDDHIST
STUPA, 1st century
Sandstone
91 x 8⅝ x 8¾ in.
(231.1 x 21.9 x 22.2 cm)
F.1975.7

This column is carved with scenes on two sides, which suggests that it was used as a corner post in a railing or gateway of a Buddhist monument. Of the eight low-relief panels, the lower six depict couples with floral offerings. The top right panel contains a knot of serpents in front of a stupa, a hemispherical funerary mound symbolic of the Buddha as well as the cosmic mountain. The top left panel features an empty bed strewn with flowers, representing Buddha Shakyamuni's death, or great release from the physical world (*mahaparinirvana*), as witnessed by two of his disciples. ❖

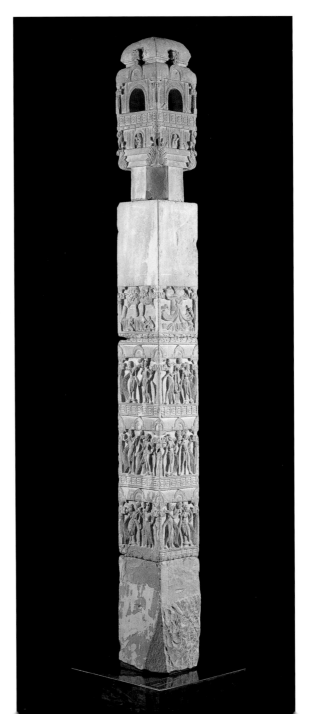

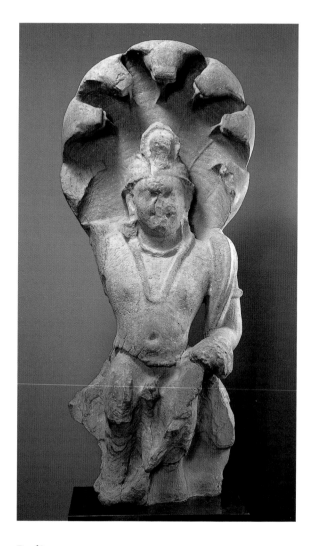

India

Uttar Pradesh (Mathura)
SERPENT DEITY, c. 100–150
Sandstone
78¼ in. (198.8 cm)
F.1972.22.2

In Indian art, serpent deities are often represented as humans
with snake hoods. Serpents (*nagas*) are thought to have the
power to cause rain, bringing forth growth and abundance.
Because they shed their skins, they are also considered
symbols of regeneration. The importance of this figure is
conveyed by his frontal pose, his monumental size, and the
seven-headed snake hood that rises above him like an enor-
mous canopy. When complete, this sculpture would have
been nearly nine feet high. ❖

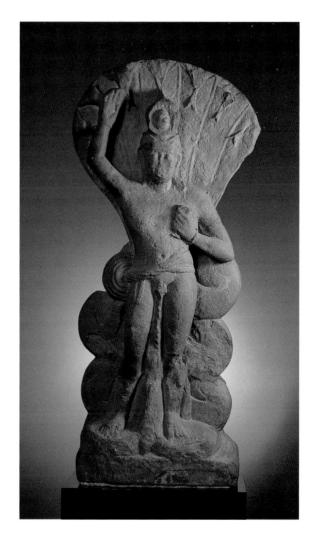

India

Uttar Pradesh (Mathura)
GOD BALARAMA, c. 150–200
Sandstone
63 in. (160.0 cm)
F.1975.15.1

As opposed to the frontal pose of the Serpent Deity, this figure stands in a contrapposto pose with his left hip thrust out and a goblet held to his chest. Balarama, a foster brother to Krishna, is closely associated with the serpent Ananta, on whom Vishnu sleeps. A serpent hood rises up behind his head and covers his entire back. The goblet is a frequent attribute of Balarama, who is very fond of drinking. ❖

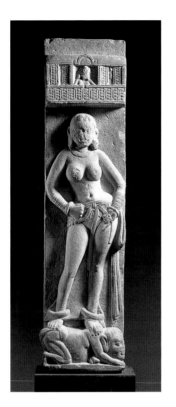

India

Uttar Pradesh (Mathura)
RAILING PILLAR WITH A YAKSHI,
2nd century
Sandstone
28½ x 7½ x 2½ in. (72.4 x 19.1 x 6.4 cm)
N.1972.12.1

This pillar depicts a nature goddess or *yakshi*, standing upon a crouching, dwarfish male figure who represents base desires and ignorance. On both sides of the pillar there are almond-shaped sockets for holding horizontal crossbars, which indicates that the pillar was once part of a railing surrounding a Buddhist stupa. ❖

India

Uttar Pradesh (Mathura)
VISHNU AS THE BOAR AVATAR, 3rd century
Sandstone
35½ in. (90.2 cm)
F.1975.16.6

This image depicts an important myth of the Hindus, in which Vishnu assumes the form of a boar to rescue the earth after it disappears under the ocean. In this manifestation, he is known as Varaha and has the head of a boar and the body of a man. With one breath of air, he is able to swim to the bottom of the ocean and return with the earth, shown here as a female goddess held gently in his mouth. The second, larger female figure is Vishnu's principal wife, Lakshmi, who holds a lotus flower. ❖

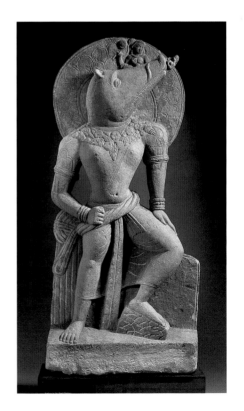

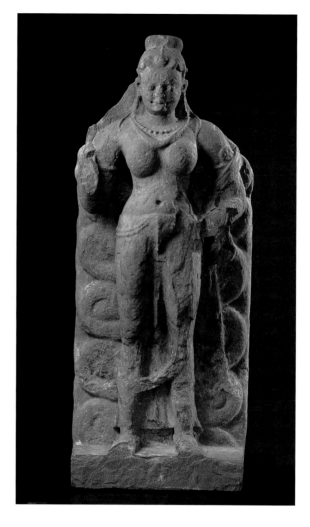

India

Uttar Pradesh (Mathura)
GODDESS REVATI, 4th century
Sandstone
66 in. (167.6 cm)
F.1972.37

This monumental sculpture represents the goddess Revati,
the wife of Balamara, and is the companion to an impres-
sive sculpture now in Zurich. Revati is given a snake hood
because her husband is a serpent deity and an avatar, or
manifestation, of the cosmic serpent Ananta. Snakes are
associated with the waters and are said to guard the trea-
sures that lie deep within the earth. Carved in high relief
to emphasize her volume, Revati stands in a frontal posture
with both feet planted firmly on the ground. ❖

India

Uttar Pradesh
KUBERA, THE GOD OF
WEALTH, 4th century
Sandstone
20⅛ in. (51.1 cm)
M.1975.II.4

Kubera is regarded as the god
of wealth and the ruler of the
northern quadrant of the uni-
verse. One of his attributes is a
cup for holding liquor, of which
he is very fond. He can also be
identified by his distinctive
posture, as he sits on his haunches
upon a low seat. His potbelly
manifests his well-being and
good fortune. ❖

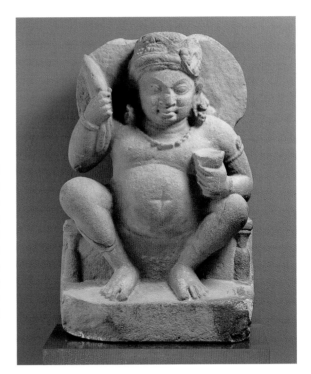

India

Bihar
BUDDHA SHAKYAMUNI, C. 550
Bronze
16½ in. (41.9 cm)
F.1972.I

Portraying the historical Buddha
Shakyamuni, this bronze prob-
ably emerged from a Tibetan
monastery, like most other
Gupta period (c. 300–600)
bronzes. Perhaps this bronze
survived because it was taken to
Tibet as a sacred relic or a monk's
souvenir. The Buddha's slim
and graceful body is revealed
by his transparent monastic
robes. His broken right hand
displays the gesture of reassur-
ance while his left hand holds
the end of his robe. ❖

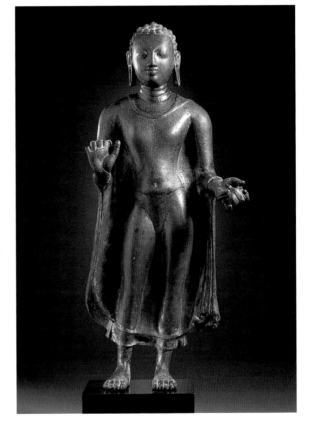

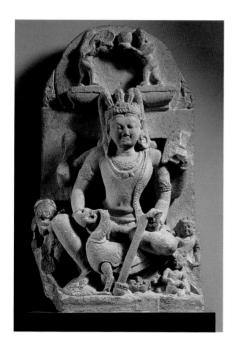

India

Uttar Pradesh
THE DIVINE GENERAL KUMARA, 8th–9th
century
Sandstone
25½ in. (64.8 cm)
F.1972.19.5

Kumara, also known as Skanda or Karttikeya, is the divine general of the gods and the son of Shiva and Parvati. Sitting lightly upon the back of his pet peacock—whose neck and head have been broken off—he is busy feeding it. The palm-leaf manuscript in his upper left hand indicates that he is also the god of wisdom. ❖

India

Uttar Pradesh
SUN GOD SURYA WITH RETINUE,
9th century
Sandstone
44½ in. (113 cm)
N.1974.6.2

Surya is the sun god within the Hindu pantheon. As is customary, he stands upright on a lotus base and wears a tall crown and boots. He holds two lotuses and is accompanied by his two wives, his attendants Dandi and Pingala, and other celestial figures. ❖

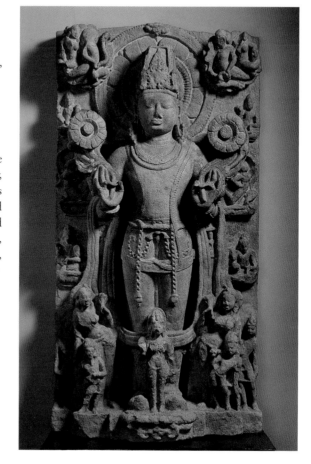

India

Uttar Pradesh or Madhya Pradesh

GOD SHIVA, 10th century
Sandstone
33½ in. (85.1 cm)
F.1975.14.7

CELESTIAL FEMALE, 10th century
Sandstone
32 in. (81.3 cm)
F.1975.14.8

Stylistically, these two sculptures are closely related and are
probably from the same temple. Each would have graced a
recess on an external wall. The Hindu god Shiva can be
identified by his faithful bull companion, who here resem-
bles an obedient dog looking admiringly at his master. He
also has a distinctive matted hairstyle and a third eye. The
female could be his wife Parvati, but without any attrib-
utes she cannot be identified. ❖

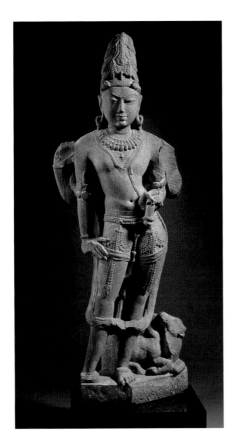
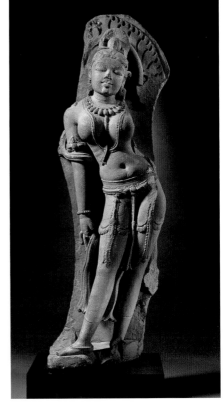

India

Madhya Pradesh
GANESH WITH SIDDHI AND BUDDHI, 1164
Sandstone
47 in. (119.4 cm)
F.1975.16.7

The inscription on the base of this sculpture
provides us with a date, the donor, as well as
the names of the two ladies sitting on Ganesh's
lap. They are his wives Siddhi (Prosperity)
and Buddhi (Intelligence). His wives hold
two of his attributes, his broken-off tusk and
a bowl of sweets, while Ganesh holds his
battle ax and a lotus bud. ❖

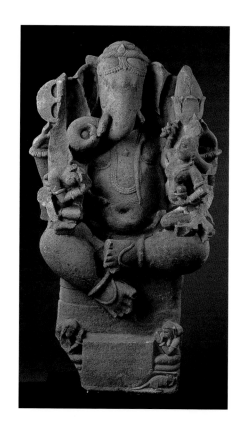

India

Rajasthan, Harshagiri (?)
A PANDAVA HERO (?), c. 956
Sandstone
86¼ in. (219.1 cm)
F.1976.7

The Pandava brothers, who battle and even-
tually defeat the Kurus, are the heroes of the
great Hindu epic, the *Mahabharata*. This
monumental figure cradles the fragment of
a bow under his left arm; his right arm prob-
ably once held an arrow. A quiver of arrows
is visible behind his left shoulder. However,
since other gods also carry bows and arrows,
his exact identification cannot be determined.
He may represent Rama, an avatar of Vishnu,
who was also a great archer. What is clear is
that this image must have once belonged to
a temple of enormous size. ❖

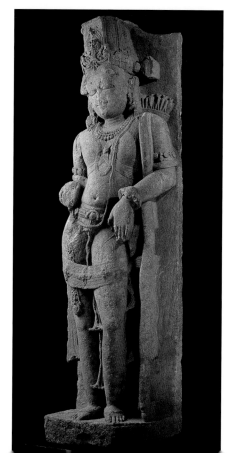

India

Bihar
GODDESS TARA, late 9th century
Schist
37 in. (94.0 cm)
M.1974.6

The Buddhist deity Tara is the goddess of compassion, who aids devotees in overcoming personal difficulties. Represented here in her classical form, she stands on a lotus base in an elegant posture. Her right arm is gracefully outstretched in the gesture of charity and a lotus bloom is carved upon her open palm. The inscription inside her halo is the Buddhist creed, which reads "[Buddha] has revealed the cause of those phenomena which spring from a cause and also [the means of] their cessation. So says the Great Monk." ❖

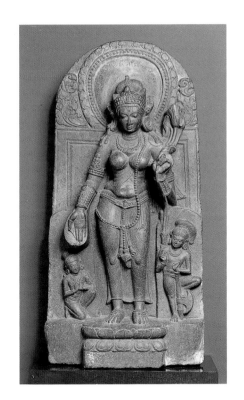

India

Bihar (Gaya Region)
BUDDHIST TRIAD WITH SHAKYAMUNI,
c. 1000
Schist
26¾ in. (67.9 cm)
F.1973.1.1

The large central figure is Buddha Shakyamuni, seated beneath the bodhi tree, suggested by the two large branches with leaves on either side of his head. The Buddha's enlightenment is signified by his gesture of touching the earth with his right hand. This triad also includes a lion throne, which serves to emphasize his transcendental nature. ❖

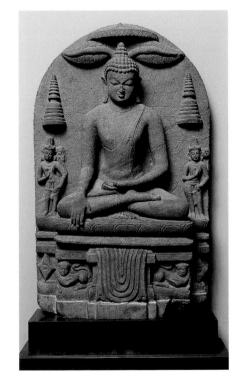

India

Gujarat
JINA AJITANATHA AND HIS
DIVINE ASSEMBLY, 1062
White marble with traces of
pigment
59 in. (149.9 cm)
M.1998.1

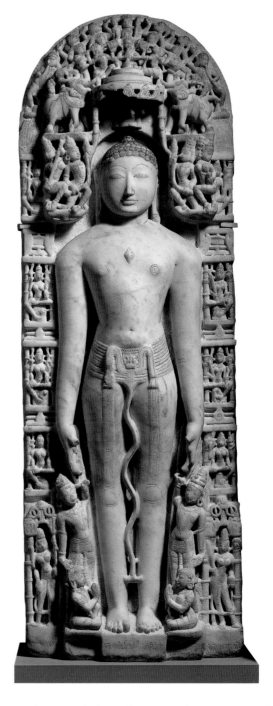

Because he wears clothing, this Jina can be associated with
the Shvetambara (white-clad) order of Jainism. The inscrip-
tion identifies him as Ajitanatha, the second of the twenty-
four liberated teachers revered by all Jains. He stands in the
conventional body-abandonment pose, in which his arms
hang to the side without touching his body. He is surrounded
by a host of deities and celestial attendants, while devout
donors are seated at his feet. ❖

India

Bihar
Man-Lion Avatar of God
Vishnu, c. 1000
Chlorite
46 in. (116.8 cm)
F.1975.17.47

In the incarnation known as Narasimha, Vishnu destroys the titan king Hiranyakasipu, who was so powerful that he could not be killed by god, man, or beast. Hence, Vishnu assumed the form of a lion-headed man, and became neither man nor beast. On the left edge of the sculpture, Narasimha is seen emerging from a column, while his wife Lakshmi stands to his left. His conch shell rests beneath his left foot as he tears open the titan's belly. ❖

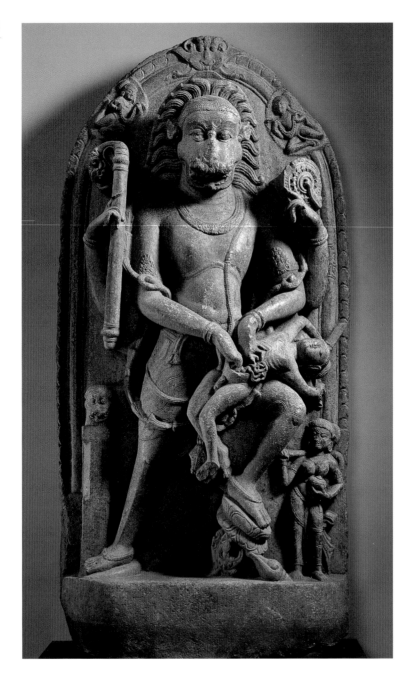

India

West Bengal or Bangladesh
SUN GOD SURYA WITH DANDI
AND PINGALA, 8th century
Bronze
7½ in. (19.1 cm)
M.1977.30.13

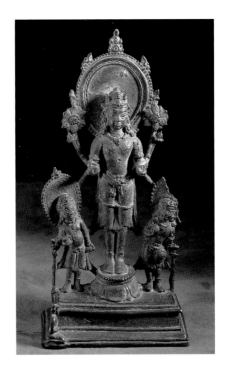

The Hindu solar deity Surya is generally represented as a regal figure with a crown, holding two lotus blossoms in his upraised hands. He has a prominent halo decorated with a bead motif, geometric patterns, and flames, as do his two attendants. Dandi, on Surya's left, is the god's measurer, while Pingala, on his right, is the recorder who writes down mankind's good and bad deeds. ❖

India

West Bengal
STELE WITH TRANSCENDENTAL
BUDDHAS AND GODDESSES,
c. 1100
Chlorite
27⅞ in. (70.8 cm)
F.1972.41

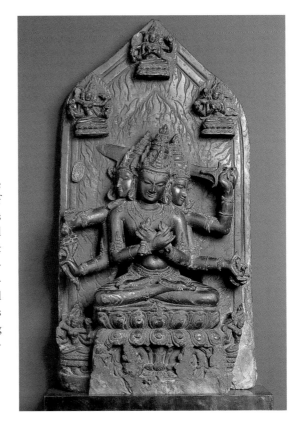

This is a rare image of one of the five transcendental Buddhas of the Vajrayana pantheon. He holds attributes of both Vajrasatva and Manjusri, two other important Buddhist deities, and is accompanied by four goddesses. Noteworthy are the multiple heads and arms, which signify the figure's cosmic nature, and the leaping tongues of flames in the background. ❖

India

Himachal Pradesh
VISHNU AND LAKSHMI WITH AVATARS,
11th century
Copper alloy
23¼ in. (59.1 cm)
F.1972.48.1

This elaborate altarpiece is one of the most impressive Hindu bronzes to survive from the Pratihara dynasty (805–1036) of north-central India. Vishnu affectionately embraces his wife Lakshmi, and the divine couple is surrounded by his various avatars, or incarnations. The supreme form of Vishnu is placed at the peak of the arch, where he sits in deep meditation holding his primary attributes, the club and wheel. ❖

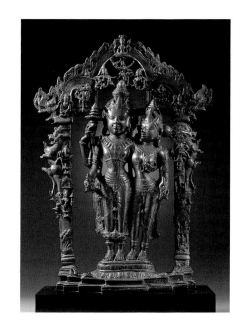

India

Orissa
CELESTIAL FEMALE WITH A BUNCH OF
MANGOS, 13th century
Brown gneiss
48½ in. (123.2 cm)
F.1975.17.2

While she cannot be identified specifically, this female is clearly a fertility deity. A robust figure, she grasps a bunch of mangos. A native fruit of the Indian subcontinent, the mango represents both abundance and auspiciousness. ❖

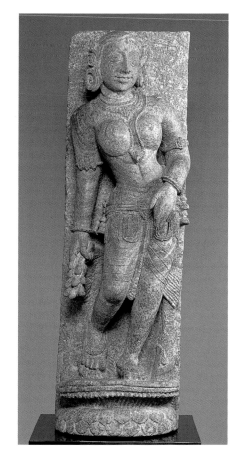

India

Orissa
AMOROUS COUPLE,
13th century
Brown gneiss
69 in. (175.3 cm)
F.1976.4

Loving couples such as this pair
are known as *mithuna*. The
depiction of affectionate couples,
symbolizing both fertility and
desire (*kama*), is a common
occurrence in Indian temple
art. Some of the boldest repre-
sentations, both thematically
and sculpturally, such as this
example, were carved for the
great Sun temple at Konarak in
Orissa. ❖

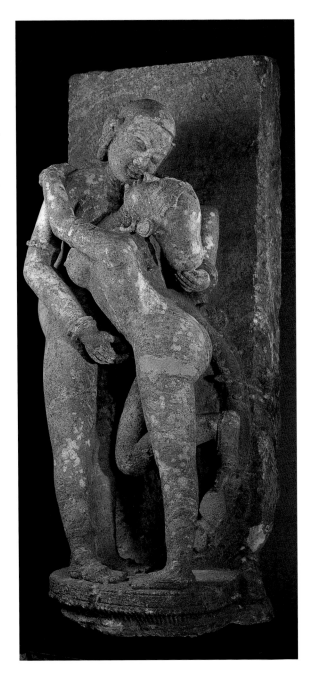

India

Tamil Nadu (Shivapuram)
SHIVA WITH UMA AND SKANDA,
c. 950–975
Bronze
23 x 27½ x 14 in.
(58.4 x 69.8 x 35.6 cm)
F.1972.23.1

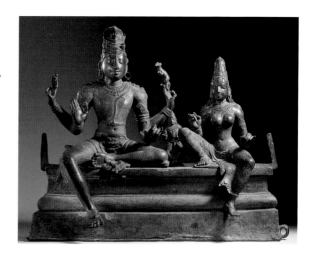

A strong familial bond is expressed in this sculpture depicting the Hindu god Shiva, his spouse Uma, and their son Skanda. This particular composition, with Skanda dancing between his seated parents, is found primarily in South India and was extremely popular during the Chola period. Protectively tucked in between his parents, the frolicking Skanda will grow up to become the god of war and leader of the armies of the gods. ❖

India

Tamil Nadu
GOD GANESH, 950–1000
Bronze
16 in. (40.6 cm)
F.1972.28

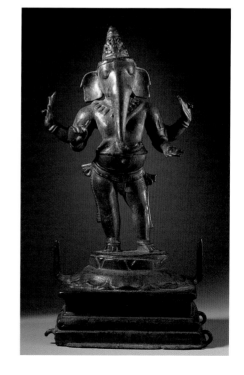

The elephant-headed god Ganesh is the remover of obstacles and the god of wisdom and prudence. The son of Shiva and Parvati, he is also the learned scribe who wrote the epic *Mahabharata* as it was dictated to him by the sage Vyasa. Several stories tell of the origin of his head, one of which involves Parvati's brother, the planet Saturn, who destroyed it with his evil eye. Remorseful over his sister's grief, Saturn grafted onto his nephew the first available head, which happened to belong to an elephant. Ganesh's trunk usually hovers over a handful of sweets, which accounts for his corpulent belly. ❖

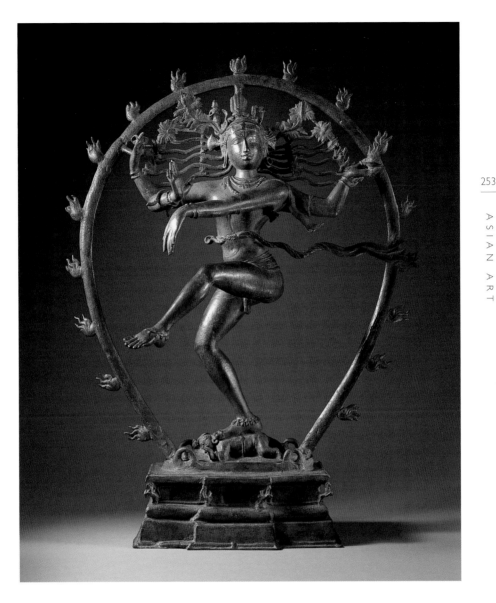

India

Tamil Nadu
SHIVA AS KING OF DANCE,
c. 1000
Bronze
31¾ in. (80.6 cm)
F.1973.5

Shiva, the Hindu god of destruction, is depicted here dancing within a circle of flames. Shiva's dance has cosmic significance, as it symbolizes the creation, preservation, and destruction of the universe in an endlessly repeating cycle. His upper right hand holds a drum, the beating of which creates the universe, while the upper left holds the flame that will eventually destroy it. His lower right hand displays the gesture of reassurance, while his lower left points to the ground as an indication of his power and strength. He dances upon a dwarf, who represents ignorance and base desires. This complex composition is rich in symbolism and is arguably one of the most familiar Indian images. ❖

India

Tamil Nadu
SHIVA THE BULL-RIDER AND PARVATI, C. 1000
Bronze
Parvati, 34½ in. (87.6 cm); Shiva, 39½ in. (100.3 cm)
F.1982.2.2; F.1972.24

Parvati is the daughter of the Mountain King Parvata. When she is with her husband, Shiva, her right hand holds a lotus flower while her left arm hangs gracefully to the side of her body "like the tail of a cow" (*lolahastamudra*). She is the embodiment of feminine beauty and grace. Her companion is the majestic Shiva Vrishavahana. He stands in a relaxed posture and would have leaned upon the head of his bull, known as Nandi or Vrisha, which is now missing. The god's recognizable attributes include his elaborate hairstyle, in which his long matted hair is piled up on top of his head to form a crown, elaborate jewelry, and armbands. ❖

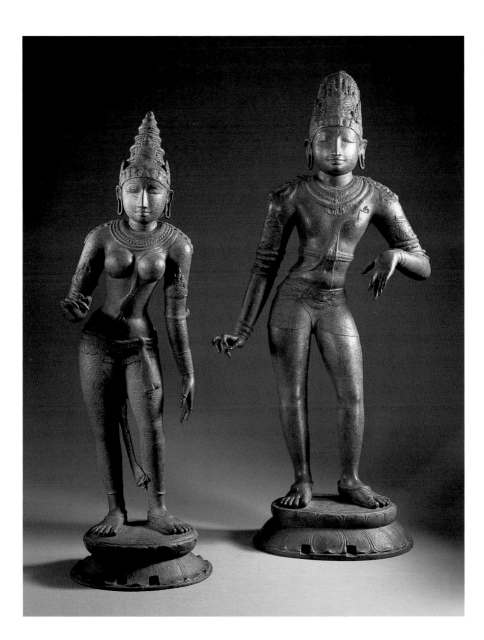

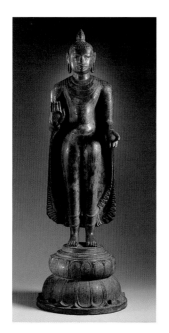

India

Tamil Nadu (Nagapattinam)
BUDDHA SHAKYAMUNI, late 11th century
Bronze
29¾ in. (75.6 cm)
F.1972.31.2

The coastal town of Nagapattinam in the southern Indian state of Tamil Nadu was one of the few areas where Buddhism flourished under the Chola rulers. In addition to being a port city, it was also a center for Buddhist faith and learning. A distinctive feature of Nagapattinam Buddhas is their flame-embellished cranial bump, which signifies transcendental knowledge. ❖

India

Tamil Nadu (Nagapattinam)
BUDDHA SHAKYAMUNI,
c. 1100
Granite
50 in. (127 cm)
F.1975.17.3

This impressive Buddha sits in a classic meditation posture in which the hands are placed palm side up on top of the sole of the right foot. His eyes are rather narrow and half-shut, as is appropriate for a meditating figure. His monk's garments are nearly transparent and cling to his fleshy form. Like the bronze example, this Buddha, too, has a flame atop his head. ❖

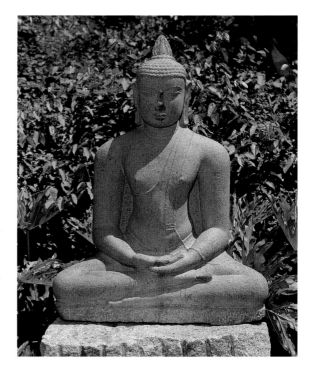

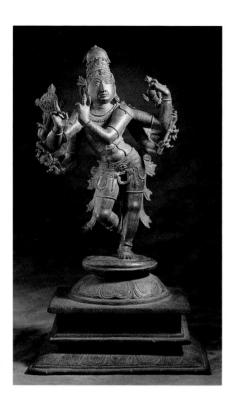

India

Tamil Nadu
COSMIC FORM OF KRISHNA, 15th century
Bronze
19⅜ in. (49.2 cm)
F.1972.19.7

Krishna is a manifestation of the great Hindu
god Vishnu and is represented frequently at
several different stages of his life. As a mischie-
vous child, he is depicted stealing butter,
dancing, or crawling. As a youth he is a hand-
some cow-herder and plays a flute to enchant
the cows as well as his female admirers.
Although this particular Krishna plays a flute,
which is now missing, his iconography is
complex and combines the concepts of Krishna
and Vishnu. ❖

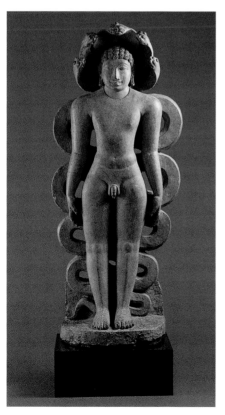

India

Karnataka
JINA SUPARSVANATHA, c. 900
Schist
32¼ in. (81.9 cm)
F.1975.17.6

Jainism is a religion that stresses asceticism.
Divine figures are depicted in the upright
pose of meditation or the body-abandonment
pose, in which the arms hang down but do
not touch the body. Out of a group of twenty-
four saints, Suparsvanatha can be recognized
by his five-headed snake hood. ❖

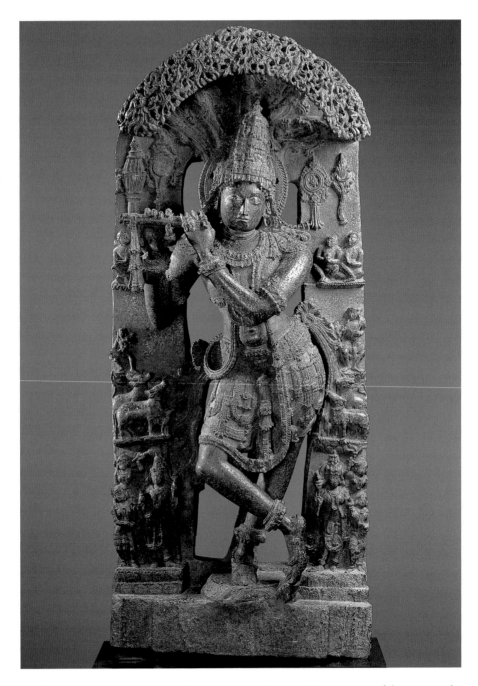

India

Karnataka
FLUTING KRISHNA IN
BRINDAVAN, 1100–1150
Schist
63 in. (160.0 cm)
F.1972.11.3

The monumental size and deep carving of this piece make it one of the finest examples of the ornate style that developed during the Hoysala Dynasty (1100–1300). Krishna spent his early life fluting in the bucolic groves at Brindavan while tending to the animals and the young ladies. Adorned with gems and jewels, he is accompanied by his wives, other musicians, and admiring sages. ❖

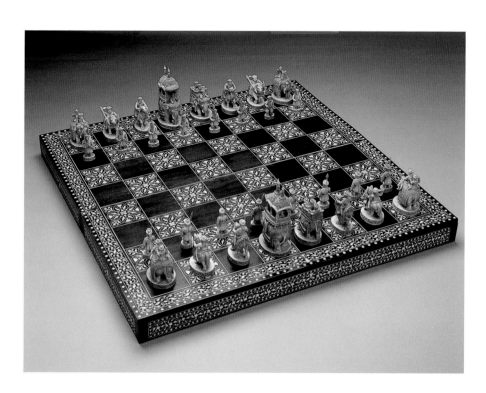

India

Delhi region
CHESS SET, c. 1850
Pieces: ivory; Board: wood
inlaid with ivory
Pieces: 3–6 in. (7.6–15.2 cm);
Board: 29¾ x 29¾ x 2¼ in.
(75.6 x 75.6 x 5.7 cm)
F.1978.20.1–33

The game of chess was invented in India many centuries
ago. It was conceived as a war game and modeled after the
confrontation of armies on a battlefield. In the first row,
the pawns appear as foot soldiers. In the second row, the
king and his prime minister ride elephants, flanked by
generals commanding the camel brigade, the cavalry, and
the elephant brigade. During the Middle Ages, the game
was introduced into Europe and transformed into a game
of courtly intrigue. The prime minister was replaced by the
queen, the camel brigade by the bishop, and the elephant
brigade by the castle, or rook. ❖

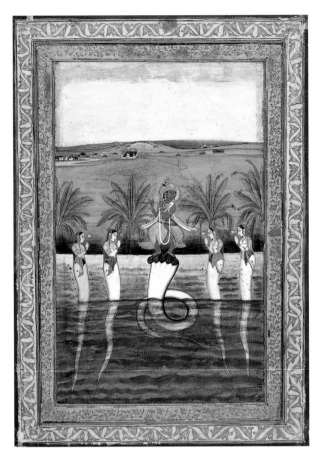

India

Himachal Pradesh, Kangra
workshop
ADORATION OF GANESH,
1800–1825
Gouache on paper
10⅞ x 14½ in.
(27.6 x 36.8 cm)
P.2000.9.3
Gift of Ramesh and Urmil
Kapoor
❖

India

Rajasthan, Kishangarh
KRISHNA DANCING ON KALIYA, c. 1775
Opaque watercolor on paper
15 x 10⅝ in. (38.1 x 27 cm)
P.2001.14
Gift of Suneet and Alka Kapoor

This painting depicts the popular myth of Krishna subduing
the serpent demon Kaliya, who was poisoning the Jamuna
River. In the center of the painting, Krishna is shown dancing
upon the multiple hoods of Kaliya, while on either side a
pair of mermaids, companions to Kaliya, plead for their
master. ❖

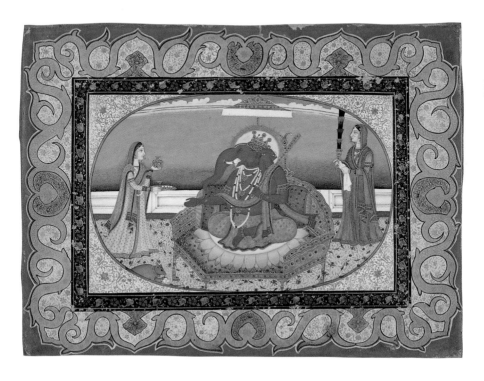

India

Himachal Pradesh, Kangra workshop
AN EQUESTRIAN PORTRAIT OF A SIKH
PRINCE, c. 1825–50
Opaque watercolor on paper
9½ x 7⅛ in. (24.1 x 18.1 cm)
P.1999.3.3
Gift of Ramesh and Urmil Kapoor

Admired for their courage and physical prowess,
the Sikhs form a distinct and admired commu-
nity in India. Sikhs are easily distinguished
from other Indians by their turbans, which
cover their long hair and beards, which they
are forbidden to cut. Sikh gurus are both reli-
gious and military leaders and are commonly
portrayed as princely soldiers, as in this eques-
trian portrait. ❖

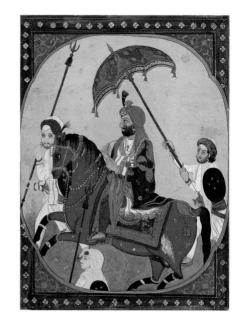

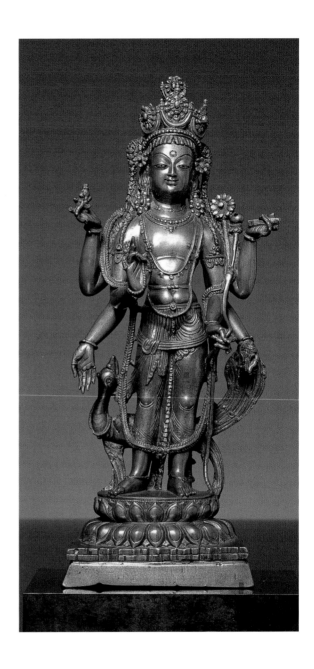

India

Kashmir
BODHISATTVA MANJUSRI,
800–850
Bronze inlaid with silver and
copper
20⅛ in. (51.1 cm)
F.1978.27

Manjusri, the bodhisattva of wisdom, is depicted here with his peacock companion, who looks up adoringly at his master. Manjusri is portrayed as a beautiful and handsome young god, whose right hands exhibit the gesture of charity, hold a rosary and the three jewels, while his left hands hold a book, a flowering lotus, and a fruit. His elaborate tiara with floral crests, multiple necklaces, and a long garland reaching nearly to his feet are all typical of Kashmiri sculptures. ❖

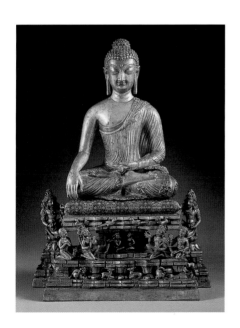

India

Kashmir
Buddha and Adorants on the Cosmic
Mountain, c. 700
Bronze inlaid with silver and copper
13¼ x 9½ x 4¾ in. (33.7 x 24.1 x 12.1 cm)
F.1972.48.2

This masterpiece of Indian metal sculpture is one of the most sumptuous Buddhist altar-pieces to have survived from Kashmir. Buddha Shakyamuni is seated in the meditation posture on a thick cushion with lavish designs, rather than upon a lotus. Beneath him is a rocky formation representing the cosmic mountain. The mountainous abode is divided into three realms—animal, human, and celestial—from bottom to top. The probable intent is to represent the historical Buddha as a transcendental figure seated on the cosmic Mount Meru, which is the central peak or *axis mundi* of the world. ❖

India

Kashmir
Preaching Buddha, 694
Bronze inlaid with silver
14½ in. (36.8 cm)
F.1973.29

The Buddha is seated upon a double lotus base in the classic meditation posture, with both hands raised to his chest, the index finger and thumb of each hand touching. This gesture symbolizes the turning of the wheel of Buddhist law into motion, which occurred when the Buddha preached his first sermon at the Deer Park in Sarnath. Other features that demonstrate his divine or suprahuman status are his cranial protuburance (*ushnisha*), symbolic of his wealth of knowledge, his third eye of wisdom (*urna*), his long earlobes, and the three rings around his neck, which are perceived as marks of beauty and imitate the three circles near the mouth of a conch shell. ❖

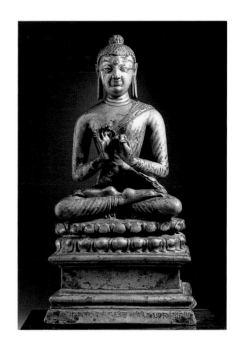

Nepal

DIPANKARA BUDDHA,
c. 1600–1650
Gilt and enamelled copper
inlaid with gems and pigments
32½ in. (82.6 cm)
M.1974.13

According to legend, Dipankara, the Buddha of the past, predicted the coming of Buddha Shakya-muni. While out on a walk, Dipankara was about to step into a puddle of water. A young man named Sumati appeared and spread his long hair across the puddle so that the Buddha's feet would not be soiled. Dipankara then pronounced that Sumati would be reborn in the future as a Buddha. Richly adorned with an elaborate crown, earrings, and necklaces, Dipankara wears the crimson robes typical of a monk, although his are made of sump-tuous brocade and folded into decorative pleats. Originally he would have been accompanied by two monk disciples. ❖

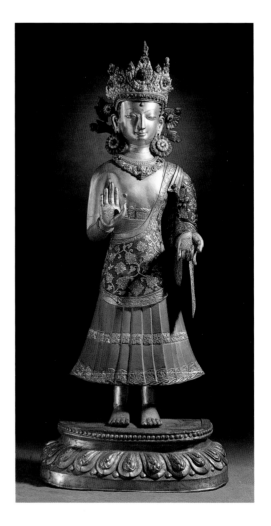

Nepal or Tibet

BUDDHIST GODDESS TARA, c. 1300
Gilt copper inlaid with semiprecious stones and pigments
34¾ in. (88.3 cm)
F.1976.5.1

The largest Himalayan bronze in the collection, Tara is a savior goddess and the female counterpart of Bodhisattva Avalokiteshvara. Born from one of Avalokiteshvara's tears, Tara is an embodiment of feminine grace and compassion. Elegantly bejewelled, her diaphanous garment accentuates her sensuous physical form. In both Nepal and Tibet she has enjoyed great popularity, as she helps devotees overcome difficulties encountered on the path to enlightenment. Her raised left hand exhibits the gesture of teaching while her lowered right hand with the palm facing outward displays the gesture of charity. ❖

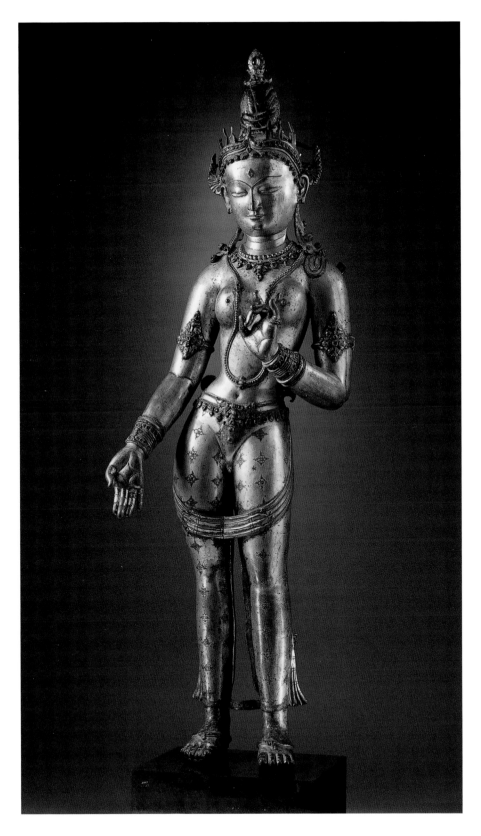

Nepal or Tibet

BUDDHA SHAKYAMUNI,
12th century
Gilt copper alloy with
pigments
27½ in. (69.9 cm)
F.1972.45.12

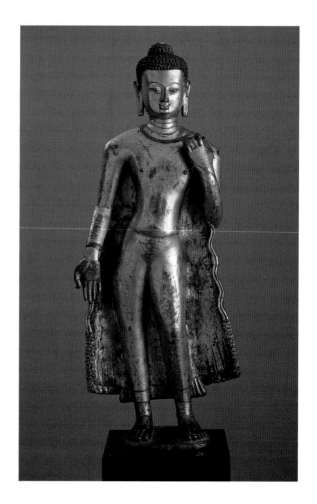

Images of the Buddha from the Himalayan regions of Tibet
and Nepal are characterized by graceful postures and elegant
modeling. The smooth, rounded surfaces of the Buddha's
body contrast with the frenzied exuberant edges of his
shawl, which create a backdrop for his sleek form. His right
palm is marked with the lotus flower and displays the gesture
of charity. While his physical build and iconography relate
to Nepali Buddha images, the traces of indigo pigment in
his hair demonstrate that he once graced a monastery in
Tibet. ❖

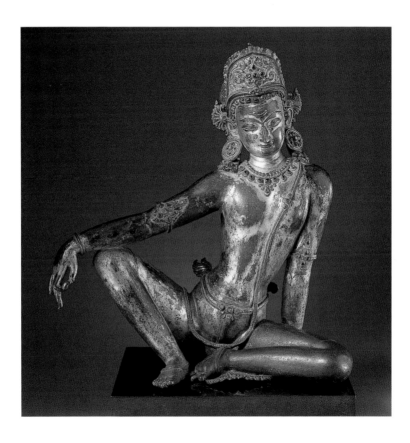

Nepal

God Indra, 13th century
Gilt bronze
16⅛ x 12³/₁₆ in.
(41.0 x 31.0 cm)
F.1972.27

Indra is the king of the gods and a prominent deity in both
the Hindu and Buddhist pantheons. In Nepali figures, Indra
usually wears a crown or elaborate tiara and is portrayed in
a royal posture that expresses a relaxed yet dignified atti-
tude. This iconographic type was an invention of Nepali
artists, whose extraordinary finesse with metalwork is also
evident in the figure's meticulously crafted details and gem-
inlaid ornaments. With an emphasis on his royalty rather
than his fierceness as a warrior, Indra is depicted without
any of his usual battle emblems. He is given one of his more
unique attributes, a horizontal third eye that resembles the
female sexual organ. Indra violated the wife of a sage, who
cursed him by marking his body with a thousand such
symbols. ❖

Nepal

A BODHISATTVA, 13th century
Gilt copper alloy inlaid
with semiprecious stones
and pigments
23¾ in. (60.3 cm)
F.1983.28

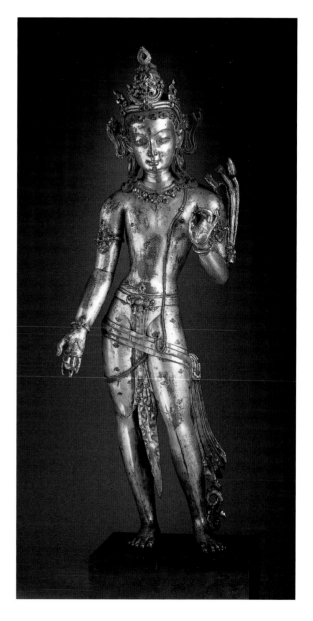

A bodhisattva is a compassionate being who postpones his
own enlightenment in order to help others along the path.
Generally, bodhisattvas wear monastic robes as well as earthly
accessories such as necklaces and crowns to distinguish them
from enlightened beings. A combination of ascetic and
prince, the bodhisattva is distinguished only by the attrib-
utes he holds, which can be lost over time. ❖

Nepal

A Bodhisattva, 11th century
Gilt copper alloy
17 in. (43.2 cm)
F.1973.13.1.S

❖

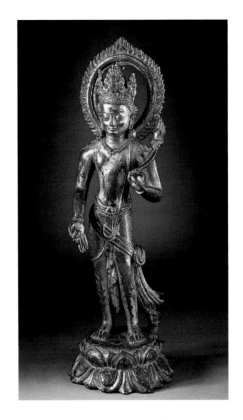

Nepal or Tibet

A Bodhisattva, 10th century
Gilt copper alloy
13½ in. (34.3 cm)
F.1972.42.3

This figure can be tentatively
identified as the Bodhisattva
Avalokiteshvara, whose primary
attribute is the lotus flower. He
holds what appears to be a short-
stemmed flower bud, rather
than the more typical blossoming
flower with a long stalk. Another
unusual feature is the large
crested tiara, which nearly covers
his tall chignon and may indi-
cate a familiarity with Chinese
artistic traditions. ❖

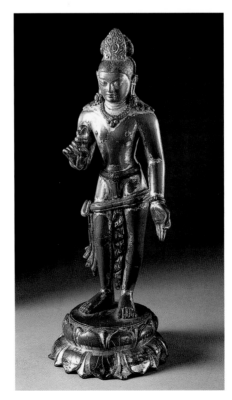

Nepal

GODDESS USHNISHAVIJAYA WITH MYRIAD STUPAS, 1533
Opaque watercolor on cotton
20⅜ x 16⅞ in. (51.8 x 42.9 cm)
P.1999.4
Gift of Doris Wiener

The deity represented within the stupa in the center of this painting is the Goddess Ushnishavijaya, the victorious goddess of wisdom and long life. A stupa is a Buddhist shrine or monument modeled after a burial mound. The goddess has three heads and eight arms, which display hand gestures and hold various attributes, including a vase of the elixir of immortality in her lap. The painting was commissioned by a Newar donor to commemorate the performance of Ushnishavijaya's rite in order to gain longevity. The numerous smaller stupas represent the symbolic gift of additional stupas by the same donor in order to earn religious merit for his next life. ❖

Nepal

Kathmandu Valley
NARRATIVE SCROLL EXTOLLING MANAVINAYAKA, c. 1575
with details
Opaque watercolor on cotton
14 x 72½ in. (35.6 x 184.2 cm)
F.1983.27

The story presented in this vividly painted scroll celebrates the virtues of the god Ganesh, who appears in a form known as Manavinayaka. The story begins in the upper left hand corner with a red Ganesh dancing on his rat mount. Next appears the great Hindu god Shiva and his wife Parvati, who are playing a game of dice (*top left detail*). A character named Vadava, the smaller flesh-colored figure beside Shiva, gives him a charm so he will win the game. Enraged, Parvati curses Vadava, who sinks to the ocean and is attacked by sea monsters (*top right detail*). Various gods advise Vadava to seek the help of Ganesh, which he does by performing special rites in his honor. As a result, Vadava is finally released by the aquatic creatures. The long panel on the bottom tier shows Vadava and others worshipping Manavinayaka (*bottom detail*). ❖

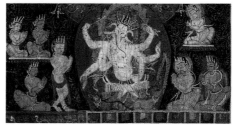

Nepal

Bhaktapur (?)
BHAIRAVA RAGA, c. 1625
Opaque watercolor and gold
on paper
7 x 5½ in. (17.8 x 14.0 cm)
M.1979.92.1

These paintings are part of a Ragamala album. The Sanskrit word *ragamala* literally means a garland of musical modes. Each mode, or *raga*, expresses a situation or mood drawn from human emotions, mythology, and nature. Each mode is personified either as a male (*raga*) or female (*ragini*). The Ragamala tradition combined the creativity of poets, artists, and musicians. The poet used the personification of the musical mode to write a short poem at the top of the page, while the painter used the poem as inspiration for his painting.

Bhairava is the awesome or angry manifestation of Shiva. He is depicted as an ascetic and his body is smeared with ash. He carries a trident and a skull-headed staff; two serpents writhe within his matted locks of hair. Jati is a beautiful young girl who feeds pomegranate seeds to a parrot. Savari wears a garment made of peacock feathers, a pearl necklace, and wraps a serpent around her wrist to wear as a bracelet. ❖

Nepal

Bhaktapur (?)
JATI RAGINI, c. 1625
Opaque watercolor and gold
on paper
7 x 5½ in. (17.8 x 14.0 cm)
M.1979.92.21

Nepal

Bhaktapur (?)
SAVARI RAGINI, c. 1625
Opaque watercolor and gold
on paper
7 x 5½ in. (17.8 x 14.0 cm)
M.1979.92.18

China

Northern Qi dynasty
(550–577)
Torso of Buddha
Shakyamuni, c. 577
Marble
35½ in. (90.2 cm)
F.1983.35

The religion of Buddhism, based on the Buddha's human-istic teachings of non-violence, meditation, and charity, spread from India to China, South Asia, and Southeast Asia. Buddhism was introduced into China early in the first millennium of the Common Era. As the founder of Buddhism, Buddha Shakyamuni became a popular figure in Chinese art. Although headless, this fine torso manifests a strong degree of abstraction and a penchant for linear rhythm in the robe's rendering, two tendencies that were preferred by Chinese sculptors. ❖

Tibet

Bodhisattva Avalokiteshvara with
Eleven Heads, c. 1500
Gilt bronze inlaid with silver and copper
17 in. (43.2 cm)
F.1972.45.11

This cosmic form of Avalokiteshvara, the
bodhisattva of compassion, is depicted with
eleven heads divided into five tiers, which
look in all directions and emphasize his omni-
science. The topmost head is that of the
Buddha Amitabha, who is his spiritual father.
In addition to multiple heads, Avalokitesh-
vara is also given eight arms that fan out
symmetrically around his body and hold
various attributes. The dark patina of his
bronze body brilliantly sets off the glistening
gold paint and the intricately inlaid designs
of his long robes and jewelry. ❖

Western Tibet

God Jambhala, late 13th century
Bronze inlaid with gemstones
8¼ in. (21 cm)
M.1975.14.6

Jambhala is the Buddhist god of wealth. As
befits his exalted position, he is richly adorned
with a profusion of jewelry, and is rather
rotund. His bulging eyes suggest that he is
guarding his treasures. With his left hand,
he squeezes the neck of a mongoose, which
spews forth a stream of gems. Jambhala sits
in a relaxed posture upon a lotus pedestal and
is draped with a garland of blue lotuses. In
the Tibetan pantheon, Jambhala is also regarded
as a guardian of the Buddhist faith. ❖

Tibet

Buddha Akshobhya or Shakyamuni,
c. 1200
Bronze
10⅜ in. (26.4 cm)
F.1975.17.26

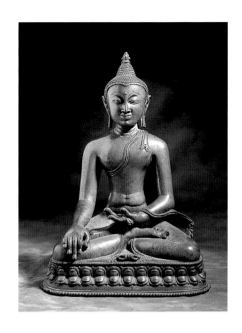

The small thunderbolt resting on the front of the lotus base is an attribute of the transcendental Buddha Akshobhya, who is the Buddha of the Eastern Paradise. The five transcendental Buddhas are a component of Vajrayana Buddhism, the dominant form of Buddhism in Tibet. Within this sect, the Buddha Shakyamuni is viewed as one in a chain of innumerable Buddhas, and more complex rituals and meditations are involved. However, the gesture of touching the earth with the right hand is also an attribute of the Buddha Shakyamuni, which makes the attribution difficult to confirm. ❖

Tibet

Kham
Descent of the Buddha (detail), 19th century
Attributed to Phurbu Tshering of Chamdo,
active in the 19th century
Opaque watercolor and gold on cotton with silk borders
18 x 12¼ in. (45.7 x 31.1 cm)
P.1998.3.3
Gift of Pratap and Chitra Pal

The event depicted in this *thanka* (rolled painting) is the descent of Buddha Shakyamuni from the thirty-third heaven. A giant triple ladder leads the way from cosmic Mt. Meru down to earth. In one of his twelve great deeds, the Buddha ascends to heaven to give a discourse to his mother, Queen Maya, who died when he was seven days old and therefore never received his teachings. He then returns to earth to continue his ministration. Halfway down, a group of monks and celestials surround him on clouds, while another welcoming party bearing auspicious gifts awaits his arrival on earth. The Buddha's ability to transcend the earthly realm in a physical way is a result of his extraordinary state of consciousness. ❖

Tibet

BOOK COVER WITH THREE
BODHISATTVAS, 11th century
Carved and painted wood
8½ x 27 in. (21.6 x 68.6 cm)
N.1977.13.1

This wooden cover once protect-
ed a Buddhist manuscript and
would have been kept in a
monastery or temple. The figure
in the center is a four-armed
manifestation of the Bodhisat-
tva Avalokiteshvara, who holds
a flowering lotus and a rosary.
To his right is Manjusri wield-
ing a sword; to his left stands
Vajrapani, who brandishes a
thunderbolt. All three figures
have mask-like faces and abstract-
ly modeled bodies, yet they
create a striking visual presen-
tation. ❖

Tibet

MAHAKALA, 19th century
Opaque watercolor and gold on cotton
29¾ x 19¼ in. (75.6 x 48.9 cm)
P.2001.7
Gift of Beata and Michael McCormick

The principal figure of this painting is
Mahakala, a manifestation of Avalokitesh-
vara and a protector of the Buddhist faith.
Immediately below is his wife, the goddess
Lhamo Remati. An important deity in her
own right, she is the patron goddess of the
Dalai Lama and the city of Lhasa. The five
figures along the top of the painting float
in cloud cartouches, denoting their celes-
tial habitat. From left to right they are:
Atisha Dipankara, Manjusri, Shadakshari
Lokeshvara, the wrathful Achala, and
Tsongkhapa. ❖

Eastern Tibet

KARMAPA MIKYO DORJE (detail), 1550–54
Opaque watercolor and gold on cotton
with silk borders
33¼ x 23½ in. (84.5 x 59.7 cm)
P.2000.6.4
Gift of Arnold H. Lieberman

The central figure in this painting depicts
Mikyo Dorje, the eighth Karmapa, or spiri-
tual leader of the Kagyu order of Tibetan
Buddhism. Mikyo Dorje lived between 1507
and 1554; presumably, this *thanka* was created
while he was still alive. The Karmapa himself
made the handprints and footprints, which
was an exclusively Tibetan practice. The
Karmapa lamas can be identified by the distinc-
tive black crowns they wear. Mikyo Dorje is
surrounded by dancing females known as
dakinis, a class of demigoddesses who act as
spiritual guides. ❖

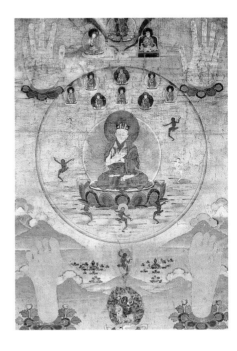

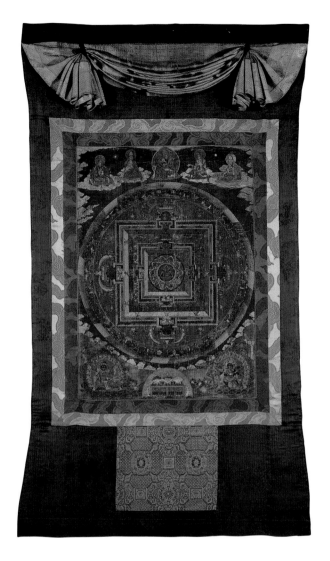

Central Tibet

MANDALA OF DORJE PHURBA, mid-18th century
Opaque watercolor on cotton with silk borders and veil
31 x 22½ in. (78.7 x 57.2 cm); silk mount: 60½ x 37¼ in.
(153.7 x 94.6 cm)
M.1975.14.11

A mandala is a symbolic map that represents the perfected
universe of a Buddhist deity. This particular mandala is
dedicated to Dorje Phurba, who is the personification of a
phurbu, or ritual dagger. A large retinue of protective and
attendant deities with animal and human heads surround
Dorje Phurba, who is found at the center of the painting.
Of the five figures across the top of the painting, Padmasamb-
hava (the Indian mystic who brought Buddhism to Tibet)
is in the center, flanked by Indian and Tibetan monks. ❖

Vietnam

Dong Son culture
DRUM, c. 3rd century B.C.E.–
1st century C.E.
Bronze
20 x 26 in. (50.8 x 66 cm)
N.1981.4

Archaeologists have unearthed
bronze drums all over Southeast
Asia. The oldest drums, such as
this fine example, date to the
third century B.C.E. and are prod-
ucts of the ancient Dong Son
culture. Drums were often buried
with their owners, perhaps because
of spiritual associations. The
zoomorphic and geometric motifs
can be interpreted as fertility or
agrarian symbols. ❖

Thailand

Mon-Dvaravati Period, Si Thep
VISHNU WITH ATTENDANT, c. 700
Gold repoussé
11⅞ x 6⅜ in. (30.2 x 16.2 cm)
F.1972.19.2

Gold plaques such as this one have
been found throughout Southeast
Asia, portraying both Hindu and Buddhist
deities. They may have been founda-
tion plaques used in temple dedica-
tions. Repoussé refers to metalwork in
which the decoration is hammered into
relief from the back. In this plaque,
Vishnu stands on a rectangular pedestal,
flanked by an attendant holding a lotus.
In Vishnu's upper hands are a wheel
and a conch; the lower right hand holds
a fruit and the lower left hand rests on
his club. ❖

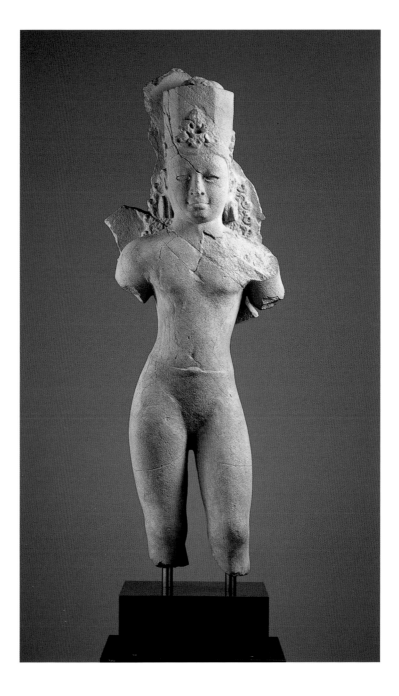

Thailand

Mon-Dvaravati Period, Si Thep
A HINDU GOD, 7th century
Sandstone
45 in. (114.3 cm)
M.1980.13

This figure is generally identified as the solar deity Surya
because of its tall, octagonal crown, but this designation is
by no means certain. Sculpted in the round, it is one of
the finest examples of early figures from Thailand. Sculp-
tures from Si Thep are noted for their simple, unadorned
surfaces, naturalistic modeling, and three-dimensional
representation. ❖

Thailand

Mon-Dvaravati Period
TORSO OF BUDDHA SHAKYA-
MUNI, 7th–8th century
Sandstone
36½ in. (92.7 cm)
F.1972.11.4

Carved in the round, this highly
polished, sensual torso belongs
to Buddha Shakyamuni. His
monastic robes are depicted as
transparent garments that cling
to his body. Sculptors of this
period were strongly influenced
by the refined, elegant style asso-
ciated with the Sarnath school
in India. ❖

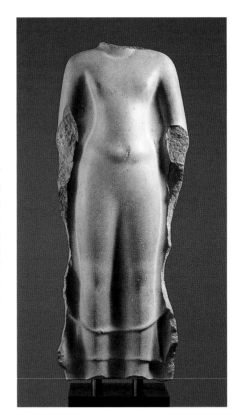

Thailand

Mon-Dvaravati Period
BUDDHA SHAKYAMUNI,
8th–9th century
Bronze
22½ x 8¼ in. (57.2 x 21.0 cm)
F.1973.12
❖

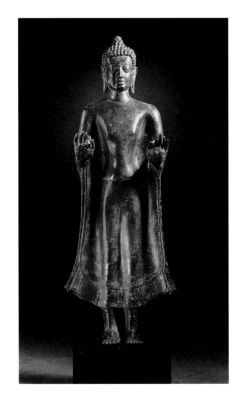

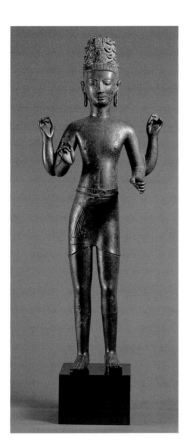

Thailand

Pre-Angkor Period, Prakhon Chai
BODHISATTVA
AVALOKITESHVARA, 8th century
Bronze
36 in. (91.4 cm)
M.1980.14

The meditating Buddha Amitabha in this graceful figure's crown of matted hair identifies him as the Buddhist savior deity Avalokiteshvara. This sculpture is one of nearly 300 Buddhist bronzes found buried in 1964 in Prakhon Chai, an obscure village in Thailand, although they were probably cast in neighboring Cambodia. Thus, although found within the geographical boundaries of modern Thailand, the bronze is a fine example of Khmer art of the Pre-Angkor Period. ❖

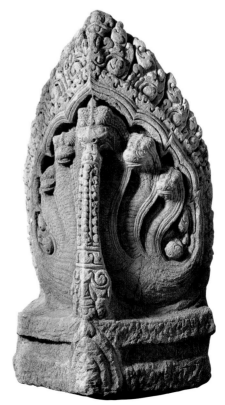

Thailand or Cambodia

ARCHITECTURAL FINIAL WITH SERPENTS,
11th century
Sandstone
42½ in. (108.0 cm)
F.1983.23

Corner pieces with multi-headed rearing serpents (*nagas*) were common embellishments for Khmer-style temples in both Thailand and Cambodia. Here, five serpents have a wheel design on their bellies, while the central one holds a long garland in his mouth. ❖

Thailand

Mon-Dvaravati Period
BUDDHA SHAKYAMUNI,
9th century
Sandstone
88 in. (223.5 cm)
F.1972.40.1

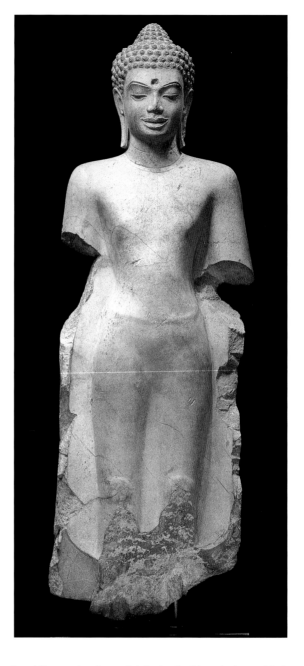

This colossal freestanding statue of Buddha Shakyamuni is a testimony to the enormous skill and confidence of the Mon-Dvaravati sculptors. The Mon-Dvaravati culture was primarily Buddhist, and prominence was given to the image of the historical Buddha Shakyamuni. When complete, this sculpture must have stood more than 9 feet (3 meters) tall and is probably the largest image of its kind outside Thailand. Although the Buddha's size is awesome, his expression is benign and his gentle smile comforting. Both his hands would have been bent at the elbow and extended with palms facing forward in the gesture of teaching [p. 282]. The hole between his eyes may have once been inlaid with a gemstone, representing the Buddha's *urna*, an auspicious tuft of hair. ❖

Cambodia

Pre-Angkor Period, Kompong
Preah Style
HARI-HARA, 8th century
Sandstone
26 in. (66.0 cm)
F.1972.40.2

This elegant figure represents
the composite form of Vishnu
(Hari) and Shiva (Hara). The
two halves are clearly distin-
guished along the vertical axis.
The Vishnu half is always on
his left; he wears a cylindrical
crown and holds a conch shell.
The Shiva side contains half of
a vertical third eye and a matted
hairstyle. Hari-Hara was an
important state deity for the
Hindu rulers of early Cambodia
and Thailand. ❖

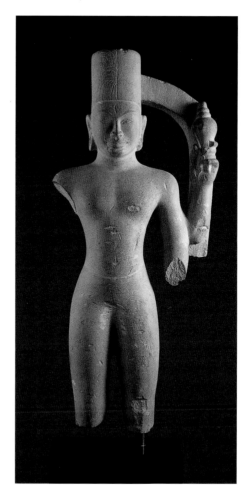

Cambodia

Pre-Angkor Period
SHIVA'S BULL, 8th–9th century
Sandstone
20 in. (50.8 cm)
M.1975.18.5

The bull is the celestial mount
of the great Hindu god Shiva,
who enjoyed a cult status of his
own in ancient Cambodia.
Although he is commonly called
Nandi, his proper appellation
is Vrisha, the Sanskrit word for
"bull." ❖

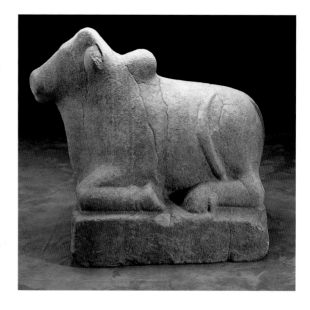

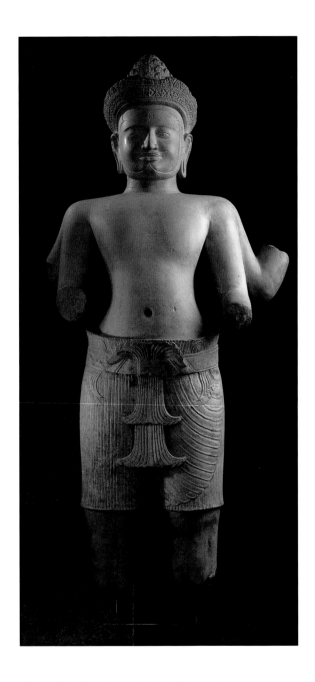

Cambodia

Angkor Period, Pre Rup Style
GOD SHIVA, c. 950
Sandstone
72½ in. (184.2 cm)
M.1980.19

Although his hands are missing, this assertive, monumental figure can be identified as Shiva by the vertical third eye on his forehead. His power and strength are evoked by the hieratic frontality of his posture and the sheer physicality of his massive body. Shiva wears a tiered conical crown that is held in place by a cloth band or ribbon. His garment is called a *sampot* and is still worn in Southeast Asia. ❖

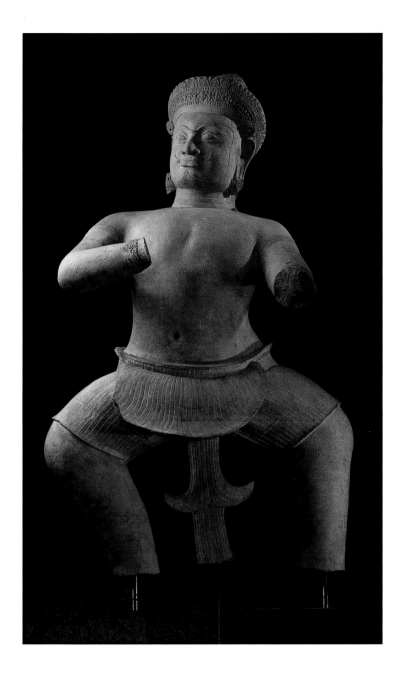

Cambodia

Angkor Period, Koh Ker Style
TEMPLE GUARDIAN,
c. 925–950
Sandstone
61¾ in. (156.8 cm)
M.1980.15

Gigantic sculptures such as this one are typical of those found at the site of Koh Ker, which for a brief period (921–928) served as the capital of the Khmer empire. This colossal figure once served as a guardian in a major temple. Apart from showing a penchant for sheer volume, such extraordinarily heroic figures reveal a new sense of movement through dramatic posturing. Identified as a temple guardian because of his threatening posture and scowling facial expression, he could as well be a wrestler or a dancer. ❖

Cambodia

Angkor Period
A GODDESS, 10th century
Sandstone
34½ in. (87.6 cm)
F.1978.25.S
❖

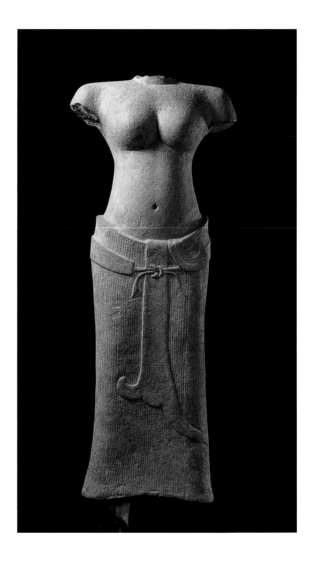

Cambodia

Angkor Period, Pre Rup Style
GOD VISHNU, c. 950
Sandstone
72 in. (182.9 cm)
M.1980.16

This monumental image of Vishnu is distinguished from other Angkor Period sculptures in the collection by its highly polished surface. Vishnu is the preserver of the universe and the embodiment of truth, goodness, and mercy. The conch shell in his upper left hand is a symbol of the five elements, denoting the physical world. The palm of his right hand cradles a small orb or globe, which represents the earth in the Khmer realm. ❖

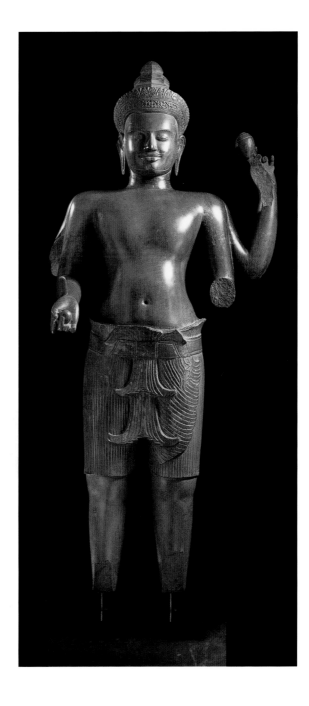

Cambodia

Angkor Period
STELE WITH FIVE PLANETARY
DEITIES, early 10th century
Sandstone
17½ x 49 x 11 in. (44.5 x 124.5
x 27.9 cm)
F.1975.13.2

Only five of what would have been a row of nine planetary deities and their celestial mounts remain intact. Known collectively as *navagraha* ("nine seizers"), these planetary divinities were incorporated into both the Hindu and Buddhist pantheons. Planets were thought of as deities who had the power to "seize" and influence the destinies of mankind. From left to right they are: Surya (Sun) on a horse-drawn chariot, Chandra (Moon) seated upon a throne, Mangala (Mars) upon his goat, Budha (Mercury) upon a bird, and Brhaspati (Jupiter) upon an elephant. The missing figures are Sukra (Venus) on a horse, Sani (Saturn) on a buffalo, Rahu, the god of the ascending Moon within a cloud, and Ketu, the god of comets, meteors, and the descending Moon, on a lion. The spout on the end of the stele is to drain off liquids, which indicates that it was purified ceremonially. ❖

Cambodia

Angkor Period, Bayon Style
SHIVA AND UMA, c. 1200–1250
Bronze
Shiva, 19 in. (48.3 cm); Uma,
17¼ in. (43.8 cm)
F.1975.5.1–2

The Hindu god Shiva and his wife Uma stand in the rigid posture known as *samapada*, on rectangular bases that were probably inserted into a common pedestal. The male figure can be identified as Shiva due to his tall, matted hairstyle. He once held a trident in his right hand, the tip of which is still attached to the base near his foot. ❖

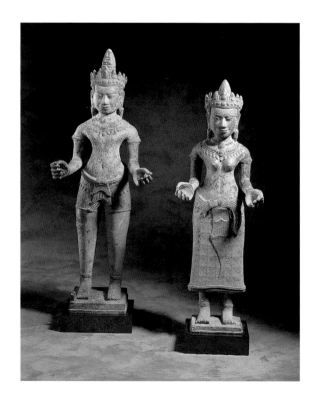

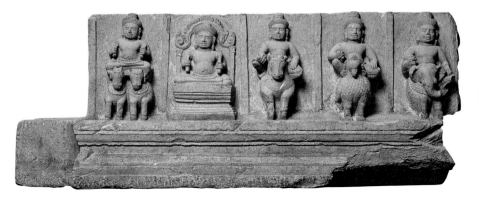

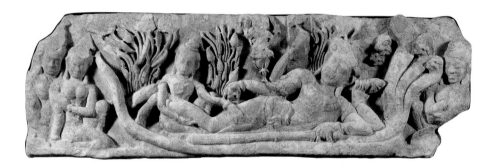

Cambodia

Angkor period, Baphuon Style
LINTEL WITH RECUMBENT VISHNU AND RETINUE,
11th century
Stone
18 x 57 x 8½ in. (45.7 x 144.8 x 21.6 cm)
M.1975.15.2

This relief, which would have been located above a doorway in a Khmer Hindu temple, depicts Vishnu asleep upon the serpent Ananta, or Eternity. The cosmogonic myth is presented here much like the way it is shown in Indian reliefs of the same event. Vishnu slumbers upon a bed of serpents that floats in the cosmic ocean. From his navel emerges a lotus blossom, with Brahma sitting on it. Vishnu is considered the preserver of the universe, while Brahma is the creator. ❖

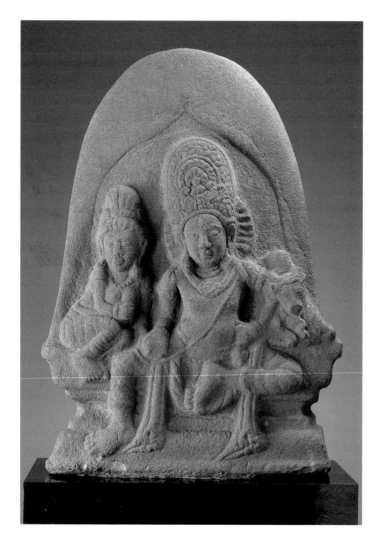

Vietnam

Ancient Champa
SHIVA WITH UMA AND BULL, 10th–11th century
Sandstone
24³/₁₆ in. (61.4 cm)
F.1975.13.4

As in Cambodia, both Hinduism and Buddhism flourished
in ancient Champa, in what is now Vietnam. Flanked by
his mount the bull, Shiva is seated in a hieratic posture,
with his wife in a more casual attitude. The Hindu god is
portrayed in both an anthropomorphic form and a symbolic
form, as the shape of the stele behind the group suggests
a linga. ❖

Vietnam

Ancient Champa
CELESTIAL FEMALE, c. 1100
Sandstone
28 in. (71.1 cm)
M.1977.20.2

This "Celestial Female" may represent the river goddess Ganga, who is always personified as a beautiful woman. Bejewelled and wearing a tall crown covered with lotus petals, she assumes a dancing posture. ❖

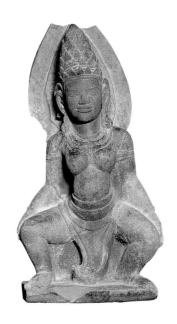

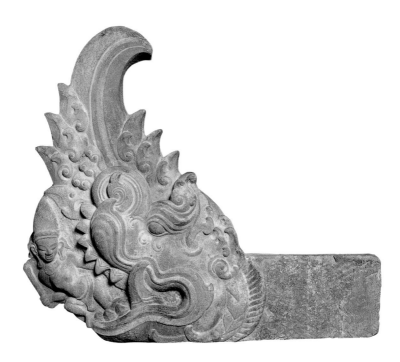

Vietnam

Ancient Champa
ARCHITECTURAL PIECE WITH MYTHICAL ANIMAL, c. 1100
Sandstone
35½ x 41⅜ in. (90.2 x 105.1 cm)
M.1977.20.1

Shown in profile, a mythical aquatic creature (*makara*) is about to swallow a male figure who holds a sword. Heroes in Indian mythology are said to extract pearls from the *makara's* mouth. ❖

Indonesia

Central Java
DURGA KILLING THE BUFFALO TITAN, 10th–11th century
Andesite
24 in. (61.0 cm)
P.1997.3
Gift of Pratap and Chitra Pal in memory
of their mothers

294

This goddess is Durga, who is known for destroying an evil
titan named Mahishasura while he assumed buffalo form.
She is usually eight-armed; here her unbroken hands hold
a club, a conch shell, and the buffalo's tail. She is worshiped
for ten days every autumn by Hindus, with great devotion
and fervor. Images of Durga are usually placed in a niche
in the northern wall of all Hindu temples, or in her own
shrine. ❖

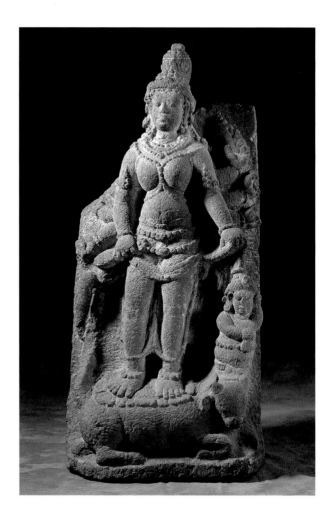

Indonesia

Central Java
THE HINDU GOD BRAHMA, 10th–11th century
Andesite
18½ in. (47 cm)
P.1998.1
Gift of Michele Wiener Caplan

Hindus believe in a triad of deities: Brahma the creator, Vishnu the preserver, and Shiva the destroyer. Brahma can be distinguished by his four heads, signifying that he is all-knowing and can see in all directions. Seated in a meditation posture, he holds a rosary to his chest, symbolizing the eternity of cyclical time. ❖

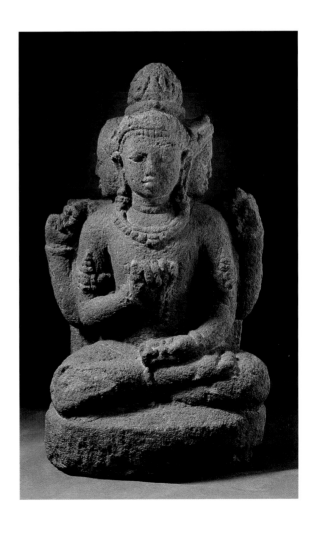